the magic of
digital
printing

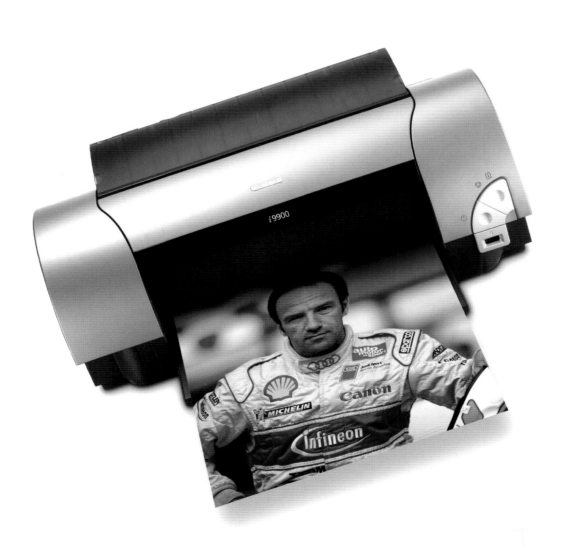

D1122753

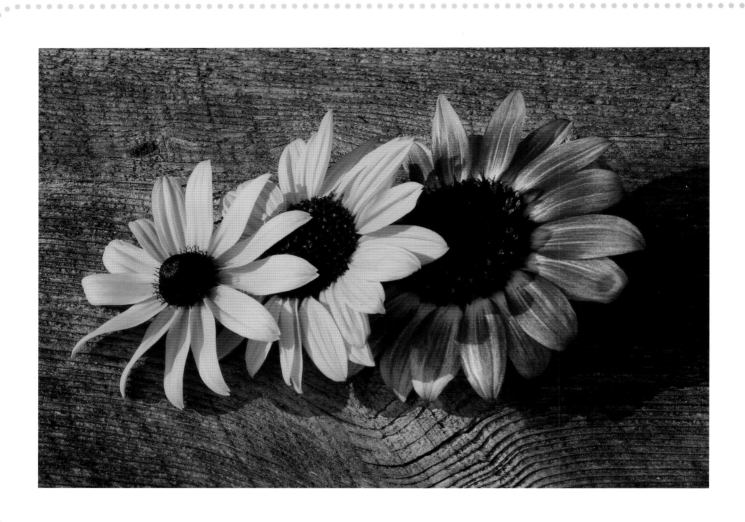

the magic of digital printing

Derek Doeffinger

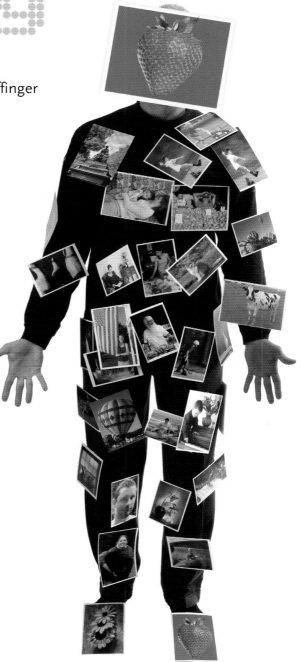

LARK BOOKS

A Division of Sterling Publishing Co., Inc.
New York

Editor: Mimi Netzel
Book Design and Layout: Tom Metcalf
Cover Design: Thom Gaines
Editorial Assistance: Haley Pritchard

Library of Congress Cataloging-in-Publication Data

Doeffinger, Derek.
 The Magic of digital printing / Derek Doeffinger.
 p. cm.
 Includes bibliographical references and index.
 ISBN 1-57990-689-3 (pbk. : alk. paper)
 1. Photography—Digital techniques. 2. Digital printing. I. Title.
TR267.D64 2006
775—dc22
 2005010784

10 9 8 7 6 5 4 3 2 1
First Edition

Published by Lark Books, A Division of
Sterling Publishing Co., Inc.
387 Park Avenue South, New York, N.Y. 10016

© 2006, Derek Doeffinger
Photography © Derek Doeffinger unless otherwise specified.

Special thanks to:
Gary Whelpley for creative product photography.
Cindy McCombe-Akers for the text and great creative projects in Chapter 8.

Distributed in Canada by Sterling Publishing
c/o Canadian Manda Group, 165 Dufferin Street,
Toronto, Ontario, Canada M6K 3H6

Distributed in the U.K. by Guild of Master Craftsman Publications Ltd.,
Castle Place, 166 High Street, Lewes, East Sussex, England BN7 1XU
Tel: (+ 44) 1273 477374, Fax: (+ 44) 1273 478606,
Email: pubs@thegmcgroup.com; Web: www.gmcpublications.com

Distributed in Australia by Capricorn Link (Australia) Pty Ltd.,
P.O. Box 704, Windsor, NSW 2756 Australia

If you have questions or comments about this book, please contact:
Lark Books
67 Broadway
Asheville, NC 28801
(828) 253-0467

Manufactured in China

ISBN 1-57990-689-3

For information about custom editions, special sales, premium and corporate purchases, please contact Sterling Special Sales Department at 800-805-5489 or specialsales@sterlingpub.com.

Introduction

In the past decade has any electronic device leaped ahead in quality and performance faster than the ink jet printer? It seems unlikely. In less than ten years, it has been transformed from a sluggish device that made pictures of Mom and Dad look like Dagwood and Blondie in the Sunday comics into a high-tech precision instrument capable of producing prints worthy of display in the Museum of Modern Art.

If you own a digital camera then it's time you celebrate the liberator of your pictures: the modern ink jet printer. With it, you can free the hundreds, maybe even thousands, of digital pictures held prisoner on your hard drive and turn them into vivid wall displays and captivating family albums. While supermarkets and photo stores may spend tens of thousands of dollars and photofinishing labs may spend over a hundred thousand dollars to buy equipment to print your pictures, you can plunk down a hundred dollars and buy an ink jet printer capable of matching them color for color and detail for detail. Amazing? Indeed, it is.

efore the digital revolution, how many people could print a terrific picture at home? Sure, you might have taken a photography course at some point in your life. You might have even set up a darkroom in your basement. However, the relatively simple processes of a black-and-white darkroom meant hours of mixing, pouring, and slopping around with smelly and sometimes toxic chemicals. And still you would take your color film to the lab for processing. Why? Color printing was far too complex and costly. Expensive—a good color enlarger cost about $500. Difficult—you needed the preci-

sion of a circus knife thrower. Demanding—you could forever ruin all your pictures on a roll of film if the temperature was a few degrees off. Intellectual—maybe not, but you needed a stack of books and a thorough understanding of color theory and processing procedures. Time-consuming—you could spend hours creating—or just trying to create—one good print.

The point of this ramble is revolution. Today you've got it made. Today you can make an exceptional color print in minutes, in your home, without a huge investment of time or money. Now that you have this option, what would you

like to do with your photos? Turn your home into a family gallery? Create a fine-art photo exhibit for the local art gallery? Adorn attendees of next summer's family reunion with their own photo T-shirts? Rejuvenate the family photo album and revive your family history? Regale friends with stunning photo greeting cards? Or reinvigorate your family spirit with a chronicle of their past year's adventures in an annual calendar? You'll be able to do all this and more.

Soon you will be cranking out superb prints on your ink jet printer. We will show you special techniques to take digital pictures designed to make great prints. We will help you choose the right picture-editing software and then show you how to make both basic and advanced adjustments of your digital pictures. Your pictures will look so good they could be hanging in a gallery. You'll learn the ins and outs of improving color, cropping, and how to quickly run cost-saving test prints. You'll know when to sharpen, when to darken, how to pick the perfect paper for a portrait of your great-grandmother versus a landscape of snow-covered Pike's Peak.

You'll come to understand ppi, dpi, resolution, file size, print size, six-color versus four-color ink sets, and just about everything else you need to know about making high-quality photos on your ink jet printer at home. You'll make amazing prints with your new digital knowledge!

Getting Started

introduction

1

Only a few years ago, you would take a roll of exposed film to the drugstore and return a few days later to pick up the prints. Now you can take a picture and make a print on the spot. Only a few years ago, photos meant standard 4 x 6-inch (10 x 15-cm) prints, okay maybe a double set. Now, at home, by yourself, you can put your digital photos on T-shirts, mouse pads, greeting cards, websites, magnets, CD covers, business cards, and just about anything you can think of.

What hasn't changed over the past few years are the essential elements required to create excellence in any field, including that of making high-quality photo prints. Those essential elements include experience and expertise. You may have some of that skill, but you probably don't have it all. And if you haven't made your own high-quality photo prints in an old style traditional darkroom, you may not even be sure what a high-quality photo print is. It all starts by getting the right printer, software, and accessories.

Setting Up a Digital Printing System

When I was ten years old and shivering during winters in a drafty 100-year-old Pittsburgh farmhouse with a coal furnace, I somehow made my mother feel guilty enough about all the clothing and bicycle hand-me-downs from my older brother that she bought me an aquarium. That's when I first learned that no hobby is simple. You don't just fill the aquarium with water and pour in fancy guppies from the pet shop plastic bag.

No, you need a filter with cleansing charcoal and angel hair, a pump to circulate the water through the filter, a heater to warm the water, a thermometer to monitor the heat, a cover to retain the heat, purified sand to hold aquatic plants, a full-spectrum light to keep the plants growing, a cleaning tool to scrape off the algae that grows on the sides of the glass, special snails to cleanse the sand on the bottom of the tank, a multi-entranced castle for the shy fish, nutrient-enriched guppy food to bring out their colors, and if you really wanted healthy, happy fish, maybe some frozen miniature shrimp treats. But there's more: dechlorination chemicals, methylene blue to ward off fungus, a glass separator or floating mini-aquarium to separate the babies from the adults, a book or two to guide you, and maybe the monthly *Fancy Guppy* magazine to make sure you're current on the latest guppy trends.

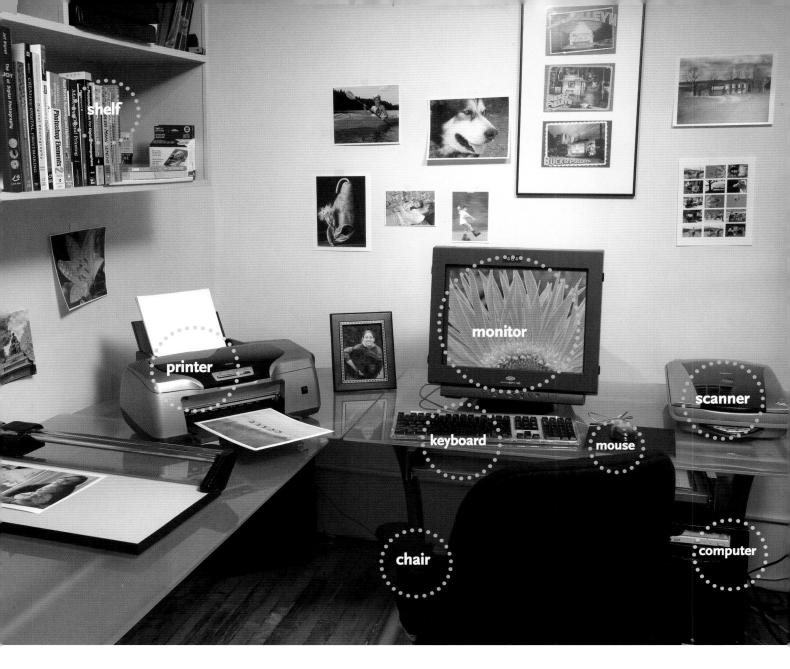

So I got my aquarium as a gift. But to pay for all the accessories, I started my first job. I planted, watered, weeded, and harvested a backyard crop of radishes, beans, and tomatoes. Then I sold them door-to-door throughout the neighborhood—twenty-five cents for a pound.

Whatever your passion, you can be sure that you won't just buy the central item and be done with it. So it is with ink jet printing. Sure, with a printer and a stack of paper, you can churn out some nice photos. But since you bought this book, you want to do more than print some nice snapshots. So let's take a look at the many things you will be considering as you become involved in printing your photographs.

dedicated space

You'll need a space for your printing setup. Ideally, you can dedicate a small bedroom or office area to your computer/printer setup; a nook in a larger room is less ideal but also acceptable. You'll need about 100 to 150 square feet, but not a square shape. A modified capital "L" works well for me, with the long leg holding a table to function as a finishing area and the foot holding a smaller table for the computer and printer. In that space you'll need to control the lighting, make closet space for supplies, and install bookshelves for reference materials, and maybe add a few electrical outlets. You'll need furniture. Perhaps the most important piece is a comfortable chair.

primary equipment

The printer, of course, is the main piece of equipment. Since we have a whole section on choosing that, let's move on. The computer and monitor are the other primary equipment pieces. What type of computer? Let's avoid the Windows-Apple battles and say it doesn't matter a whole lot. Hold it down, you Apple aficionados—I can hear you screaming, "It doesn't matter!" Okay if you're into professional or fine art printing and plan to implement color management, Apple computers seem to be better at it. If you're at a lower level, Windows has the advantage of working with many more software programs (and many companies don't even bother to make a version for the smaller Apple computer market). Software that works for both computer systems works almost identically. So get whichever system you prefer, but get plenty of RAM—a minimum of 512 MB, a big hard drive—minimum 100 GB, and a CD/DVD writer.

You can choose the cool and trendy, lightweight but somewhat expensive LCD monitors or the older style but better color rendering CRT monitors. Commit to a minimum 17-inch screen, try to get a 19-inch screen, and if within your budget, strive for a 21-inch or bigger screen. CRT monitors are generally accepted as giving truer colors, providing easier viewing, better matching to prints, and better accuracy in color management systems. They are also cheaper. LCD monitors are hip, a bit more difficult to use because of limited viewing angles, and generally considered less suitable for color-managed systems than CRTs. But most LCD models will meet your printing needs if you aren't too critical in your color needs. The bigger and better LCD models can easily cost twice as much as comparable CRTs. Of course, their lighter weight advantage is nice. My new 22-inch CRT monitor sat for a month in the downstairs hallway before I risked my back lifting all 58 pounds of it up to my printing room.

secondary equipment

For manipulating your pictures, a mouse is okay but a pen tablet, which functions much like a pencil, is the way to go. It simplifies making selections because you simply trace with the pen, a more natural motion than moving a mouse. Its pressure sensitivity allows you to easily adjust opacity and brush size simply by regulating the pressure on the pen, and it doesn't tire out your hand and fingers the way clutching a mouse does.

You'll also need a backup hard drive to safely secure your photos, and maybe a portable storage device for storing images from a heavy day of shooting on location. An extra printer dedicated to document printing would be handy. A surge protector, a mat cutter and rulers for framing prints, color management hardware and software are all items to consider. You'll need CDs and DVDs for backing up and sharing photos, and the jewel cases to protect them.

software

Any activity involving a computer will be inundated with software options. Picture-editing and picture-organizing software are first and foremost. Basic versions often come with the printer or digital camera. For snapshooters, they'll be enough. Photo artists, scrapbookers, and crafters will find a wealth of software to enhance their photo manipulation and printing activities.

supplies, finishing materials, and storage

You'll need extra paper and ink, and boxes or albums to store finished prints. To display your best prints and create impromptu gifts, keep on hand a small stock of frames and mat board and a ruler, mat cutter, paper cutter, and scissors to do the finishing. You'll need drawers or cupboards for the smaller items and a flat area to store paper boxes and mat boards.

finishing area

The finishing area is for prints that are fresh off the printer. What do you do with them? Well, they need to dry for at least a few minutes before you can evaluate them and sometimes overnight if you want to frame them. That requires a clean, flat surface. You may want an area large enough to lay out several prints without them overlapping. If you mat and frame your own prints, you'll need an even larger finishing area.

reference materials

Magazines, books, equipment and software manuals—you need them and you need to know where they are. They should be within arm's reach, or at least within a few steps, of where you make your prints. So a small bookshelf in your work area will prove invaluable when you're stumped by an adjustment or printing problem.

a pleasant environment

Do you want a television to divert you? Superb speakers to entertain you? Posters from the master photographers to inspire you? A drawer with snacks? Personalize your printing area and your time spent there will be more pleasurable.

Get the picture? Like golf, gardening, cooking, or any other serious pastime, making great prints of your favorite pictures involves more than just a printer. So start thinking about what will enhance your printing activities.

Choosing a Printer

Not surprisingly, a top-notch printer is critical to making top-notch prints. Fortunately, ink jet printers have improved as fast as cell phones. Only a few years ago using a cell phone was like holding a baguette to your ear and the reception was about equal to what the bread might give you. Now, it's like holding a 3 Musketeers bar, and the reception is indeed sweet—well, usually.

So it is with ink jet printers. Especially regarding the sweetness. Fifteen years ago, there was no such thing as a color ink jet printer for home use. And then suddenly there was. And it was good for many things, but printing photographs was not one of them. But all that has changed. Buy a new printer today and, once you become skilled, friends won't be able to tell your prints from those of a professional photo lab.

When it comes to photo printers, you really have only three or four manufacturers to consider: Canon, Hewlett-Packard, and Epson. Lexmark (who makes Dell's printers) is a distant fourth for photo printing. Epson has gained the reputation as excelling in photo printers, but Canon and Hewlett-Packard also make exceptional photo printers.

Over the past years, ink jet printers have improved so much that you can create acceptable prints with almost any brand-name printer. Eight years ago 300 dpi (dots per inch) printers were common and 600 dpi ones were considered leading edge. Five years ago 600 dpi printers were common and 1200 dpi models were the breakthrough to photo quality prints. Now 1200 dpi printers are common.

If you're getting the feeling that dpi (dots per inch) is important and that more is better, you're right. But once 1200 dpi was reached, printers had the ability to print photos equal to traditional photo prints. Nowadays, nearly all printers offer at least 1200 dpi. In printer specs consider only the lower dpi number as representing real resolution; the higher number indicates the increments a stepper motor moves the paper. So in 4800 x 2400 dpi resolution, 2400 is the number representing real printer resolution. Unless you're trying to spend less than $50 for a new printer, the resolution of the printer will almost certainly meet your needs.

Since most printers have passed the critical dpi threshold of 1200, you need to focus on the other factors required to meet your printing needs. Which

factors you give priority depends on your printing goals. Will you primarily print photos? Or will you or others in the family also print lots of school reports and letters? Will you print several photos a day or a few every week or month? Will you print big enlargements, such as 8 x 10s (20 x 25 cm), or even bigger enlargements, or mainly standard 4 x 6-inch (10 x 15-cm) prints? Will you always be printing from your computer or do you want a printer you can take along to outings and make prints without hooking up to a computer? How much do you want to spend? Do you want exceptional quality or just good quality?

From cost to speed to quality to size, there are several important differences to consider. In the end, you should research reviews of printers in photo and computer magazines and visit their corresponding websites.

types of printers

An ink jet printer is an ink jet printer. And a car is a car, and a camera is a camera. Just as cars, cameras, refrigerators, televisions, and computers come in a variety of categories so do ink jet printers. More important than their shapes and sizes are their functions and goals. Some are aimed right at us—the people who want to print photos as part of their hobby or job. Some are aimed at our families—for printing photos, school reports, and letters. Some are aimed at our business alter egos—for printing photos, scanning, and faxing business documents. And some are aimed at people more demanding than most of us—the pros who make their livelihood from photos.

general-purpose printers

General-purpose printers are the low-end, inexpensive four-color printers that can do many things well: term papers, lost dog flyers, chore lists, the church newsletter, and, of course, photos. Typically costing less than $75, you might not think of these when it comes to printing photos. I know I didn't. But when I tested out a few models and compared prints from them to true photo printers I was amazed to find the quality of several prints nearly equal to those created by the photo printers. If budget is an issue, I wouldn't hesitate to try a general-purpose printer. Just don't expect it to print the tough subject areas—solid blue skies and light skin tones—quite as well as a true photo printer.

Dye versus Pigmented Inks

The advantages of either type of ink are slowly evaporating as manufacturers overcome shortcomings. Pigmented ink printers, primarily offered by Epson, are renowned for long-lasting prints—when all the right papers and storage conditions are used. Pigmented inks tend to dry quicker and be more water-resistant. Disadvantages include a slightly narrower range of colors (probably not noticeable to most people); higher maintenance, as pigment particles are more likely to clog printer heads, particularly if used infrequently; and bronzing or differential gloss when the print appears to have a bas-relief effect, especially on glossy paper. Selective application of special glossy ink lessens the problem. Because Epson is the main maker of pigmented ink printers, you're limited to their products—the choice of models is limited. They probably aren't a good choice as a general-purpose printer unless you look at the business models that use DuraBrite inks, which don't match the photo quality of their photo-oriented pigmented-ink printers.

Dye inks excel in providing a wide range of rich, bright, saturated colors. Printers using them are easy to maintain and less susceptible to head clogging. Printer manufacturers make a variety of general-purpose and photo-specific printers that use dye-based inks. Print longevity has increased dramatically in recent years but still falls short of prints made with pigmented ink. Dye-based prints are less water-resistant and usually take longer to dry.

multi-function
or all-in-one printers

These printers combine a printer with the functions of a scanner, copier, and sometimes even a fax machine into one unit. These units are increasingly being designed to offer photo quality printing. Those multiple functions are attractive and the prices are typically low. Who wouldn't like to add a copier to their home office for that price? Many scrapbookers and crafters like the combination of a scanner and printer. Scanner functionality usually doesn't quite match that of a dedicated flatbed scanner, typically lacking the film holders common to the better scanners. Although a bit bulky, they take up much less space than having a separate printer, scanner, copier and fax machine. The footprint is about the same as a page-size photo printer. How is their photo output? Look at samples displayed in stores and decide for yourself.

letter-size photo printers

Letter-size photo printers are the heart and soul of photo printing. Although they can easily print normal text documents, they are designed to print photos up to 8.5 x 11 (A4) inches that will bring tears to your

Piezo versus Thermal Printers

Just when you thought you knew it all. Not only do inks come in pigmented and dye-based varieties, the technology for applying the ink comes in two technologies: piezo and thermal or bubble jet. Although manufacturers tout their own technology, the differences in print quality are not readily noticeable. Epson uses piezo exclusively for both their pigmented and dye-based ink printers. The piezo method applies electrical current to a tiny crystal in the inkhead. The crystal changes shapes and pushes out a droplet of ink. The advantage is that the ink is not heated, so inks can be designed without being limited to those few compounds capable of withstanding high temperatures; and the ink drop size can be varied for great precision.

Canon and Hewlett-Packard use thermal technology. Electricity heats a tiny resistor in the ink head that literally boils an infinitesimally small amount of ink to form a small bubble that pushes a droplet of ink out of the head. Ink ingredients must be able to withstand temperatures up to 1000°F even though it's only that hot for a microsecond. That excludes the use of many chemicals and solutions.

Should you consider the technology of piezo and thermal in making your choices? No. You'd be hard pressed to see the differences resulting from the different technologies. And quality of output, which is based on many factors, remains the primary concern in the selection process.

eyes. What sets them apart is that they are designed specifically for printing photos. They offer extra colors of ink, which enable superior smoothness and detail in light tones, especially faces and skies. The extra inks also produce a wider range of colors. And even the blacks and dark tones will be deeper while showing more detail.

Some dye-based ink photo printers use a pigmented black ink to extend print longevity and increase print density. Some photo printers use extra nozzles to speed up printing; most have printer software (the printer driver) and functions specialized for reproducing photos. Available in models that use either dye or pigmented inks, these are the printers that photographers will choose most often. Costs are moderate.

tabloid-size photo printers

These larger printers are the choice of dedicated photographers who crave big images. For many of us, the 8 x 10-inch (20 x 25-cm) prints coming out of a letter-size printer only torment us with possibilities. With a tabloid printer, the output is 13 x 19-inch (33 x 48-cm) paper—or a whole wall of 13 x 19-inch prints matted and framed to glorify our creative abilities. Or at least that's the dream. Tabloid printers share many of the same features found in the better letter-size printers. You may not find such consumer-oriented lures as a built-in card reader, wireless connection, or an accessory tray for snapshot paper. You will find that hardware, ink, and media costs all jump. Epson has long led the field with its famous pigment-based printers as well as dye-based printers. But Canon offers the fastest printers, and HP has built a niche as well with its ability to produce excellent black-and-white prints. Expect to pay a higher price for such a printer.

snapshot printers

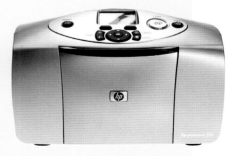

Snapshot printers are perfect for those who love to entertain friends and family by handing out prints as they take them. These printers crank out only 4 x 6-inch (10 x 15-cm) snapshots, but they're fast, they're fun, and they're portable. Some even run on batteries. Most will connect directly to the camera and also take a memory card. Some offer a wireless connection. They make a great second printer, and many models use dye sublimation technology (discussed later) instead of ink jet. These are usually economically priced.

wide-format printers

Wide-format printers crown the world of ink jet printing with their ability to produce 40 x 60-inch (102 x 152-cm) and larger poster prints. Fine artists, professional photographers, professional labs, and those who have struck it rich are likely candidates to purchase one of these technological wonders. If you can make money selling big prints and like to have total control, read more about them at the websites for Encad, Canon, Epson, and HP. Expect to spend big money to get one of these. And then figure out where you can fit it in your house. And consider that a roll of paper may cost as much as a letter-size printer.

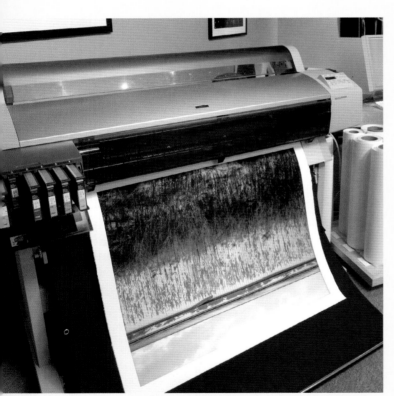

Wide-format printers are not usually in the home user's budget. A professional lab can make you a poster-size print from a digital file.

cost of the printer

For $75 to $300 you can buy a letter-size printer capable of giving you excellent photo prints. For $400 to $700, you can buy a tabloid printer that produces professional quality 13 x 19-inch (33 x 48-cm) prints. Spend more than $1000 and you can buy an entry-level wide-format printer capable of producing poster-size prints.

Let's focus on letter-size printers. When you spend over $100 for a letter-size printer, you buy both versatility and convenience. Sort of like buying a plain old knife versus one of those Swiss Army knives with a saw, corkscrew, pliers, screwdriver, scissors, and oh, yeah, a knife.

More expensive letter-size printers offer more functions and faster operation. They typically have more built-in memory or extra ink jet nozzles so that you can make prints faster, sometimes twice as fast. More expensive printers may offer the capability of accepting memory cards directly from cameras so you can make prints without a computer. They may offer a liquid crystal display on the printer and allow you to make simple image adjustments without ever using the computer. More expensive printers may offer more versatile media handling. Notice the use of the word media here instead of paper. That's because many more expensive printers can print directly onto CDs, fabric, and other materials. Won't your spouse look great in underwear with a photo of you on it?

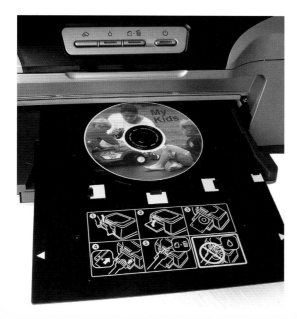

The cost of a single sheet of quality photo paper ranges from \$.50 to \$1.50. Although plain, uncoated bond paper is the cheapest at a penny or so a sheet, it's terrible for photographs. With photo paper, cost tends to reflect quality. Since you can use ink jet paper from a variety of manufacturers in your printer, you can easily find one that gives you the right combination of price and quality.

Ink is another matter. Third parties also make ink for your printer, and you may want to try them out. But in general, you should stick with the inks made by the printer manufacturer. Most manufacturers discourage the use of third party inks. So choose a printer that allows you to get the most out of your inks for a reasonable price. In other words, what is the cost per page for ink? Keep in mind that HP makes roughly \$10 billion a year on ink alone. So they and other manufacturers take steps to keep the money flowing like maximizing ink quality and minimizing warranties if you use third-party ink.

Surprisingly, more expensive, higher-end printers may not provide better print quality. Indeed, their print quality is often the same as a model at half the cost. Just as the same car engine or chassis may be used in several different models of a car line, many printer families use the same basic ink jet engine. The more expensive models simply add more features that don't necessarily improve the quality of the print. You may want some of those features, but if the cost of a new printer is critical, look for the lower end model with the core features you need.

How the ink is packaged may affect cost. Some manufacturers combine three or more colors of ink into one cartridge so that if one color runs low, you have to buy a whole new set—even though the other remaining ink colors may be abundant. You are in effect forced to discard ink. Other brands package each color of ink separately, so you buy only the ink color that has run low. Being able to buy individual ink colors can help hold down ink costs.

cost of supplies

You may not think of yourself as a caviar and champagne kind of person, but if you print ink jet photos your cost per ounce rivals that of some fine products. Think Cristal champagne and Chanel No. 5. Think over \$3000/gallon of ink. Don't believe it? Just multiply the cost of your inkjet cartridge by about 300.

But if those individual tanks are expensive you may not save anything. How inks are contained tells you nothing about how efficiently the printer uses them. Like a high-mileage car, some printers get a lot of mileage from their inks through efficient application. The cost for their cartridges might be high, but if you get a lot more photos (cost per print) printed from them, then they can be quite economical.

Then again, don't think that way. Think of the great prints and memories you are preserving at a very reasonable cost. And think of the fun and enjoyment you get from taking and creating your own prints. You're in total control and exercising your creative powers for less than \$2.00 for an 8 x 10-inch (20 x 25-cm) print.

The most effective way to find out the cost of producing a printed photo is through research. Magazine and Internet sources often indicate the cost to print an individual photo when they evaluate printers. Make sure you look at the cost to print a photo and not simply a colored page printed on plain bond paper.

Print Quality

There's more to quality than a high dpi. Much more. Let's make this clear right off the bat. The only way you can truly judge print quality is to look at prints made by different printers. Ideally, you could take a picture file to the store and print it out on the printers you're considering. However, you probably won't be able to do that. Instead, carefully examine the sample prints. Prints should not be blotchy or marred by subtle streaks. Look for smooth transitions between colors, sharp details, uniform tonality in areas of solid color, and good flesh tones. Having said that, your personal evaluation of a print is the most important factor in choosing quality. Assuming you have a good picture file, here are the main printer features that affect print quality: dpi, dot size, number of inks, ink application, and ink/paper quality. Don't overemphasize any single feature. Like a great symphony, all the components work together to define the performance or in this case the final print quality. Let's look at each of them.

pixels and dots

Cameras create pixels. Printers create dots. They are not the same. And though both products like to speak of resolution as a key factor in image quality, they are speaking different languages. As stated above, you don't really need to know how to translate from one to the other, but if you're interested let's try to untangle the terminology tango.

the resolution solution

If pixels equaled dots and dots equaled pixels, the digital world would be a simpler place. But in the world of ink jet printing not even dots always equal dots and while pixels may equal pixels some pixels are more equal than others. The terminology can be confusing.

Pixels belong to digital files—images created with cameras and scanners. Dots belong to printers and prints. When you take a picture of your grandmother, her eyes, eyelashes, nose, lips, and teeth are all

About Pixels and Dots

Perhaps nowhere does digital photography become more confusing than at the intersection of picture resolution and printing resolution. Fortunately, as difficult as the explanations may be, their implementation is simple. Before we can get into the explanation, you should try this with your printer.

Choose a typical picture to make some test prints. Use 4 x 6-inch or 5 x 7-inch paper to print your test pictures. Now you are going to print the images at four different image resolution settings to see if there is a noticeable difference: 300, 250, 225, 200. In your image-editing software, set the resolution, (dpi or ppi—different software programs use different terminology) to each of these numbers. For example, in Photoshop Elements, go to Image > Resize > Image Size > Resolution, and in the Resolution box (pixels/inch) enter each setting and make a print.

On the back of each completed print, mark the setting you used. When all prints are done, look at them both closely and from a distance of about 15 inches. See which resolution setting gives you the quality you need. Yes, the 300 will probably give the best results, but the point here is that you may not be able to see a significant difference between it and the print made with the 200 setting. The main advantage of lower settings is faster printing and less ink consumption. Also, you can make bigger prints without artificially increasing the file size. For most printers, a setting of 225 to 250 will provide exceptional quality prints without taking forever to process through the printer.

captured by the pixels on your digital camera's sensor. It may help to think of a digital image as a mosaic—a picture made from tiny points of color. If you have only a hundred pixels to represent the face you photographed, then the pixels will be big and the face will appear coarse. If you have a thousand or a million pixels, then you can capture the subtle shading, shapes, and details of the face.

In general, more pixels are better. For digital photography millions of pixels are required to make highly detailed pictures. A million pixels are referred to as a megapixel. Digital camera resolution is expressed in

megapixels. To make 8 x 10-inch (20 x 25-cm) prints, you should have at least a 4-megapixel camera. A 4-megapixel camera has a sensor that contains 4 million pixels. The sensor is actually a small chip, typically about 0.5 x 0.66 inches (13 x 17 mm) in size. For that sensor to hold 4 million pixels, you know those pixels have to be tiny.

The term resolution is used to express the number of pixels a camera or scanner captures. You can think of resolution as square footage. A 4-megapixel camera's resolution would typically be about 2400 x 1700 pixels. Multiply those two numbers (just as you would

to get square footage of a room) and you get 4,080,000 pixels. A 4-megapixel camera can make up a high-quality, richly detailed print of about 8 x 10 inches. An 8-megapixel camera could make a high quality, richly detailed print up to about 13 x 19 inches (33 x 48 cm). Or it could be cropped and still make a high quality 8 x 10-inch print. Professional cameras have enough pixels to make a big poster.

Now let's consider dots. Printers apply dots of ink to paper. The dots of ink are tiny, microscopic even, so they, too, can reveal the fine detail of grandmother's face. One dot of a printer actually consists of several smaller ink droplets placed by the printer to make up that dot. HP says their better printers use 32 ink droplets to form a dot. One measure of a printer's ability to render fine detail in a print is how many dots it can place per inch—the famous dpi or dots per inch. Once a printer can achieve 1200 dots per inch, most of us can't see any improvement even if the printer can do 2400 dots per inch.

The dots represent the pixels you originally captured with the camera, but they are not pixels themselves. Your camera creates an image made of pixels. Your monitor displays the image using pixels. If you use your image-editing software to magnify the image more than 500%, you can see the individual pixels as tiny color squares. You can also use the image-editing software to set the size of the picture and the number of pixels per inch that is appropriate for the best quality. For a printer, that setting usually ranges from 200–300 pixels per inch. How big you can print something depends on the number of pixels in the image and the quality you desire. You could make an 8 x 10-inch (20 x 25-cm) print with five pixels per inch, but the quality would be terrible. The pixels would be gigantic. Or you could use 100 pixels per inch and the picture would look better but still jaggy because the pixels would be smaller but not small enough to hide their "squareness."

For a nice-looking 5 x 7-inch (13 x 18-cm) print, many photographers prefer using an image resolution of 300 pixels per inch. That equals a total of 3,000,000 pixels. A 3-megapixel camera creates pictures with 3,000,000 pixels, so it would be up to the task. But what if you wanted to make an 8 x 10-inch

(20 x 25-cm) print? Because a 3-megapixel camera creates only 3 million pixels, you'd need to make the pixels bigger. You do that in the image-editing software by setting the pixels per inch to about 200. The pixels would be 50% bigger than they were for the 5 x 7-inch (13 x 18-cm) print. The consequence is that the print loses detail and doesn't look as sharp.

A 16 x 20-inch (41 x 51-cm) print at 300 ppi, would need over 28 million pixels. But again, you could make the pixels bigger to fill up the 16 x 20-inch (41 x 51-cm) space by changing the pixels per inch setting, in this case 100 pixels per inch. If there are 100 pixels per inch, each pixel is 1/100 inch wide and while it may not be clearly visible, seen up close the print begins to look less sharp. The print may not look terrible and from a normal viewing distance it may look fine. But the bigger you make the pixels, the lower the quality of the print.

Eventually you decide on what size print you want and send the picture to the printer. The printer's software, called the driver, analyzes those pixels and creates instructions that tell the printer how to lay down the inks as a series of dots that recreate the image on paper.

300 ppi **150 ppi**

When adjusting a picture for printing, you would typically set the ppi between 200 and 300. A print is noticeably less sharp at values below 200ppi.

dots per inch

Dots per inch (dpi) is commonly accepted as the most important factor in creating a good ink jet print. It is important, but since most printers already have passed the critical 1200 dpi threshold, the other criteria become even more important. Those other criteria include producing and precisely positioning small ink drops.

drop size and ink patterns

Drop sizes and ink distribution patterns also contribute to print quality. Currently, the smallest drop size of any printer is 1.5 picoliter or 1.5 trillionths of a liter. That's small. Some printers lay down varying drop sizes on the theory that this creates better tonal gradations, differentiation between light and dark areas, and more subtle shades and hues. Other printers emit only one specific drop size but use varying distribution patterns to improve tonality, eliminate streaking in solid colors, and so on.

You may think that the printer simply places a drop of colored ink that corresponds to the color in the picture. But it's not that simple. Consider that a four-color printer really only has three ink colors: cyan, magenta, yellow. (The fourth color of ink is black, which doesn't really add color to the image.) That's why ink distribution is important. Through effective placement of only three different colored ink drops, the printer can create the illusion of millions of colors. Often referred to as halftoning or dithering, this ink distribution can be critical to print quality. Manufacturers spend countless hours and dollars developing software algorithms for their printer drivers that enable the few colors of ink in your printer to produce full color prints. The effectiveness of the different methodologies used by different brands varies. The only way to judge quality is by viewing actual prints.

From the Horse's Mouth: Manufacturers Talk about Ink Distribution

From HP's website:

"Quality printing—especially for photos—requires precise placement of ink on the paper. That's where ink jet cartridges come in.

There's very little margin of error in photo printing: The naked eye notices dot-placement errors as little as 4/10,000 of an inch.

Perfectly straight rows of ink are actually a bad idea for photos when it comes to printing. For the best pictures, complex algorithms evaluate the photo before distributing the colors.

An integrated circuit inside the cartridge receives data so it can manage more than 300 microscopic ink nozzles, firing up to 36,000 blasts of ink per second onto the paper."

From Canon's website:

"Revolutionary Innovation Results in New "MicroFine Droplet Technology" To create high-quality images, it is essential that ink jet printers provide high resolution, multi-level gradations and low graininess. This means the size of the ink droplets must be minimized, but the challenge doesn't end there. The droplets must also be accurately delivered and in consistent volumes to the surface of the paper. When they are so minute, even a slight variation in the amount of ink discharged by a single nozzle can produce a lack of sharpness in the printed image. Unless all of the ink nozzles discharge the droplets directly, evenly and without air resistance, variations will arise in the ink placement."

From Epson's website:

"Epson printers use Epson's Variable Size Droplet Technology, where the printers can produce a number of different ink droplet sizes. The newest four-color models produce up to 6 ink droplet sizes and the six-color photo models produce up to eight ink droplet sizes. Variable Size Droplet Technology has a number of advantages:

When printing at low resolutions, large ink drops can be used to achieve faster speeds.

Different ink droplet sizes can be combined to achieve more tone representations.

The smallest ink droplets can be used in the low-density or highlight areas, reducing the visibility of printed 'dots.'

Large ink droplets are used in dense coverage areas to achieve fast print speeds."

number of ink colors

The number of ink colors is critical to print quality. In general, the more ink colors a printer uses, the better the print should be. With more inks you should see a wider range of colors, richer colors, deeper blacks, more detail in light areas, and better rendering of those all-important flesh tones.

The number of ink colors handled by printers on the market ranges from four to nine. Four-color printers can create good quality photographs but most can't match the richness and color accuracy of six-, seven-, eight- and nine-color printers. The standard four-color printer uses black, cyan, magenta, and yellow inks. A six-color printer also uses light cyan and light magenta inks. Seven-color printers usually add a second black ink. Eight-color printers add two additional colors, either red and green or red and blue plus three blacks. Light yellow is not used because the eye is not very sensitive to yellow hues. If you are committed to producing high quality photo prints, get a printer that uses at least six ink colors.

25 Years

15 Years

10 Years

5 Years

1 Year

Will your printer last? Read manufacturer's claims about longevity and choose materials carefully if you want your ink jet prints to last

print longevity

Who is that strange man holding hands with my mother at the beach (and where did they get those weird bathing suits)? When I was seven, I was rooting around in a drawer of old photographs and came across that picture. For sure I wasn't going to ask my father about the strange guy with the funky hairdo. Did I dare ask my mother? No way! That's what big sisters are for. She quickly informed me that the strange man was my father—before he went bald.

That's the value of print longevity. Your pictures will be around for your kids and maybe their kids to ooh, aah, and snicker over. Your family will have its history in pictures.

For many people print longevity is a critical factor. And it should be. Print longevity commonly means how long a print will last before its colors noticeably or objectionably fade. Most traditional photo prints last upwards of fifty years. Only a few years ago, ink jet prints would noticeably fade after several months. Recent improvements have been made in the longevity of ink jet prints. Prints made on the right paper with pigment-based inks can last longer than traditional photo prints. Varying combinations of ink and paper, kept from direct sunlight, will last anywhere from several years to over a hundred years.

If long-lasting prints are critical for you, review manufacturers' claims and the conditions required to meet those claims. Usually the longest lasting prints require you to use both the inks and paper made by the manufacturer of your printer. Sometimes the greatest longevity is achieved only by using a specific, often expensive, type of paper.

Another factor affecting print longevity is the ink you use. In general, prints made with pigment-based dyes will last longer than those made with the more common alcohol soluble dyes. But that gap is closing fast. The tradeoff is that printers using pigment-based inks are less common and that pigmented inks usually can't quite match dye-based inks for color accuracy, range, and richness.

print speed

If you hate to wait, if you're always in a rush, or if you just plan to make a lot of prints, you're the type who needs a fast printer. It will cost more, but it will be worth it.

Evaluating print speed can be tricky. It's not standardized among manufacturers. And some manufacturers may base speed specifications on printing a smaller picture or lower dpi setting than you would normally use. So read independent reviews closely to find out which printers are actually faster.

print size

Most ink jet printers accept 8.5 x 11-inch (22 x 28-cm) paper. Some printers are designed just to make 4 x 6-inch (10 x 15-cm) snapshots. Others can output 13 x 19-inch (33 x 48-cm) or even larger prints. What size printer should you get? By far, most of us would be satisfied with a letter-size printer. Letter-size printers can produce great snapshots, while also printing enlargements, and even doubling as a printer for school reports and business documents. Snapshot printers are dedicated to making small prints and nothing else. Their portability and small size are great benefits. Some are even battery powered, so they're easy to take to parties and family events to liven up the action. And they're great for scrapbookers and dedicated album keepers. But for me, snapshots are a secondary need. I make them for the family, but seldom make them for myself. And my letter-size printer handles them well.

Tabloid printers are for the truly dedicated digital photographer and print maker. These are for the professional photographer, the advanced amateur, and the fine-art printer who want total control. I bought one of the early tabloid printers, but I seldom used it at full size. The majority of my prints were 8 x 10s (20 x 25 cm). I own a newer tabloid printer now, and still the majority of my prints are 8 x 10s. But the bigger size is eye catching.

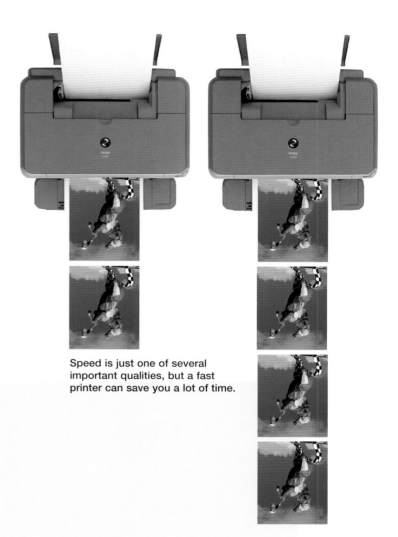

Speed is just one of several important qualities, but a fast printer can save you a lot of time.

If you plan to print snap shots to share with friends and family and maybe the occasional enlargement, a letter-size printer will suit your needs.

Keep in mind, that to make high quality 13 x 19-inch (33 x 48-cm) prints, your picture file should be 18 megabytes or bigger—preferably bigger. That means you should be using at least a 6-megapixel camera. A higher resolution camera will allow you to crop the image and still maintain enough resolution for a large print.

built-in card reader and LCD display

Some printers have a built-in picture card reader, so you can print pictures without a computer. Just remove the card from your camera and put it in the printer. The LCD shows the pictures and may even have controls for cropping and simple picture adjustments. That's convenient if you want to print away from home without lugging a computer. At sports events, parties, reunions, and school activities, you could print pictures on the spot.

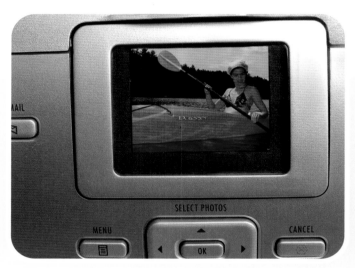

wireless communication

Wi-Fi or Blue Tooth capability is available on a few printers. With this function you don't need a cable to connect the camera or computer to the printer. This feature is most useful for users of camera phones— and families who want to share a printer from all over the house. It is less useful for those of us dedicated to printmaking. We need to be there when our prints come out.

paper handling

More expensive printers conveniently accept a range of traditional photo paper sizes, such as 4 x 6 inches (10 x 15 cm) and 5 x 7 inches (13 x 18 cm), often using extra paper trays or special paper holders, so that you can access multiple paper sizes without making any adjustments or swapping adapters and paper. Some more expensive printers also have built-in paper cutters that trim your prints saving you time; some have a second paper tray or can handle duplex (front and back) printing. Some printers handle panorama size sheets, some are fitted with roll paper attachments to create banners, or can accept other special media. If you love to print craft projects, review the latest models for their ability to handle a wide variety of media types.

Non-Ink Jet Printing Options

dye sublimation printers

Dye sublimation (know as dye sub) printers are hot competitors in the snapshot market, and they also come in letter-size models. Dye sublimation gives true continuous tone prints that are nearly indistinguishable from traditional film-originated photo prints made on traditional (silver halide) photo paper. Are they better than ink jet printers? No, they're different, but not better.

The paper is transported over a series of heating elements behind a ribbon embedded with cyan, magenta, yellow (and sometimes black) dyes. The degree and duration of heat applied to the ribbon determines how much and which colors will diffuse into the paper. Unlike the ink jet process, which places individual dots of separate color that are so small and so close together that they seem to blend into continuous tones, the dyes of a thermal printer actually do overlap and combine to give true continuous color.

Dye sublimation or thermal printers are the major alternative to ink jet printers.

The dyes diffuse into the paper to create millions of colors. The ribbons of some dye sub printers include a clear laminate layer applied to protect the print from water and other environmental elements. The quality is excellent, the longevity generally good, the speed average to good, but the cost for both hardware and media is a bit high. The ease of use? Well, easy. For the snapshot models, such as the Kodak EasyShare printer dock, you simply sit the camera atop the printer to make the connection. You then use the camera LCD to select the picture and press a button to make the print. Letter -size models that make 8 x 10-inch prints are also available. These make a nice alternative to ink jet.

The major limitation is lack of availability of a variety of paper surfaces and sizes. And you're mostly stuck with the papers provided by the manufacturer of the printer. One confusing spec about dye sub thermal printers is their pixel per inch rating. Most range from about 250 to 400 ppi. Because ink jet printers claim up to ten times as many dots per inch, you might think dye sub prints aren't sharp. But that's not the case. Comparing dpi ratings between these two different technologies is fruitless.

in-store kiosks

In-store kiosks take the letter-size thermal dye printer discussed above and turn it into a veritable photo lab. A kiosk most often uses a thermal printer, similar to those discussed above, placed in an attractive chest-high housing with instructions provided on the exterior and on the screen. They usually accept almost any kind of camera memory media, as well as diskettes and CDs. You simply walk up to the unit, insert your camera's memory card or a CD and follow the on-screen instructions. In just a few minutes, you can obtain a high-quality print.

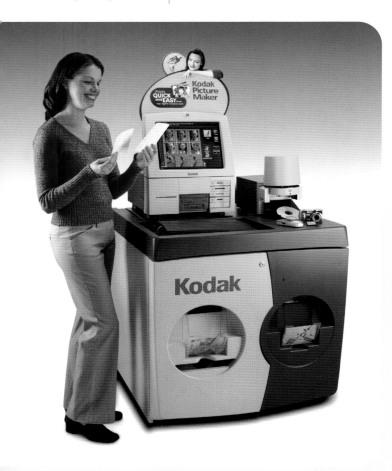

Found in many stores, the KODAK Picture Maker is a kiosk printer that accepts CDs and most types of camera memory cards to make high quality prints up to 8 x 10 inches (20 x 25 cm).

Store kiosks give you all the quality of the dye sub printer but with faster output and a variety of size and output options, such as frame and border templates to surround your picture on the print, and text greetings that you create. Kodak has far more units placed in stores, but Sony and Fuji kiosks also are popular.

The major advantage is convenience. Kiosks are located where you shop. They give good quality with minimal involvement on your part. Somebody else takes care of all the problems. The expertise is built into the machine and requires you to follow but a few simple instructions. When you don't want to take the time to create prints at home or want to make some prints while on vacation, these can provide nice results.

in-store photo labs

Now you can drop off a CD or camera memory card just like you once left a roll of film. In fact some stores no longer accept film for processing. Some day, future generations will be bored by tales of that odd contraption called a roll of film, that was like a ribbon curled up in a tiny can and it had to be washed with chemicals. I'm already nostalgic for film.

In-store digital labs take your digital image files, print the pictures and return your prints in a few hours or a day later along with your memory card or CD. Pictures are usually made on traditional silver halide photo paper optimized for digital printing. The price is reasonable, quality is good, and the convenience can't be beat.

on-line photo services

Convenience, storage, and product offerings are the primary benefit of working with on-line photo services, such as Kodakgallery.com, Shutterfly.com, and ImageStation.com. These companies provide image storage as well as tools to organize, adjust, and share images. In exchange, they hope you order photo prints and a variety of photo gifts.

You create one or more secure online albums by uploading JPEG files to the company's computer. Often they provide proprietary software to transfer pictures. The process is simple, although it can be time consuming even with a high-speed connection if you have many files to upload. Basic editing tools let you improve pictures. In addition to snapshots, you can order enlargements and a variety of other photo outputs, such as greeting cards, photo T-shirts and mugs, calendars, special album pages, and more. One of the hot new products is the photo book. You arrange your photos into a book template, and the provider will print it out and bind it. They look quite nice and have become a popular item. At the same time, if you're willing to spend the time and effort, you can do many of these same things with your ink jet printer.

Another major advantage is you can share your online albums with friends and family by simply notifying them of its Internet location. New parents especially seem to take advantage of this function by frequently uploading new pictures of the baby so family all over the world can see the pictures by simply logging in to the album. And they can order their own copies of prints, saving you that trouble and expense.

professional photo labs

When you can't do it, a pro lab should be able to. Extra quality, extra big prints, superb film scans. You name it and a pro lab should be able to do it—for a price. Normally you'll go to a lab when you want a big enlargement of exceptional quality. Larger labs will offer you a choice of ink jet prints or silver halide prints. This is largely a matter of preference and price. Both can look exceptional when handled by an expert printer. Labs will give a professional touch to all your adjustments, but will charge extra for retouching that goes beyond the basic exposure, contrast, and color adjustments.

Labs are probably your best choice when you need exceptional film scanning quality. Consumer flatbed scanners may give a decent film scan but are no match for the quality delivered by a professional scanner. That quality shows in your prints.

But like any business, some pro labs are better than others. So don't automatically assume that just because a lab is for professional photographers that it will meet your needs. Ask friends to recommend labs they've used. Often working with a local lab is best because you can establish a personal relationship. But in smaller communities, the local lab may lack the expertise or the service you require. There's no shortage of online labs that you can send files to but checking their quality and service is more difficult. Consult on-line forums for references by others.

Labs spell out how they will accept files. They may provide an online upload interface, accept files via email, or take images that are on a CD. They'll also spell out how they want the files prepared and identify the file types they'll work with. The best way to find out more is to visit some of the labs listed in popular digital photo magazines and websites and review their requirements, and then place a few small orders to see how things work.

Getting Digital Pictures

introduction

Getting a digital picture is a bit like traveling the 132.85 miles (according to MapQuest) from Pittsburgh to Cleveland. You have a lot of options: drive a car, ride a bus, take a train, or hop on a plane (but don't hitchhike and accept a ride from a Cleveland Browns fan). So, too, are there lots of ways to get to a digital picture.

Simply put, the most critical factor in making a good ink jet print is sending a good digital picture file to the printer. An apple pie made from rotten apples won't taste so good, regardless of the baker's skills. An ink jet print made from a poor digital file won't look so good, no matter how good your printer is. How do you get an image file that will make a good ink jet print? By choosing a digital camera or scanner that creates a superb image file.

By far, the hardest part of making an ink jet print is choosing the camera that creates the picture for you to print. The choices can be overwhelming. How many digital cameras are currently on the market? Hundreds, for sure. How many combinations of features do they offer? Thousands, at least, maybe even tens of thousands. Camera companies compound the problem by burying us in features. You need to be a database wizard to sort them out! Five megapixels with a 2.5-inch LCD and a 3x optical zoom lens. Six megapixels with a 1.8-inch LCD and a 10x optical zoom lens, plus 5x digital zoom and image stabilization. Eight megapixels with a 2-inch LCD and an electronic viewfinder with RAW file format support. The choices can be overwhelming, and the terminology can leave you gasping.

From magnesium bodies to ultrasonic zoom motors to Fluorite crystal elements to articulated LCDs, you are left to sort it out. Am I exaggerating? Not at all. Here are a few more terminology tidbits: an LCD with Transmissive Micro Display; Venus Engine Plus; DIGIC II Image Processor; Night Display Function; Auto Noise Reduction (nothing to do with reducing noise in your car); iESP multi-pattern AF with spot AF; TruePic TURBO Image; in-camera red-eye fix; 7-bladed lens diaphragm. Yikes. All you want is a camera that will give you good pictures. Well, we'll point you in the right direction. Try not to get too hung up on all the jargon and manufacturer claims. Most mid- and high-level cameras (and scanners) from the top manufacturers will give you good files that can make great prints.

Scanners for Film and Prints

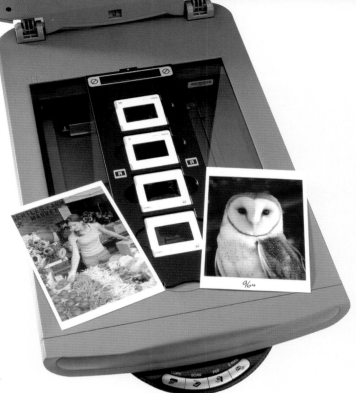

'll be the first to admit it. Scanners don't get my heart pounding. When I walk into an electronics or camera store or get an email promoting new digital products, I don't immediately search for scanners.

But a scanner is a critical tool for those of us past the age of thirty. For we have memories, and those memories are locked in the dyes of color prints, negatives, and slides. Hundreds of pictures, usually prints, of vacations in Cape May and the Adirondacks, birthday parties and sleepovers, anniversaries and Christmas celebrations, and the endless but invaluable mementoes of our everyday lives spent together as a family. If the memories are handed down from our parents in the form of photo albums, they may suffer wrinkles, creases, and folds from being passed from hand to hand and home to home over several generations and from being unceremoniously tossed into boxes and drawers.

Scanners are also a critical tool for the creative crafter and artist. Such folks take the scanner beyond its original intention of scanning pictures and documents and unleash its potential. Leaves, flowers, birch bark, fabric swatches, ribbons, movie tickets, and a host of other objects can be pressed against the platen as a form of creative experimentation.

choosing a scanner

Film scanners and flatbed scanners are the two basic types of scanners. A film scanner excels at scanning negatives and slides. It cannot scan prints. It offers superior speed and image quality over film scans made by a flatbed scanner. Its superiority is most obvious in the dark shadow areas where it will reveal detail beyond the capability of a flatbed scanner. When it comes to scanning film, it also reveals better color and detail throughout the entire brightness and color range than does a scan of film from a flatbed scanner.

If you have a stock of negatives or slides and seldom scan prints, documents, or other flat documents, a film scanner is for you. Try to find a system that includes automatic dust and scratch elimination software, such as Digital ICE. Although film scanners are available that scan film sizes larger than 35mm, they are quite expensive.

At one time or another, everybody needs a flatbed scanner. They are versatile. Most can scan both film and prints—or any other flat document and many three-dimensional objects. The better models come with film holders into which you simply slip your negative or slide. If you're scanning only prints, most

current models, both inexpensive and expensive, can do a good job—although certainly you should read reviews about quality and effectiveness of features.

If you plan to scan high volumes of pictures, look for batch processing or automation features to speed up your work. If you're scanning lots of old color prints, check for software that provides automatic color correction of faded photos.

Dramatic differences appear between models when it comes to scanning film. Film presents many more challenges than does a print. Film, whether negative or slide, is tiny compared to a print. And film has a wider range of brightness (from the deepest black to the whitest white) than a print.

If you intend to scan film with your flatbed scanner, get a model with a resolution specification of 2400 dpi or higher. Even many low-end models offer at least 2400 dpi. If you'll only scan prints, 1200 dpi will suffice. Scanners tend to publish figures for dynamic range (another way of saying brightness range). If you expect to scan a lot of film, find a scanner with a dynamic range of 3.4 or higher. If you're scanning primarily prints, a dynamic range of 3.2 will suffice. Again, read reviews to get a first hand evaluation. Nearly all models offer sufficient bit depth (get 36-bit or higher), which translates into how many millions of colors can be captured during the scan. Finally, consider that you or members of your family may have a need to scan text documents. If so, consider a scanner that includes OCR (optical character recognition) software.

5 Five Tips for Better Scans

If you're scanning old photographs, the quality of your picture may be a problem and your options in choosing alternative pictures may be limited. But when you do have a choice in the pictures you scan, always pick the highest quality original picture to scan. That means it is sharp, has a good brightness and contrast range, accurate colors, and reveals few physical flaws, such as kinks, dings, scuffs, scratches, and fingerprints.

1. Clean, clean, clean: the film, the print, the platen.

2. Correct the image's exposure and color during the scan process to maximize quality and minimize follow-up work in image-editing software.

3. Set resolution appropriately. To scan film, set resolution to 2400 dpi or higher—higher lets you crop more after the scan or make a bigger print. For prints, set the resolution no higher than 300 dpi. Try to choose a print for scanning whose size matches or exceeds the size of the print you want to make. Scanning a smaller print at a higher resolution so you can print it bigger may be your only choice, but the quality of the ink jet print you make will suffer some.

4. Crop during the scan. Use your scanner's cropping function to set the area you actually want scanned so the resolution you choose matches your needs.

5. Use the grayscale mode to scan black-and-white photos.

Determining
Resolution for Scans

Picture resolution is a key determinant in print quality. Simply put the higher the resolution, the larger you can print a picture—or the more you can crop it. So the practical meaning of resolution is how big you can print a picture.

You'll typically see picture resolution expressed in three different ways: pixel dimensions of the picture, file size, megapixels. They are all different ways of saying the same thing. I find file size the easiest to work with because it's a simple number, such as 6 megabytes.

Here's a sample of how those numbers are arrived at. For a digital camera, picture dimensions in pixels are based on number of pixels along the height and width of the sensor that records the picture. For a scanned picture, the pixel dimensions are determined by the scanner settings you make and ultimately depend on the sensor in the scanner.

So let's look at an example using the Kodak EasyShare LS443 digital zoom camera. The spec sheet says it creates pictures with dimensions of 2448 x 1632 pixels.

2448 x 1632 = 3,995,136 pixels. That's almost 4,000,000 pixels. That's a mouthful, so the digital world says the LS443 creates a 4-megapixel picture. But how many megabytes will the picture file be? It's not 4 megabytes. It's 12 megabytes. That's because the 4 megapixels represents the picture before it is converted into full color. To convert it into full color, the camera adds information for the colors red, green, and blue, which when mixed together can create millions of colors (that's how your computer and monitor create colors).

So to get the file size, you multiply the total number of pixels in the picture by the 3 colors (red, green, blue) or 3 x 4,000,000 pixels = 12,000,000 pixels or 12 megabytes. The LS443 is a 4-megapixel camera and that means each picture it creates is a 12-megabyte file.

Here's an example for a 2-megapixel camera:

Resolution = 1632 x 1232 = 2,010,624 pixels or 2 megapixels

File size = 3 x 2,010,624 = 6,031,872 or 6 megabytes.

To determine how big you can make a print, use the resolution dimensions, because your print also comes in dimensions. Let's assume you'll use the minimum recommendation of 200 dpi to make your print. You then simply divide each dimension by 200 dpi to get the maximum recommended print size.

Example: For the 2-megapixel camera above, maximum print size at 200 pixels per inch = 1632/200 x 1232/200 = 8.2 x 6.2 inches (20.8 x 15.7 cm).

For maximum print quality, you might want to adjust your picture resolution to 300 pixels per inch (ppi), which would give you a print size of 1632/300 x 1232/300 = 5.4 x 4.1 inches (13.72 x 10.4 cm).

But why not just make it easy on yourself and refer to the table on page 39. It shows how big you can print pictures based on the number of megabytes and image resolution.

key camera features

Because they're electronic gadgets, digital cameras can be loaded with software features and functions. Software-based features can be useful but are usually less important than hardware features. For example, every camera you consider should have a built-in flash; a separate viewfinder for framing the picture (it doesn't drain power like the LCD picture display panel).

A standard battery size, such as AA, is more convenient than a specialized battery, because it can be found almost anywhere. However, lithium ion batteries common to laptop computers have become increasingly common in digital cameras and are particularly powerful. One important software feature is the exposure compensation control so you can adjust picture brightness during picture taking.

Choosing a Digital Camera

Cameras to the right, cameras to the left, cameras in PDAs, cameras in cell phones, cameras in stores, cameras in cyberspace, and no doubt soon to be cameras in cereal boxes. Digital cameras are everywhere, and the choices are overwhelming. From snapshot cameras to professional models, from sleek and slick, fit-in-your-pocket models to fat and fancy, do-everything gadgets—you have to decide which is right for you.

Some are extremely cool and eye-catching. Others are the pinnacle of practicality and easy to use. Only you can decide on the cool versus the practical, the hip versus the handy. But before you do, let's look at a few features.

5 **Five Key Features:**

Resolution—greatly influences picture quality

Type of lens—affects picture quality and versatility

File format—RAW files for extra versatility

Close-up mode—lets you photograph small subjects

Manual exposure mode—gives you extra creative control

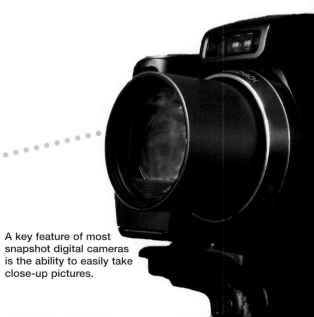

A key feature of most snapshot digital cameras is the ability to easily take close-up pictures.

Resolution

Resolution is the digital version of square footage. It expresses how many pixels (picture elements) on the sensor are used to create the picture. Resolution is expressed by the number of horizontal pixels on the sensor multiplied by the number of vertical pixels. Resolution for a typical sensor might be: 1950 pixels x 1500 pixels = 2,925,000 pixels. Or in the language of digital cameras, 3 megapixels (mega equals million).

In a digital camera, the sensor is the digital equivalent of film—only it is used over and over. The camera lens forms an image of the scene on the sensor. When you take the picture, the sensor records that image and the camera's electronics process it and store it.

The quality of the sensor and the camera's electronic processing of picture data can also greatly affect picture quality. But you'll have a very hard time judging that for yourself unless you can take the same picture with a variety of cameras. Look for reviews to provide such information.

resolution

The chart below shows how big you can enlarge a digital camera picture or any digital picture that corresponds to the file sizes. If you crop a picture, you reduce its resolution/file size, so refer to the new smaller file size to see how big you can print a cropped picture.

You'll almost always want to crop a picture at least slightly to improve it. If you are not critical of your pictures or suffer from poor eyesight, you can accept the next larger print size for each value shown below. For example, non-critical folks might be pleased with an 8 x 10-inch (20 x 25-cm) print made from a 3-megapixel camera.

Camera resolution	File size	Print size (inches) with a 300 dpi file	Print size (cm) with a 300 dpi file
3 megapixels	9 megabytes	5 x 7	12.7 x 17.8
4 megapixels	12 megabytes	6 x 8	15.20 x 20.3
5 megapixels	15 megabytes	6.5 x 9	16.5 x 22.8
6 megapixels	18 megabytes	7 x 10	17.8 x 25.4
8 megapixels	24 megabytes	8.5 x 11	21.6 x 27.9

types of camera lenses

My dog compulsively licks the inside of the car windshield. So I have a clear understanding of what it means to have the world look a bit blurry. Although few camera lenses are licked by a dog during manufacturing, some just aren't as clear and sharp as they could be. Why is that? It's probably because they're made of plastic. The best lenses are made of glass. The very best lenses are made of special optical glass precisely ground to advanced formulations and specifications. Yet those cheaper plastic lenses reduce cost to allow for cheaper cameras. Many are capable of making good pictures, but not as good as glass lenses. And if you're taking the time to read this book, we'll assume a camera with plastic lenses is not up to your standards.

Most digital cameras made today have a zoom lens. (We are talking here about cameras that don't have interchangeable lenses.) However, the term zoom is used to describe both optical zoom and digital zoom. Optical zoom always refers to the actual lens. Digital zoom uses software to enlarge the image after it is captured on the sensor. It's similar to cropping and enlarging a photo using image-editing software. You'll get better results using the optical zoom lens to enlarge the subject directly onto the sensor, thereby using the sensor's full resolution.

Zoom lenses give you more versatility than non-zoom lenses, but how much range should your zoom lens provide? Zoom lenses typically range from 2x to 5X, but 10X and even 12X zoom lenses are not unheard of. Whether their range is 2X, 3X, or 10X, most zoom lenses start out at a slight wide-angle setting—good for those sweeping scenic views. They differ in how much they can magnify a scene. A 3X zoom lens offers a slight telephoto effect, good for little league games where you can pace the sidelines. A 10X or 12X zoom lens offers a powerful telephoto good for pictures of high school athletics where you are relegated to the stands. However, more powerful zooms also tend to show more optical defects. As a recommendation, don't choose a camera with less than a 3X optical zoom lens. Read reviews and carefully examine image quality from a camera with a 10X zoom before buying it.

For cameras with less than 6 megapixels, just ignore the digital zoom. Digital zoom is a marketer's form of natural selection to identify gullible customers (sorry for being cynical). Because the digital zoom reduces resolution, it lessens your ability to make bigger prints. Cameras with 6-megapixel or higher resolution give you pixels to spare, making the digital zoom somewhat feasible when making prints less than 8 x 10 inches (20 x 25 cm).

file format

The most common file format in digital photography is the JPEG (or JPG) file. Its name derives from the organization of Joint Photographic Experts Group. Common to snapshot cameras, its primary feature is that it has very effective compression so you can store more pictures on a memory card. Most cameras offer variable amounts of compression. Just remember, when you increase compression you reduce image quality, because image data is literally tossed away.

More advanced cameras also offer TIFF (Tagged Image File Format) and/or RAW file options. The TIFF file takes up quite a bit of room on a media card but offers excellent quality (without any compression). The RAW file format is a requirement for truly serious photographers. It allows the photographer to make key adjustments normally made during picture taking at the computer. So after you take the picture and want to open it on the computer, you can use the RAW format to change the white balance, the ISO, exposure compensation, and a variety of other settings that can greatly affect quality. With the RAW file format, you are working with the original image data before in-camera processing altered it. It's sort of like taking chocolate cookies out of the oven and seeing that you've burned them a bit. Wouldn't it be nice if you could turn back the clock a few minutes and take the cookies out before they burned? With a RAW file, that's exactly what you can do.

close-up mode

Close-up mode is a joy to use for photographing flowers, insects, stamps, coins, jewelry, and many other small subjects. Make sure you get a camera with this good close-up capability: the key features being how close you can focus and whether you can use the telephoto capability in Close-up mode.

manual exposure mode

Most cameras offer a variety of automated picture-taking modes that select specific camera settings to optimize results for a variety of situations, such as action, night scenes, portraits, and landscapes.

Some more advanced cameras include a Manual exposure mode. With Manual mode, you set the camera's aperture and shutter speed. In Manual mode, you can control the camera settings to create effects you want. But you have to know how camera controls affect a picture's appearance to choose the right settings. If you own a single-lens reflex (SLR) camera, you already appreciate this extra versatility. Manual mode is primarily for advanced users who like to make sure the camera is using the right settings to give good pictures in difficult situations.

ease of use

Do you want family snapshots or do you want to photograph almost any subject, from race cars to school plays to wildlife? Before you answer, know that as capability increases so does cost and complexity. With a complex camera, you'll need to read the manual more than once. You'll have to practice with the camera to learn its many features. But once mastered, it will likely give you the capability of taking incredible digital pictures.

With a simple snapshot camera, you'll be taking good snapshots minutes after opening the box. And should your Aunt Emma ask to borrow it, she'll be able to take pictures, too. But neither of you will have quite the versatility and capability of a more advanced camera.

computer capability

If your computer is less than five years old, a new digital camera will almost certainly work with it. By that I mean that the camera's software should be compatible and the computer should have the proper connections. Nearly every camera connects to the computer through a USB (universal serial bus) port. It's a flat, rectangular plug about the size of the fingernail on your index finger. Before you buy a camera, review the specs to make sure camera and computer are compatible.

other features

A few other features and options may sway your decision. One of the hot and valuable new features is image stabilization. This technology counters the slight movement that results when you handhold the camera. The benefit is sharper pictures and the ability to hold the camera to take pictures at shutter speeds as slow as 1/15 or even 1/8 second.

Most cameras can take video clips—the variables to consider being frame rate and resolution. Some cameras accept a variety of add-on lenses that increase versatility. Some let you stitch together several pictures to create a grand panorama. Some come in product bundles that may include a complete starter's kit or individual items you want, such as picture-editing software, an extra picture card, a camera bag, or other accessories. But if you find a camera that seems to fit your needs, don't give it up for a promotion on another camera that isn't as well suited for you.

If you choose a complex camera or printer, keep the manual handy.

Taking Digital Pictures for Good Prints

introduction

How many of you failed a pop quiz in high school? How many of you could drop everything right now and be ready for a triathlon tomorrow? How many of you would be happy if when you went to work, you found out that in five minutes the big boss would be riding in your car (for me, think dog hair, muddy paw prints, and discarded Hoho wrappers and a few empty Diet Coke bottles)?

Whether it's school, work, sports, or printing your photos, preparation is nearly always the key to getting good results. You should know all the factors about taking a digital picture that can dramatically affect the quality of an ink jet print. So we're going to quickly review some important camera settings and picture-taking techniques. Preparation will help you make the best pictures before you even try to print them.

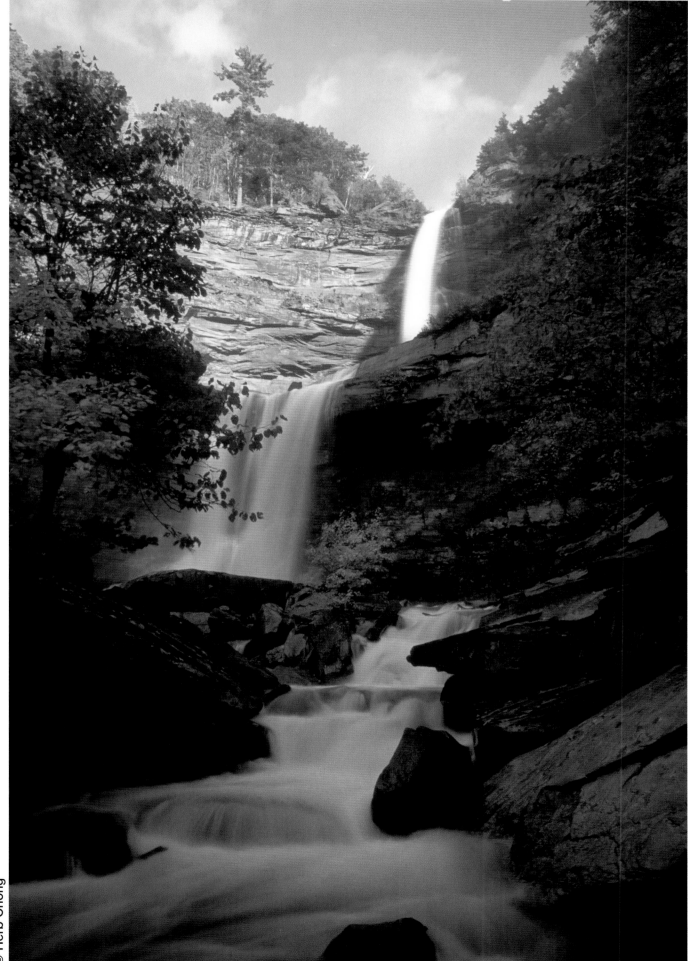

Creating
Good Exposures

Exposure is simply the photographic way of saying correct brightness. This may well be the most important step in making pictures that will create great prints. It's also the easiest to control.

If you're an ace with your picture-editing program, you might think starting off with a well-exposed picture is no big deal. After all, you can adjust it. Well, yes and no. If your picture is a tad too dark, you can lighten it and still make a good print. But if it is way too dark, restoring the correct brightness is time consuming and can only partially compensate for the areas that were too dark. If the picture is greatly underexposed, there will be no detail to see in the darker areas, and the overall picture will never look as good as it would have if properly exposed in the beginning. And if a picture is too bright or too light, there will be no detail in lighter areas and no matter how much you darken it the picture it will never look quite right.

The solution? One solution is to shoot RAW files, but that slows down your workflow and isn't available on all cameras. So if you are using JPEG files and taking pictures of important subjects or in tricky lighting, take extra pictures at different exposures that let in more and less light. One is sure to be almost perfect. Tricky lighting scenes are those dominated with unusually bright (snowy field) or dark (newly paved asphalt parking lot) areas, or those that present a mixture of light and dark areas (a spotlight shining on a singer on a darkened stage).

You can automatically adjust image exposure by setting your camera's exposure compensation control before taking the picture. It's usually a dial or menu setting marked with the +/- symbols. For most scenes, you'll want to bracket your exposures. You simply take one picture with the compensation control set to normal, take a second picture with the control set to -1/2, which will darken the picture slightly, and then take a third picture with the control set to +1/2. This is a way to ensure you'll get a properly exposed picture.

For unusually bright, dark, or contrasty scenes, take several pictures at slightly different exposures to be sure of getting one well-exposed photo.

-1 Stop

Normal Exposure

+1 Stop

Don't hesitate to increase exposure compensation to +1 if experience shows it's required. For example, if you're taking pictures of scenes with large white areas—snow, white, sandy beaches, white buildings—then set the control to +1/2 and +1 for the second picture. But for most cameras and most scenes, the 1/2 setting will work fine.

Now you'll have three pictures with different exposures to review on your computer. Make sure to evaluate the photos on your computer monitor, not just the small LCD display on your camera. The better picture is the one picture that shows some detail in both lighter areas and darker areas, while also making the main subject look good.

Use the Best Quality Settings

Use your camera's best quality/resolution settings so your prints look their best.

Nearly all consumer digital cameras offer several controls that affect picture quality:

- Compression setting
- Resolution setting
- ISO setting
- White balance control

quality

The quality setting typically has three settings named something like: good, better, best (or fine, very fine, superfine). The control determines how much compression the camera applies to the image file that is made. Nearly all cameras can store pictures as a JPEG file. All JPEG files compress the picture to create a smaller file size. That's good. The bad part is that compression reduces picture quality. At the best setting this reduction in quality may not even be noticeable in a print. But at lower settings, it can be. It

shows up as jagged edges and little splotches in uniform tone areas, such as blue sky and faces. It's always a safe bet to use the best setting.

resolution

Many cameras also have a resolution setting. Its settings may be designated by words, such as small, medium, large; by pixel dimensions representing the actual resolution you set; or by a combination of the two. The resolution setting doesn't actually lower picture quality. It just reduces the file size, which affects the largest print size you can make.

Think in terms of a can of paint. The highest resolution setting is a gallon of paint. The middle resolution setting is a quart of paint. The lowest resolution setting is a pint. When applied, the paint from each container looks equally good, but the coverage differs dramatically. With the gallon, you could paint an entire small room, the quart would only cover a closet, and the pint barely enough for a cupboard. So in making photo prints, the high resolution might be great for making 8 x 10-inch (20 x 25-cm) prints, while a lower setting might be enough for only 4 x 6-inch (10 x 15-cm) prints. And, of course, the high resolution setting lets you crop the picture so the subject fills the frame and still make a decent-sized print.

When Not to Use the Best Quality and Resolution Settings

1. If you're traveling and don't have a lot of camera memory, you may want to use a medium setting so you can fit more pictures on your memory card.

2. If your camera's best setting is for a TIFF file, don't use it except for once-in-a-lifetime photos. Although the TIFF setting creates a very high quality file, it takes a lot of space, often 15 megabytes or more. This will quickly fill up your storage card.

3. If you only make snapshot-size prints or rarely crop your pictures, then feel free to use medium-quality settings. Avoid low-quality settings unless you don't care about making good prints or are desperate to fit more pictures on your storage card.

With snapshot digital cameras, using an ISO setting of 400 or higher typically results in image noise.

ISO

The ISO setting is actually a quality control, especially on snapshot digital cameras. Digital SLR cameras use a higher quality sensor to record the image than snapshot cameras, so the ISO setting has less effect on image quality. Normally, you think of the ISO setting being used to make it easier to take pictures in different lighting conditions. A high ISO setting, such as 400, means the camera needs less light—good for cloudy days, twilight shots, and action photography when you want fast shutter speeds. A low ISO setting is good for bright sunny days.

The sensor actually is set for just one ISO, usually around 50 or 100. Then, like a video camera, the ISO control increases the "volume" of the electrical signal coming from the sensor. Increasing the volume also increases the "noise." Noise is stray colored pixels that increasingly appear at higher ISO settings. By

ISO 400 in snapshot cameras, the noise is obvious and distracting. If you have a dark background, the noise from stray pixels may make it appear to be filled with colored confetti. The noise also builds up at longer shutter speeds (say one half second or longer), but many cameras have built-in programs that help reduce this type of noise.

The amount of noise varies with different cameras, but most cameras use sensors from just a few manufacturers. The best solution to minimize noise is to use the lowest ISO and hold the camera extra steady (use a tripod or support it against a tree, column, or chair) if a slow shutter speed results. But unless experience with your camera shows otherwise (meaning your camera has good noise reduction software built in), avoid exposures longer than 1/4 second or so, because again the noise can build up—even at low ISOs.

Other image controls also affect image quality but to a lesser degree. These controls include contrast, sharpness, and saturation settings. Read your camera manual to determine if your camera offers these controls and how much they affect the picture.

Most photographers like to change these factors with image-editing software. It offers much more control and effects can be applied to a copy of your image rather than the original. Setting the camera controls to increase contrast, sharpness, or saturation creates picture characteristics that cannot easily be undone. If you keep such camera settings neutral and alter these image qualities with your image-editing software, you can gain much more control, including the ability to match what your camera would have created.

My snapshot camera offers these controls. I have them all set to neutral. Even as I write this, I'm going to review my manual and check if maybe I shouldn't lower each of the settings. However, it is my snapshot camera, and I am pleased with the results of my snapshots. Experimenting with and understanding your camera's image quality controls help deliver the ultimate image quality in your print.

10

Top 10 Tips for Taking Great Pictures

Here's a summary of the techniques we've discussed in this section, plus some additional tips. Use as many of them as you can when you want the highest image quality possible from your camera.

1. Get the highest quality file by using the RAW file format or if RAW isn't available use the highest quality JPEG and resolution settings.

2. Use the lowest ISO setting to minimize image noise.

3. Set the white balance to match the light in the scene—or use custom white balance.

4. Use a tripod so the image is extra sharp.

5. Compose the picture so it requires minimal cropping.

6. Clean the lens periodically so smudges and dust don't degrade the image.

7. In bright sun, use a lens shade or use your hand to block direct sunlight from striking the lens and causing flare.

8. Minimize or turn off in-camera settings for saturation, sharpening, and contrast; you can alter those with more control using your image-editing software.

9. If your camera offers a choice of RGB and sRGB modes, choose RGB because it offers a greater range of colors.

10. Take extra pictures.

Set the White Balance Control

Is your camera's White Balance control set to Auto? It probably shouldn't be if you are keen on making good prints with a minimum of fuss. If you recall, during picture taking, the White Balance control adjusts a picture's color range to be "normal" for the type of lighting in a scene. The most common lighting, of course, is daylight, which is usually thought of as sunlight, but can also be the cooler, more bluish light of cloudy days. And the color of daylight does vary throughout the day, from the orange light of sunrise fading into yellow an hour later, then fairly neutral until an hour from sunset when the light again warms up. There's also the light from your camera's flash and household lighting, such as tungsten and fluorescent lamps.

Since each of these light sources has a different color balance, each can affect the perceived colors of an object. Because the colors in their light aren't dramatically unusual, your eye and brain adjust to make scenes appear normal. Your camera doesn't, however. Think of how a light blue bowl looks in red light (it looks dark gray). The orangish light of a household light bulb makes people's faces look too yellow, the greenish light of a fluorescent tube makes faces look a sickly green. Both film and digital cameras capture these unwanted color casts.

A digital camera's auto white balance tries to identify the light source illuminating a scene and then adjusts the overall colors accordingly. And it often does a good job, sometimes just an okay job. But it almost never does a perfect job, because it can never really distinguish between the light illuminating the scene and the light being reflected by colored objects in a scene.

That's why you should set the white balance control to the lighting you're in. It will consistently give you more realistic colors that require less adjustment. Outdoors, use the appropriate daylight setting: sunlight, shade, overcast, or sunrise/sunset. Indoors, use the flash setting or if you're not using the flash indoors, set the white balance for the type of light dominating the room, typically tungsten or fluorescent. If there are no artificial lights on when you're indoors, use the daylight setting. If you want to truly dial in the white balance, use your camera's (not on all cameras) custom white balance setting.

Camera Handling

Sure there are a few golfers out there with herky-jerky swings that can still shoot below par and a few pro basketball players whose high point average belies a shooting motion that looks like somebody pressed a hot iron against their rear, but fundamentally sound camera handling is critical to good prints. At the top of that camera-handling list is holding the camera steady. How many times have you heard or read this? Probably more times than you can count.

Camera shake can produce an unsharp picture and an unsharp picture will yield a poor print. It cannot be corrected by any amount of sharpening using your image-editing software. The solution? Use a fast shutter speed and hold your camera as steady as possible. The rule of thumb is that your shutter speed should be at least 1/focal length of the lens. For example, if the focal length of your lens is 100 mm, don't use a shutter speed slower than 1/100 second. Handholding is not recommended at shutter speeds slower than 1/60 second unless you have no other option.

Holding your camera as steady as possible means using a tripod more than you would expect. Indoor portraits by window light, twilight skyline shots, landscapes, sports subjects, and images made with a telephoto lens—all will yield sharper pictures if you use a tripod.

Next best thing to a tripod is to gain the additional support offered by a nearby immobile object: a fence, a tree trunk, a chair, a wall, and so forth. If you end up handholding the camera without additional support, and most of us will, then take a stable, steady stance and very gently and smoothly press the shutter release. Don't jab it.

If you're in the market for a new digital camera, consider one that offers image stabilization technology to counteract the slight handholding movements that can blur your shots.

If you didn't bring your tripod, you can steady your camera on the back of a chair.

Full Frame Equals Full Resolution

Even if you have an 8-megapixel camera, you should compose your pictures as if you don't want to crop them. If you carelessly compose the picture, you'll have to crop it to make it look nice, and you'll likely end up throwing away millions of pixels. By cropping out millions of pixels, you've thrown away much of the picture's enlargement potential. There's no advantage to having an 8-megapixel camera if you're constantly discarding half the image data.

The answer is to carefully and tightly compose your pictures so you don't have to crop later. Does that make you nervous? Do you think you might miss something by composing too tightly? Take several photos. Take a tight shot that won't need to be cropped later, then back away and take a couple of extra pictures that give you more of the scene. How much can you crop and still make quality prints? See the section on cropping for that answer.

Five Tips for Better Pictures

From *The Seven Habits of Highly Effective People* to *Ten Tips for Faster Reading*, any process can be boiled down to the fundamental principles that lead to success. So it is with taking digital pictures.

be a picture rustler

What does a rustler do? He goes where the cattle are and rounds them up. As a photographer you should do the same. Don't just passively sit back and wait for the photos to come to you. Find them, create them, and round them up. When a photo opportunity arises, circle your subject, take a good look at it from every angle, and take charge. Move your visiting brother and his son to that big picture window with the soft light ideal for a portrait. Climb down the hill for a viewpoint that includes those brilliant red sumac leaves in the foreground. Or ask your daughter to point that kayak toward the lower corner of the picture area to create a dynamic diagonal. In short, take control of the scene and rustle up the compositional components to your advantage.

single out your subject

When it comes to composing a picture, you want the subject to be the center of attention. Use some of the photo techniques that single out a subject and direct attention to it. These techniques include moving in close so the subject fills the frame, using a plain background so there are no distracting details, using diagonals and other directional elements to lead the viewer's eye to the subject, and finding ways to contrast the subject with the rest of the picture so it stands out.

© Herb Chong

challenge conventions

Should you hold the camera steady? Sure, most of the time. But when you want to shake things up, follow the "shake, rattle, and roll" rule and see what your pictures look like. Should you hold the camera straight? Absolutely. But when you're bored to tears, tilt that camera to convey a sense of mayhem and disorientation.

Capture that beautiful face? Who could possibly turn their back on beauty? Maybe you. Ask your beautiful niece to turn away from you and photograph her from the back. Use the rule of thirds to position a subject in the viewfinder? Why not try putting the subject on the extreme edge of the viewfinder as if it's falling out of the picture. Conventional picture taking is fine most of the time. But if you can't rattle your pixels once in a while where's the fun.

try a new perspective

That new perspective might mean varying your physical position. Most of us hold the camera somewhere between five and six feet off the ground. The obvious change is to kneel, even lie down on the ground and shoot up to give a child's, or even a frog's, view of the world.

How about changing your cultural perspective? Think of yourself as being from the land of sneerers. How would you photograph people? Or what if you came from the land of "what did I walk by?" and your culture called upon you to turn around and photograph those things you had walked by and ignored. Silly? Perhaps. But getting a new view on life isn't going to just happen. These types of self-imposed exercises can be fun and train you to see the world differently.

to thyself be true

I admit it. I have a thing for photographing gourds. And I must confess, it took me two weeks after becoming enamored with one particular gourd to realize that Freud would have a heyday with me—but so what. I find the bulbous, curvaceous, sinuous shapes of gourds intriguing.

For you, it may be the kitchen sink (again, I must confess, I like the kitchen sink), ripples on ponds, silhouettes of leafless trees against a barren sky. The point is don't deny your own interests for the sake of conformity. Artists arise from following their instincts and passions. So follow yours and see if Freud still beckons from your dark inner recesses.

Five Tips for Better People Pictures

The most cherished pictures are almost always those of people. By following a few simple techniques you can create exceptional photos of your family and friends that they will clamor for.

soft light for soft skin

Professional photographers spend thousands of dollars on lighting equipment that imitates the soft outdoor light of cloudy days and shady areas. Why? Because this soft light caresses the face to reveal its subtle tones and delicate nuances, while minimizing cosmetic flaws. When you have a choice take pictures of people on overcast days, wait until the sun is behind a cloud, or take your subject to a shady area. Indoors, position your subject by a window without direct sunlight, and you can get that soft outdoor light.

Bright sunlight is generally unflattering for people pictures. It's harsh, washes out flesh tones, spotlights flaws, causes squinting, and creates unattractive facial shadows. Get the point? Avoid harsh sunlight when you can. Indoors, the harsh head-on light from your camera's flash all too easily can create what could pass for a driver's license picture. Not too pleasant. But nearly every home has soft, flattering light coming in through a window. For portraits, sit or stand somebody near that window. Certainly there are occasions when you'll want to use your flash indoors, but when you want to make a portrait, head for the nearest window.

use flash in bright sunlight

Bright sunlight is a reality and when handled correctly, it can even make good people pictures. Did we just contradict ourselves? No. It's considerably harder to get good portrait-style pictures in bright sunlight than in the diffuse light of an overcast day—but it can be done.

Most of the problems from sunlight arise from the deep, harsh shadows it throws across the face, hiding eyes and highlighting wrinkles and pimples. Reduce those shadows and you reduce their effects. The easiest way to

without flash

with fill flash

reduce them is to have your subject turn fully or partially away from the sun. Next, turn on your camera's flash and take the picture, standing five to eight feet from the subject. The flash will lighten facial shadows, and add an inviting sparkle to the eye. Don't stand too far away, or you'll reduce the effect of the flash.

move closer

Whether you step in close to the subject or zoom in with the lens, the goal is to fill the picture area with the person you are photographing. The biggest mistake most photographers make is to show a subject too small in a picture. A person standing before you seems—and is—as big as life. When reduced to a few inches in a picture, that same person seems drained of the personality you felt while taking the picture.

So show that person large in your picture, and you'll capture their personality. Move in close to reveal the details. Up close, freckles emerge, eyes twinkle, and hair shines. Up close, eyelashes tease, lips pout, and nose rings taunt. From even a few feet further away, such provocative details vanish and with them the emotions they arouse.

shoot at eye level

The surest way to pull somebody into a picture is to have eyes staring back at them—at their level. Eyes are people magnets and when they gaze out at you from a picture they pull you into the scene.

For most subjects, you should hold the camera at their eye level or slightly lower. That means when you're photographing children you may need to kneel. To give somebody an air of authority, hold the camera at their waist or chest level, so they seem to be taller than you, almost towering over you.

catch expressions and candid actions

Heartfelt hugs, brotherly teasing, claps on the back, rollicking laughter—nothing engages viewers more than spontaneous expressions and candid actions. Emotions and everyday activities reveal personality better than a "smile-and-say-cheese" picture any day.

Certainly pose subjects and create formal portraits when that's your intent. Just as often, politely lurk in the background with camera ready and capture the natural emotions and expressions of life. Show your mother pruning her prized roses or lugging weeds to the compost pile. Photograph your dad hip-checking his 10-year-old grandson during a driveway basketball game. Catch your daughter lounging on the floor studying the latest in teen fashions. (Of course, she may not suffer such intrusions graciously but years from now she'll laugh at such pictures.)

Shooting Pictures for Printing

Many of us take pictures for the sheer pleasure of taking pictures, to release the creative currents coursing through our heads. Others take pictures to build a sense of family history, to cement family bonds, and build harmony and appreciation for each other.

But few of us take pictures with the pure intent of printing them out for a display. However, as printers of photographs we should all think that way. Once you begin looking at things in the world as possible trophies for your wall, you'll see pictures differently. You'll take pictures differently. Once you realize that the shapely rose with a hopelessly busy background can easily be separated out in Photoshop, you'll take its picture. Or that the bland sky above that swayback horse beside that sagging barn can be replaced with those burgeoning storm clouds from last March,

you'll photograph it. Once you realize that the bubble pattern of your pool's brilliant blue solar cover might make a nice background, you'll add it to your collection of interesting background photos.

Once you begin to think of your image-editing software and printer as creative collaborators that can expand your vision, then you will begin to see and photograph the world in entirely new ways. Your imagination will seem to be on steroids as you learn to combine time, distance, and dimension in ways never possible when shooting film. Sound fanciful? Then let's prove we can stir your fancy and unleash your imagination.

stock images

Keep the collaging and combining potential of your software in mind. You should regularly shoot and collect a wide variety of stock images: fluffy clouds, patterns of ferns, flowers, dried mud, and rain pelting a pond; unusual objects like antique milk cans and lanterns; colorful subjects like umbrellas and pumpkin patches; personal objects like pocket watches and worn shoes. Try scanning surface textures like parchment paper and canvas. When you have a collection of images, you can replace dreary skies, add in an emotional personal touch, or take a bland photo in a new direction through collage techniques.

print mosaics

From the simple and straightforward stitching of panoramas and posters to combining several prints, dozens of them, or even hundreds of snapshots to form mosaics that build a picture, your printer gives you new ways of expressing yourself. Consider an uncommon approach when you specifically have a display in mind for a room or wall. You can find software that will automatically stitch together several pictures to create a panorama or poster. You can photograph your cat (or any other subject) in a series of close-ups at varying distances to create a collage out of a dozen or more prints.

black and white

Unless your background includes traditional black-and-white photography, you may not look at the world beyond its colors. Black-and-white photographers regularly find beauty in scenes that color photographers turn from. Watch for scenes with a wide range of brightness, scenes rich in form and shape, scenes reverberating with your psyche for reasons unknown.

Your digital camera may have a black-and-white mode (also called grayscale or monochrome). If not, image-editing software can easily convert color images to black and white. These can slide out of your printer and look every bit as classic as traditional black-and-white prints.

scrapbooks and albums

Scrapbookers love enhancing their creations with objects both real and photographed, such as ticket stubs, buttons, and fabric swatches. All photo stories can benefit from such effective details. Use your camera to show that special dessert on vacation, the parking ticket on the windshield, the colorful foreign currency, the label on the wine bottle, and then add small prints to your album or wall display.

sequences

Sequences are simply two or more related image displayed side by side. In the fine art world, they are known as diptychs and triptychs, and tend to be both subtle and dramatic, are often conceptual, and usually go beyond the familiar before-and-after pictures. They can show a subject changing over time, be it a garden from planting to harvest, your son captured in the same pose from ages five through ten, or a motion study of a dog leaping for a thrown stick. And they need not be the same subject but could be a paired theme or thought.

Organizing, saving, and backing up your pictures

introduction

Remember Beanie Babies? All the rage only a few years ago, parents, moms especially, scrambled to find the latest and cutest so their precious and precocious kids could add it to their collections. What do Beanie Babies have to do with organizing digital pictures? Well, when you tracked down the much sought after Goochy the Jellyfish in June and secreted her in a hidden nook in the house to be retrieved later for a Christmas surprise, guess what happened? Come December 24, after frantically ripping through every drawer, cupboard, and closet and coming up empty-handed, you realized your organization methods might need work.

Your picture files need to be secured and organized. That's no easy task. One of the great promises of digital photography was the elimination of shoeboxes and drawers stuffed haphazardly with negatives and prints. The digital evangelists said these things would all go away. For the disorganized, keeping track of digital pictures is as much of a challenge as keeping track of negatives and prints. Like your house, your hard drive is full of hundreds, nay thousands of nooks and crannies where files can hide from you. Each digital picture is a small, easily lost file that can disappear among all the other files on your computer, or let a week slip by and you can forget where you put it.

As hard as it is for a disorganized person like myself to admit, picture organization is the bedrock of printing. When it comes to printing, you can't print what you can't find. Just imagine spending hours adjusting and retouching the four-generation family reunion picture you took last summer. Now the requests for it are pouring in, but you can't find it.

Software for Organizing Your Pictures

If there's a need, there's a software program. And boy is there ever a need for organizing pictures. A variety of programs offer photo organization features. Increasingly, photo editing and photo organizing programs are converging so that both offer functions to organize, adjust, and print photos. But there's not a combined program yet that will meet all the needs of serious photographers.

Of the many organizing programs to choose from, they tend to fall into four levels of increasing capability and complexity. The mere fact that you're reading this book strongly suggests you are a candidate for a level three program, possibly level four if you have thousands of pictures and you use them to make money (or are a database geek).

level 1: your operating system software

For snapshooters who take a few hundred pictures a year, your computer's operating system provides a simple and effective way to handle and view pictures. It's a built-in image management system. For example, starting with the MyPictures folder in the MyDocuments folder, the Windows XP system offers a file hierarchy ready-made for picture handling. It also gives you several viewing and image management tools. Apple's built-in iPhoto organizer, which reviewers give high marks for its simplicity, offers similar features. The photographer who expects his total number of images to exceed 1000 will be better off using dedicated image management software.

level 2: your digital camera's software

The software that comes with most digital cameras is more advanced. The manufacturer's software is often multifunctional and powerful enough to meet basic needs. The software provides both organization and adjustment functions.

Kodak EasyShare software typifies the offerings. It lets you adjust brightness, contrast, rotate pictures, eliminate red-eye, and make other simple adjustments. Its organizational features let you indicate "favorite" pictures, use keywords, add captions, and create folder categories. It also simplifies sharing pictures via email, printing, or uploading to online albums. With simplicity as its hallmark, it enables you to accomplish most tasks with one or two clicks of the mouse. Canon and Nikon, aiming at a more advanced market, provide software for their cameras that is more advanced in adjusting pictures. There is even freeware, such as Irfanview or Picasa, that is quite capable of meeting your basic needs. All these programs work well for folks with limited needs.

Stay Organized

Compounding the storage problem are the many versions of digital pictures we often create. In addition to the original file, we may have a small version for emailing, a custom version for Aunt Jane, an adjusted version, a print version, a backup version. These are all the same picture, but each file has been altered for a specific use.

What should you do? Follow my advice, not my example. Organize your pictures along every step of the digital workflow. To achieve organizational nirvana, you need the right tools and mindset. They include:

* Organizational software

* Organizational hardware

* Organizational strategy

Batch Renaming with Windows XP

With your digital camera spitting out picture after picture named alphanumerically, if you don't manage them right away, they accumulate like snowflakes into huge drifts (and like snowflakes they all seem similar). Eventually you'll face the daunting task of renaming the files. Windows XP provides a way to rename all similar files (say your vacation to Cape May) with just a few keystrokes.

Batch renaming works best with pictures of a single event or category that can all be described with the same root name, such as a reunion, a birthday party, or a vacation.

Go to the folder holding the pictures you want to rename.

Click on the Views button and set the view to Thumbnails.

Select all the pictures you want to rename. To select multiple pictures, hold down the Ctrl button and click on each picture you want to rename. If the pictures are all in a continuous sequence you can click on the first picture you want to rename and then holding down the Shift key, click on the last picture in the sequence—all the pictures in-between should now be selected.

Right click the first picture, and choose Rename.

Rename the first picture (example, BenFirstHaircut). Click in the space between pictures and all your pictures will be renamed with the root filename of the first picture and a number. For example, BenFirstHaircut1, BenFirstHaircut2, BenFirstHaircut3, and so on.

level 3: photo management software

For a step up in functionality, capability, and also cost, look at the albuming programs. For about $50 you get software that gives you increased organizational and image adjustment features. These programs include Photoshop Album, Ulead Explorer, and Paint Shop Photo Album. They can acquire pictures from scanners, connected cameras, CDs, mobile phones, and portable storage devices.

You'll find additional organizational features, such as album pages, increased search and viewing capabilities, and greater file compatibility. However, some don't support RAW file formats. And since the RAW file format isn't standardized like other file formats, you have to check that the software supports your specific camera's RAW file format. So if you shoot in the RAW file format, make sure any software you buy supports your RAW files or use the software supplied by your camera manufacturer to convert RAW files to a compatible format.

Most of these programs also include a variety of publishing functions to help you share your pictures via slideshows, the web, or print. Automated online galleries offer templates to assist you in printing postcards, greeting cards, business cards, calendars, album pages, and scrapbook arrangements.

Of course, greater functionality leads to a greater learning curve. Each new version of albuming software offers extra image editing and printing capabilities so you can soon expect a full-featured image-editing program combined with a full-featured organization program. Currently, the closest any program comes to meeting both organization and adjustment needs is Photoshop Elements.

A good digital image management program makes it easy for you to find, organize, and manage your images.

level 4: digital asset management programs

A serious category name gets you some serious software. Asset management programs offer you not only a serious name, but also serious power—you can really take total control of your images. Prices start at about $50 and go up to several thousand dollars—for that price, you get software as well as servers and support. The range of software covers a wide variety of image organization needs: the advanced amateur, the professional photographer, the multi-person/multi-computer studio, or the corporation with offices around the world.

Popular and powerful software for under $100 for individual photographers come from ACDSee and Cerious. Professional and corporate solutions come from Extensis and Cantos. Their automatic backup functions minimize your risk and save you time. If you've got lots of pictures to manage and are comfortable with computers and software, check out these programs and you may never lose an image again.

The Stages of the Organizational Workflow

Although some folks may add or subtract a stage or insert interim steps, for most of us there are three definite stages to organizing your digital pictures:

1. Transferring pictures from camera to computer

2. Adjusting pictures

3. Printing pictures

transferring pictures from camera to computer

If you take lots of pictures, you need to discipline yourself to act immediately or on a regular schedule. Before transferring pictures to your computer edit them ruthlessly. If you edit as you shoot, you'll make this task easier. Just get rid of the obviously bad and meaningless pictures.

Secondly, rename your files immediately after transferring them. The obscure alphanumeric names assigned by the camera to digital picture files are meaningless. Would you know that P821008 is a picture of a farmer in yellow rain overalls at a farm stand making change from a wad of bills? Or that 102_1141 is my daughter kayaking? Certainly not. A real advance in digital photography would be a camera that lets you name the file when you take the picture. Some cameras let you annotate picture files with a microphone, but that's not what I mean. Maybe it's not too far off that voice recognition software will let you name a file by speaking its name to the camera at the moment you take the picture.

Unfortunately the obscure camera file names are not always unique. For reasons unknown to me (did I unknowingly reset the camera?), I have gotten a message during file transfer asking if I wanted to overwrite an already existing file with that same name. I most certainly did not, but some of my pictures are gone forever because I unwittingly wrote over them. Renaming files after transferring them not only simplifies organization, but it also avoids accidentally overwriting an existing file with the same name and losing that picture forever.

organizing pictures for printing

How you organize pictures depends on two things: your personal preferences and the structure imposed on you by the software. A folder/category organization system is recommended for your pictures, but ultimately you have to set up an organization that works for you.

Make a "PricelessOriginals" folder

Your original pictures are priceless, thus the folder name recognizes this and serves as a reminder. Why are original pictures priceless? Whether they look good or bad, only these originals contain all the information available at the time you took the picture. They contain complete and original image data, which you can go back to time and again to make a picture better.

As you become more expert, you'll find better ways to adjust favorite pictures. As you work on new photo projects, you'll revise older pictures accordingly, and as technology improves, you can improve older pictures. You can only do this if you kept the original, unaltered images.

Every time you take a noteworthy picture, put the unaltered picture file in a "PricelessOriginals" folder. Don't wait. Then, be very careful to never change the pictures in this folder. They are irreplaceable. The only thing you should do to them while they are in the "PricelessOriginals" folder is rename them. When you want to edit one of them, save a copy in a different folder and give the copy a new name. That way you preserve the priceless original picture and always have it available to fall back on.

After you've color corrected a photo, retouched flaws and blurred the background, you don't want to lose it somewhere on your hard drive. A good organizational system will make your photos easy to find.

Depending on the software you use, your organization will probably be based on a folder structure or a category structure. We'll try to cover both methods. The folder structure is an actual set of folders and subfolders that contain files. The category structure is simply a designation or common identifier assigned to each file. The files can be anywhere on the computer, but when you tell the software you want to see all pictures in the category "Pets," they'll appear in a window—not within the folders they're contained. That's the power of image-management software. You don't have to physically arrange the location of the pictures—just give them designations (categories, keywords, favorites, file names, whatever) that the software can search on.

Whatever software and organizing methods you opt for, I suggest you use these folders or categories because for the most part they match the workflow a digital image follows from downloading to printing. I tend to add redundancy by including a descriptive suffix in the file name that tells something about the file. You'll see what I mean in the scheme below:

• PricelessOriginals: This designation contains renamed but otherwise unaltered picture files from your camera. Organize the picture files within it however you choose, but give the folder or category a name similar to mine, because your original picture files truly are Priceless. Not every last picture deserves this designation but use it for your best and most treasured pictures. I add "PO" to the file name.

• PicturesToBeOrganized: Put pictures in this folder when you lack the time to rename, categorize, keyword, or otherwise organize pictures while downloading them.

• PartiallyAdjustedPictures: This is for files you are adjusting but haven't finished. Again, this is just a holding area until you finish adjustments and place the picture in the correct folder. When you expect to spend a lot of time (more than 15 minutes) adjusting a picture, save an intermediate version that is a third or half finished. That way, if you have a computer crash, you won't have to recreate all your work. Be sure to save it under a new name, so you don't accidentally save over the original file. The suffix used for the file name? "PAP," of course.

• FullyAdjustedPictures: You will want to clearly identify pictures you've spent a lot of time adjusting. This can be a subfolder, category, or a keyword, depending upon the software and your organizing preferences. Just to be sure, clearly identify those pictures you have printed successfully so you know you don't have to rework them.

• PrintReady: Image files in this category or subfolder have already been successfully printed. Clearly identify them so you know you don't have to rework them the next time you want to print one. The file name suffix is "PR."

Step-by-Step Procedure
for Organizing Your Pictures

1. Once you choose your picture organization software, be sure to use it effectively. I've combined the term "folder/category" to cover the needs of those using the operating systems' folder structure and those who use management software, where you can simply identify a picture's category rather than actually move it to a folder.

2. Set up a folder/category structure.

3. Upon transferring pictures to the computer, edit (meaning delete) those you don't want. The fewer pictures you have to organize the easier it will be.

4. Rename your pictures with meaningful names upon transferring them. For important pictures, add keywords, categorize them, tag as favorites, or use other identifiers that enable you to easily search out important pictures. I typically add a suffix to the file name that further describes a picture's status. For example, "FAP" indicates that an image has been fully adjusted.

5. Mark its category as a PricelessOriginal or move it into a PricelessOriginal folder or subfolder; the name indicates that the file should never be altered. Make a copy before applying any adjustments.

6. Upon making major adjustments to a picture, save it in the adjustment folder/category with the suffix "FAP" or something similar to remind you it's been adjusted and so it won't overwrite the original.

7. Upon achieving a good print, mark its category as PrintReady or save the print file in the PrintReady folder; to the file name add PrintReady or PR. This reminds you that it's a file ready for printing and prevents you from overwriting the adjusted file or the original file. Steps 5 and 6 may seem to create duplicate or similar files, but they are intended for different applications and will save you time in the future.

8. Regularly backup your files to CD/DVD, making a second backup for important pictures. One is for your use, the other you should put away and never use unless something happens to the first. By now, we all know that CDs/DVDs can get damaged, that's why you need a duplicate for important pictures.

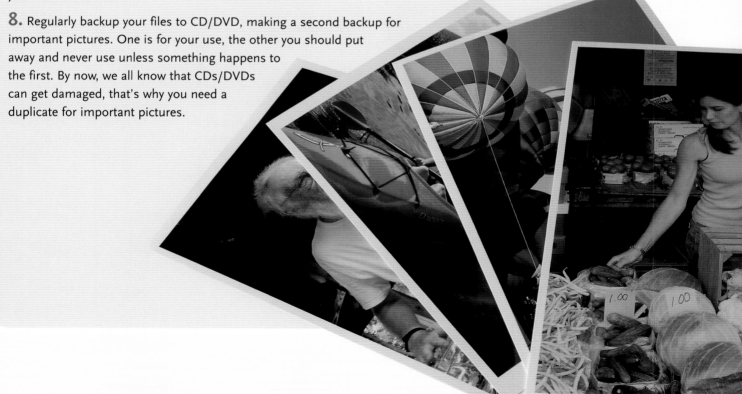

save files in the best format

For best results, save files either as a TIFF (tagged image format) file or in the picture-editing program's native format. The native format varies by program. Here are some typical file extensions for common picture-editing programs: Photoshop: psd; Photoshop Elements: ppd; PhotoImpact: uld. If your file is named "GaryGraduatingHighschool," it might look like this: GaryGraduatingHighschool.tif or GaryGraduatingHighschool.psd or GaryGraduatingHighschool.uld.

Do not repeatedly open and resave pictures as JPEG files. Do not save finished files in the JPEG format. JPEG files are fine when you want a file for emailing, posting to the web, or for uploading to a printmaking website, such as Kodak EasyShare gallery. The JPEG file format is not good for printing files at home. The JPEG format always reduces the quality of your picture. Always. This file format compresses the picture to reduce its file size. Each time compression is applied, picture information is thrown away. The first or second time a file is saved in JPEG format, the loss of quality may be negligible but like a hole in a bucket, eventually the quality will dribble away. And once it's gone, you can't recover it. Fortunately, you followed my advice and saved the priceless original, you can go back to that file and start over again.

Hardware for Organizing Your Pictures

The equipment you choose to backup and secure your pictures will depend on the volume of your picture taking and the priority you give to securing your images. The more importance you put on your pictures the more equipment you'll need. So let's take a quick look at the storage and backup options to see what you might need.

field storage

Photographers who shoot high-volume or high-priority images on location frequently use photo wallets, photo viewers, field CD writers, and other portable storage devices. These devices accept a wide variety of camera memory cards so you can download pictures wherever you are. Most use a 20-gigabyte or larger hard drive so you can shoot to your heart's content. Some include an LCD panel for viewing images and software for organizing images on the go. Increasingly, these are becoming multi-functional devices in which storage is a secondary—but still vital—aspect as they take on MP3, CD, and video playing functions. You could use a laptop computer instead, but it would be considerably larger and more fragile than most field storage devices

Who needs portable storage? As an example, wedding photographers not only take a lot of pictures but their livelihood depends on delivering these pictures to their clients. They can't risk losing images on a camera memory card, so many of them use portable, battery-powered devices to back up their images on site. Although most weekend and casual photographers don't need such devices, they could prove invaluable for special events and vacations.

built-in hard drive

It goes without saying that your computer's hard drive is the de facto storage device for pictures first transferred to your computer. Your hard drive should be 80 MB or bigger. Avid video shooters may want to install the biggest economical hard drive available.

CD/DVD writer

Standard to home computers, CD and DVD writers are the traditional means of backing up pictures. Because they're cheaper and hold fewer pictures, which in my mind makes them easier to manage, I use CDs for regular monthly backups and special event backups, such as vacations and social gatherings. I use DVDs for my semi-annual "total" picture backup in which I write all pictures on my computer hard drive to one DVD. Use only non-rewritable media, so there is no chance of overwriting (destroying) pictures you want.

backup hard drive (portable hard drive)

I have an external hard drive dedicated to pictures only. I backup pictures to it every time I add new pictures to my computer's hard drive. You could choose an internal hard drive, but I like the portability of an external hard drive. I can move it between computers in my house or take it to a friend's computer. And because it's external, I can isolate it from any problems that may strike the computer, such as power surges and viruses. I disconnect my external hard drive from the computer and from its power source immediately after backing up pictures. Most of the time it is offline, unused, and secure.

what you shouldn't use

Don't use camera storage cards to backup your images. Their small size makes them easy to lose and sooner or later somebody will delete the pictures. Don't use cheap CDs or DVDs because their longevity may be questionable.

Storing Important Pictures

Your 200-gigabyte hard drive can hold thousands and thousands of pictures. That means it can also lose thousands and thousands of pictures. The saying "Don't put all your eggs in one basket" has new meaning: Never, never, never rely on only one hard drive to store your pictures. Back them up. How often? Every time you have a picture or a collection of pictures that you don't want to lose. How? You have a couple of choices.

Although rewritable CDs are a convenient way to frequently backup pictures, they are risky because anybody could accidentally write over your beloved photos.

The only sure way to backup your photos is to save them on non-rewriteable CDs or DVDs and to place them in jewel cases to avoid damage. Before deleting any pictures from the hard drive, confirm that you can open pictures from the CD. And for your most priceless of photos make a backup CD to the backup CD. Since most image-editing and organizational software programs make it easy to print thumbnail images on a CD cover, you might want to do just that as a reminder of what's on the CD. Don't place a label on the CD (it might get warm and peel off in the drive); if you write on it, use only a pen rated for writing on CDs, as some Sharpies are. Non-archival pen inks can eventually reduce the life of a CD.

Will CDs be around in twenty years? If you are looking for storage that will survive any technology changes, make a high-quality print of your picture. Yes, a print—a good ink jet print will be fine. Since people will always have prints, companies will always provide ways of digitizing them. (Although you can be certain those ways will be constantly changing.) Back up your pictures electronically, print your best pictures, store them archivally, and you will have done everything you reasonably can to outwit the forces of destruction.

Adjusting Pictures for Printing

introduction

Are you one of those people? Probably not. But you know who I mean. We all know who I mean. The person that effortlessly glides through life. Walks into Anatomy 201 at 8 a.m. and aces the surprise quiz without ever cracking a book. Spends a week in Paris and by the last day is chatting happily away in French with the doorman. Runs a marathon and looks better after the finish than before the start. Gets offered jobs before the interview is half over. Squeals to a halt at the ocean overlook because not only has a rainbow appeared out of nowhere but it's arching down to a three-masted schooner with sails billowing. And then on the first try cranks out a print that would make Ansel Adams jealous. Hey, wait a second. Rewind the movie. Nobody makes perfect prints with so little effort.

Nearly every picture you take can be improved in some way. And for certain, every picture will print better with some adjustment. You may choose not to adjust it, but it could use it. And if you've ever toured through an advanced image-editing program like Adobe Photoshop CS, then you know it can feel like stepping into the operations room of a nuclear power plant. There are enough controls, menu selections, and adjustments to spend a lifetime on.

While you may never use many of those tools and adjustments, there are plenty of basic adjustments you can use to perfect your pictures. This chapter will help you understand which individual adjustments are important and how to make them work together like a finely tuned orchestra. You'll develop a strategy appropriate for the type of print you are making and discover how to best adjust for specific subjects. Landscapes and portraits each have different needs to look their best when printed. These adjustments all start with an image-editing program. Such programs range from basic, easy-to-use programs to complex "I-wish-I-had-a-degree-in-this" programs.

Choosing a Picture-Editing Program

Picture-editing programs let you manipulate your digital pictures, from making simple adjustments of color and brightness to experimenting with complex and creative adjustments. Common needs for working with pictures include: adjustment capabilities, managing and organizing quantities of pictures, and printing functions.

In choosing a program, you need to decide what functions you need from a program and how much effort you are willing to put into learning the software. Even if you don't feel confident with computer software, given enough time, you can master even the more complex programs, but you may be better off starting with a basic program.

The quick way to tell if you're dealing with basic or advanced software is the size of the buttons when you open up the software. If the buttons are big, shiny, and resemble gumdrops, you're looking at basic software. If the buttons are small and the menu bar is full of functions, you're looking at advanced software.

The prices for basic to intermediate programs run from free to $100. Low-cost, basic programs typically provide a minimum of features. That can be a blessing if you don't want to spend too much time learning the soft-

ware. More advanced programs have increasing complexity, but often allow you the option of using one-click basic adjustments as well. Many companies let you download trial versions that typically remain active for thirty days. But since download files range anywhere from 10 to 100+ megabytes in size, you'll need a high-speed transmission line to take advantage of such an offer.

basic picture-editing software

Surprisingly basic software often tries to take care of all your picture needs, offering adjustment, organization, and publishing functions. But usually each function includes only a limited set of features. One good thing about basic software is that it's often free. Digital camera and printer manufacturers often provide basic picture-editing software for free in hopes you'll use their paper or other products.

Many basic picture-editing programs enable one-click printing and make a variety of adjustments automatically. Basic software typically lets you adjust the essentials of a picture: color, brightness, contrast, cropping, and offers other controls, such as resizing, rotation, and red-eye removal. But not much more. Basic programs make adjustments simple and easy. Most procedures can be done with one or two clicks. The programs "automate" functions for adjusting pictures, making prints, and e-mailing pictures. Compared to more advanced programs, functionality and user control is quite limited.

For example, to resize a picture, you might just click a Size button and choose from a list of set sizes, such as 4 x 6, 5 x 7, or 8 x 10 inches (10 x 15, 13 x 18, or 20 x 25 cm). The software will then automatically resize the picture, but not let you control the pixels per inch for printing. Color and brightness controls tend to be simple sliders that affect the entire image as opposed to the sophisticated controls of more advanced software where you can affect specific tonal areas and color ranges.

A basic program may lack some tools, such as sharpening, cloning, selection, text, layers, and channels. You'll likely find only a few publishing templates for printing postcards, greeting cards, CD covers, and album pages. However, a limited set of simple automatic tools with templates for print projects is enough for snapshooters and others who simply want to do the bare minimum with their images.

Basic software is not for us. It's perfect for those who want to print or share pictures as easily as possible without having to read a manual or help screens. However, if you're taking the time to read this book, then you need the greater flexibility and control offered by intermediate or advanced software. In its quest for simplicity, basic software often restricts you from accessing the controls that affect print quality.

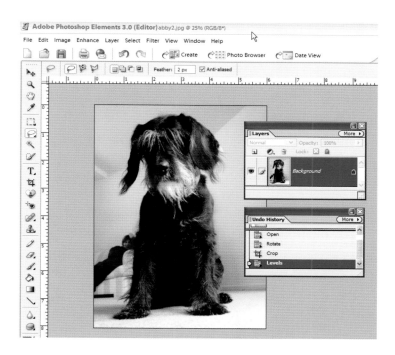

intermediate picture-editing software

With intermediate software, you can begin to explore your artistic visions and create craft projects. You'll find more advanced picture-editing capabilities, such as tools for sharpening pictures, adjusting color saturation, dodging and burning, colorizing, cloning, and creating a variety of graphic and special effects. There may also be some time-saving batch tools that allow you to automatically adjust a large number of pictures. Best of all are the many templates provided so you can print your own greeting cards, CD and magazine covers, business cards, newsletters, and a variety of other photo-rich communications. Just be prepared to spend more time learning the ins and outs of such a program. Programs at this level include Microsoft Digital Imaging Suite, ArcSoft PhotoImpression, and Roxio Photosuite.

advanced picture-editing software

If you like playing with pictures and are comfortable with your computer, this level of software is for you. Although it's only a fraction of the cost (usually less than $100) of professional picture-editing software, it allows you to do almost as much with your pictures. How much? Just about anything you can envision. It gives you the power of layers; adds additional methods and increased precision for adjusting color and contrast; and provides advanced tools for selecting, retouching, and adjusting parts of the image. It also introduces a large variety of creative effects.

Color management functions make their appearance, allowing you to optimize your workflow and produce great-looking first prints. Advanced picture-editing software has multiple tools for retouching, such as the Rubber Stamp and Clone tools. You'll get to play with advanced creative tools, including "filters" that yield a wide variety of artistic effects. You can give your photos the look of a watercolor painting or a charcoal drawing. This is the level where you can

buy books that explain how to unleash the potential of your software. Advanced picture-editing software includes programs like Adobe Photoshop Elements, Paintshop Pro, and Ulead PhotoImpact.

And I must make a confession. I like this level of software and in particular Adobe Photoshop Elements. I have a stack of the latest Photoshop books, each 500 plus pages, and I belong to the National Association of Photoshop Professionals so I can see all the cool things you can do with the professional version of Photoshop. Although I often use the advanced tools provided by Photoshop software, I much prefer the simpler toolset of Elements because it's not only manageable but it fully meets most of my needs and fits the way I work.

I love taking and printing pictures. But I don't love spending hours on the computer adjusting them. Each hour on the computer is an hour away from hiking through the woods or kayaking down a stream or tending my sunflowers so they'll give me gorgeous August blooms to photograph. If your emphasis in photography is to take pictures, then go for an intermediate or advanced program that you can learn and master. Later, take on the professional version if you need it.

professional picture-editing software

Moving from basic to intermediate to advanced to professional software is a bit like walking through the automotive section in a Sears store. On the shelf, you'll see a small plastic case with a set of screw drivers, wrenches that lets you replace spark plugs, further along is a full-size toolbox that looks like you could take apart an engine, then finally you come to the chest-high, rolling cart with enough tools to repair the space shuttle.

If you are new to professional image-editing software, the best way to understand the complexity and capability of this class of software is to go to bn.com and search for books on the standard bearer, Adobe Photoshop. I did just that…twice. The first time I got 1685 results, the second search yielded over 4000. That's a lot of books. A Google search on "Photoshop" brought up over 10,000,000 results—in less than 0.28 seconds.

Are you beginning to get the idea that there might be some depth to Photoshop software that requires explaining. The message is reinforced when you click on a few of the titles in the search result and look at the book specs. For example, *Adobe Photoshop Fast and Easy* by Eric Grebler is 424 pages. How fast and how easy can 424 pages be? *Photoshop TimeSaving Techniques for Dummies* is 423 pages. How much time can a 423-page book save you? Knowing that there is a national organization (National Association of Photoshop Professionals) with thousands of members hints that you might need to learn a few things to make good use of such software.

If your livelihood depends on creating pictures, then professional image-editing software may be what you need. But be prepared. Although it can do everything you need, you may need only a fraction of its capabilities; it can be a bit overwhelming and all consuming. Adobe Photoshop is the leader here in features, use, and price. As mentioned earlier, it's virtually an industry standard. Nearly all professional photographers and professional imaging services use it.

Another comprehensive software program with features aplenty and a lower price is Corel Paintshop Pro. For about $100, you can do almost anything you need, but you won't find nearly the support system of books, seminars, and services that accompany Photoshop.

The complexity and corresponding potential of these programs is beyond the scope of this book. If you want to keep up with the professional imagers, learning Photoshop is probably in your future. However, you do not need Photoshop to produce exquisite prints that would hold their own even in a gallery exhibition of professionals.

Making Adjustments in the Right Sequence

Would you cover the ground with mulch before planting your tulip bulbs? Would you sand and stain that cherry board before cutting it? Whether you're planting bulbs, crafting a bookshelf, or prepping a digital picture for printing, there's a certain sequence of steps to follow.

By following the right sequence in prepping your digital pictures you'll not only save time, you'll also get better results. You'll have fewer remakes, saving you the cost of materials and the time required to redo printing.

Select your picture. What could be more obvious? Not much, but to facilitate creating a good print, choose a picture with strong technical and artistic qualities. If you bracketed exposures or changed the composition, evaluate each image and choose the best from the series.

Crop the picture. Eliminate extraneous and distracting elements and create a design that will work well with how you plan to show the print. Cropping also implies you know how big you want to print or at least the aspect ratio. Most cropping tools let you set a picture's dimensions. If you crop too much you will reduce print size or quality.

Size the picture. Set the ppi for the quality you desire or according to output size limitations. In general, use 225–240 ppi (300 ppi for highest quality).

Adjust the brightness, contrast, and color of the picture—in this order. Use adjustment layers (so you can easily undo adjustments) if your software offers this feature and it fits your working method.

Retouch spots, blemishes, and minor distractions.

Rename and save the file after you've completed this adjustment work. You might want to name the file something like "RoseInVase_FAP."

If you've used layers to make adjustments, flatten the file to reduce its file size to speed up printing.

Sharpen the file, using Unsharp Mask. Sharpening should be the last adjustment step. Don't save it.

Load paper into the printer.

Select Print from the image-editing program and open up the printer driver by clicking on Properties. Set the driver for the type of paper, the size of the paper, and, if not automatically set by choosing paper type, the quality level you want. Click the Print Preview box so you get one final look to see that everything is okay. Note: If you're using a paper profile, choose it from within your image-editing program. Click OK until you send the picture to the printer.

Review the print in soft daylight (not bright sunlight) or under a full-spectrum daylight lamp. If this is a critical print, let it dry for half an hour before evaluating it. If the print looks good, save this file as "RoseInVase_Printready." If any corrections are required, note them, reopen the "RoseInVase_FAP" file, and make the corrections.

Using a 6-megapixel or higher camera, enables you to creatively crop a scene to make "new" pictures that can be printed at 5 x 7 inches (13 x 18 cm) or larger.

The Art and Science of Cropping

The irony of cropping is that if you carefully composed the picture to begin with then cropping may be unnecessary. And that's good. Because cropping is a corrective action and typically a destructive one because it discards pixels and lessens enlargement potential.

The reasons for cropping are two: technical correction and artistic interpretation. If the camera was not level when the picture was made, you may need to make a technical correction to straighten a sloping horizon line or a building that appears to tilt. Rotating the image slightly and cropping the edges solves this problem. You may want to eliminate extraneous content along the picture edges that distracts from the main subject.

Cropping also lets you see your pictures in dozens of new ways and opens up entirely new artistic interpretations. Simply put, there is nothing I enjoy more than cropping my pictures—in part because it is the first step to printing pictures, but also because it's a creative step. Be playful with your cropping because it's a great teaching tool for learning how to compose

When the picture calls for it, don't hesitate to use an unusual crop.

your pictures. Crop tightly to see the effect of a bold, in-your-face composition. Crop to position the subject off to the side or even to slice it down the middle. Crop to subordinate the main subject and change the emphasis of the picture.

When you do crop a photo, be sure not to reduce the resolution lower than what is needed for the print size you're making. The act of cropping throws away pixels. If you have a file from a 6-megapixel camera and are making prints that are 8 x 10 inches (20 x 25 cm) or smaller, you can crop substantially and still get good results. With smaller files or bigger print sizes, you'll need to be extra careful while cropping to be sure you don't reduce resolution to the point that quality is affected.

setting the aspect ratio

The relationship of width to height is the aspect ratio. You will usually need to crop your image a little to establish the correct aspect ratio for your print; the aspect ratio of a 4 x 6-inch (10 x 15-cm) print is not the same as a 5 x 7- or 8 x 10-inch (13 x 18- or 20 x 25-cm) print. Photoshop and many other programs let you plug in the width, height, and ppi values that your crop will create. The easiest way to set the aspect ratio is to choose the paper size you want to print on and then put in the dimensions of the image you expect to create.

For example, a digital camera file with a 2:3 aspect ratio has the same aspect ratio as a 4 x 6-inch (10 x 15-cm) print. You wouldn't have to crop the image at all if you only want a 4 x 6-inch print. An 8 x 10-inch (20 x 25-cm) print is a common enlargement size. Frames are readily available in this size. The aspect ratio of an 8 x 10-inch image is 4:5, slightly squarer than the aspect ratio of the 2:3 digital file. The digital file's aspect ratio gives you an 8 x 12-inch print. You have to crop the photo a little to fit it into the 8 x 10-inch format.

The composition of some pictures will suffer if you try to make them fit a standard photo size. It's sort of like trying to wear a shirt with a size 16 neck when yours is 15-1/2. Don't hesitate to create an unusual aspect ratio. A tall, narrow picture can be quite eye-catching and a square picture can do wonders for creating a sense of balance. Unless you're using a snapshot printer you have an 8.5 x 11-inch (22 x 28-cm) or larger sheet of paper to use. Don't limit yourself to the standard photo sizes.

Although the main goal of cropping is to create a picture with impact, you can also use it to teach yourself about composition and new ways of taking pictures.

how much can you crop a picture?

How much you can crop a picture depends on the original file size (resolution) of the picture and how big you want to print it. Generally speaking, it's best not to crop too much. If you have a 3-megapixel camera (which gives a 9-megabyte picture file) and you like to make 5 x 7-inch (13 x 18-cm) or smaller prints, you can crop a picture in half. If you crop a picture in half from a 2-megapixel camera (which gives a 6-megabyte picture file), you should make prints no larger than 4 x 6 inches (10 x 15 cm). The table clearly shows the extra creativity you can get from a larger digital file simply because it gives you much more cropping power. These are only guidelines. In the end, base your judgment on how a print appears.

Output size* when you crop from a picture

MP	FULL SIZE	50% CROP	25% CROP
3	7.7 x 10.25 inches (9 MB) 19.6 x 26 cm	5.8 x 7.7 inches (5.1 MB) 14.8 x 19.6 cm	3.9 x 5.1 inches (2.3 MB) 9.9 x 13 cm
4	8.5 x 11.4 inches (12 MB) 21.6 x 27.9 cm	6.4 x 8.5 inches (6.8 MB) 16.3 x 21.6 cm	4.5 x 5.9 inches (3 MB) 11.43 x 15 cm
5	9.7 x 13 inches (15 MB) 24.6 x 33 cm	7.3 x 9.8inches (8.4 MB) 18.5 x 24.9 cm	4.6 x 6.5 inches (3.7 MB) 11.7 x 17 cm
6	10.7 x 14.25 inches (18 MB) 27.1 x 36.2 cm	8 x 10.7 inches (13.5 MB) 20.3 x 27.2 cm	5.3 x 7.1 inches (9 MB) 13.5 x 18 cm
7	11.5 x 15.4 inches (21 MB) 29 x 39 cm	8.5 x 11.5 inches (15.8 MB) 21.6 x 29.2 cm	6.7 x 7.7 inches (10.5 MB) 17 x 19.6 cm
8	12.25 x 16.3 inches (24 MB) 31 x 41.4 cm	9 x 12.25 inches (18 MB) 22.9 x 31 cm	6.2 x 8.1 inches (12 MB) 15.7 x 21 cm

*Based on printing at 200 dpi, which is suitable for good quality prints. Best quality prints at this size are usually based on 300 dpi, which would lower these print sizes considerably.

decreasing file size

Too tight and you get blisters. Too big and you end up tripping. Just right, and you can dance the night away. Whether it's shoes, shirts, dog collars, houses, or your digital pictures, size can make a big difference.

With digital pictures, setting the proper resolution affects print quality as well as productivity since big files take longer to adjust and print. And I'll admit, I tend to be an impatient guy so I don't like to wait too long. That's why for most of my printing I use one of the fastest printers on the market. That's why I pay attention to picture file size.

Since I print most of my pictures 8 x 10 inches (20 x 25 cm) or smaller, I usually reduce file size. Some folks don't like to reduce resolution for the same reason they don't like to increase it. Your software program has to mess around with the pixels. This is called resampling. In the case of reducing file size, pixels are thrown out. Purists worry that quality is adversely affected. I have a tough time seeing that quality reduction, but if you can see it, then for your critical pictures you may want to send the full image file to the printer, even when it's providing more information than necessary. Just remember if you send extra information you'll pay the penalty of extra printing time as the printer now has to chew, swallow, and digest that much more information.

For example, I just ran a short test with my printer. My 5-megapixel camera creates a 14.4 megabyte file. Keeping the file size at 14.4 megabytes, I set the print size to 4 x 5.3 inches (10.2 x 12.7 cm), which resulted in a whopping 486 ppi setting. From the time I pressed print to the time the printer spit out the print, took one minute and forty-eight seconds. Next, I resized the file to a 225 ppi setting. The new file size was 3.07 megabytes and the print time was one minute and five seconds. A forty-three second savings and negligible quality difference. Good deal for impatient me.

increasing file size

You can't create something from nothing. Which means you can't effectively increase the file size or resolution of your pictures any more than you can bake a cake if your cupboards are bare. This is important because by now you understand that the size you can print a picture is determined by how many megabytes or pixels it has. And you are probably trying to get around that.

Some picture-editing software allows you to increase a picture's file size. Some programs are designed specifically to increase file size for the purpose of making larger prints. An example is pxl SmartScale by Extensis. The Extensis website says that this software can "scale images up to 1600% with no

Using interpolation to increase the resolution of a digital image file can result in a low-quality print.

discernable loss in printed quality." Maybe I'm overly skeptical but my experience has been that although such programs offer better interpolation than picture-editing software they don't live up to their bold claims.

To increase resolution, software must create entirely new pixels where there are none. It does that through complex algorithms that analyze the pixels and their neighbors throughout the entire picture. New pixels are then added to fill in between the existing pixels. Somewhat surprisingly, the greatest problem areas tend to be smooth, even tones like sky and skin. Flaws are most readily revealed in such areas. Textured areas, like sand or bark, or areas with lots of detail, like a busy street scene, hide the flaws better.

How much can you resize a picture and still get quality output? That's a subjective question and the answer depends on your quality needs, the receptiveness of the subject to interpolation, and the actual program doing the interpolation. I would tend not to expect more than 25–50% enlargement. In practical terms, that's enough increase to produce a 13 x 19-inch (33 x 48 cm) print using a 6-megapixel camera.

In the end, interpolation is the equivalent of adding water to paint in an attempt to cover more surface area. The effect is that you lower the quality. The original file size—along with how critical you are of picture quality—determines how big you can print a picture. You can certainly make an 8 x 10-inch (20 x 25-cm) print from a one megabyte file, but the quality won't be very good.

viewing distance and image size

The 300 ppi rule of thumb for pictures is tossed about quite a bit. But once you realize that billboards are often sized at 25 ppi you might begin to wonder just how big you can print your pictures and at what setting. Just as human physiology dictates that you hold a newspaper or magazine at a certain distance to read it, so does it dictate that you view different-sized pictures from different distances. Of course, whether it's a poster-sized print or a snapshot, we photographers can't resist the urge to walk up to a print and scrutinize it at close range in search of some flaw. In reality, normal viewing distance is much greater than a few inches, and because our visual acuity falls off quickly with distance, we can't see details well the further we get from a print. That's obvious. And that's why billboards look good from a distance. But up close their dots are the size of mini M&M's.

The rule of thumb says the viewing distance should be roughly equal to the diagonal measurement of the print. Tie that in with visual acuity and you can reduce the ppi significantly when you make a large print. That's why photo processors can recommend making poster-sized prints from even 4-megapixel cameras. For most folks they'll be acceptable. They can even look great when seen from across the room.

To resample or resize an image in Photoshop Elements, click both the Resample Box and Constrain proportions box. Then under Document size, type in the width, height, and resolution. In the drop down menu, you can choose the type of resampling.

What Does a Good Print Look Like?

To adjust a picture, you must first know what needs adjusting. You may have an artistic eye and be able to readily crop a picture to improve its appearance. But if you've never been trained in making professional-quality photo prints, how do you know when you've made a good print.

To help you, we've created a couple of high-quality prints of common subjects and called out the areas that give them outstanding print quality.

the three basic adjustments: brightness, contrast, and color

Get the three basic adjustments right and your prints will look good even if you don't do anything else. Sometimes darn good. Adjusting the brightness equally lightens or darkens the entire picture (light, medium, and dark tones). Adjusting the contrast simultaneously lightens light tones and darkens dark tones but does little to medium tones.

Brightness (sometimes called lightness) refers to the overall lightness of a picture. Contrast refers more to the extent of tones—how deep are the blacks and how white the whites. Adjusting contrast is a bit like stretching a rubber band—with the greatest change occurring at the extremes and the least in the middle. As in most picture adjustments, there's quite a bit of subjectivity in what makes for appropriate brightness and contrast. Although we get quite specific later in this chapter, let's first be a bit vague and say that the printed picture should look good, and if it does, you've probably adjusted the brightness and contrast correctly.

But what does "look good" mean. Although "looking good" varies by subject matter and creative intent, it means that the tones and colors in a picture are appropriate for the subject matter and lighting in the scene and relate to each other well. For example, a sunny day picture at the park should show the pond a rich blue with sparkling highlights in the water, the

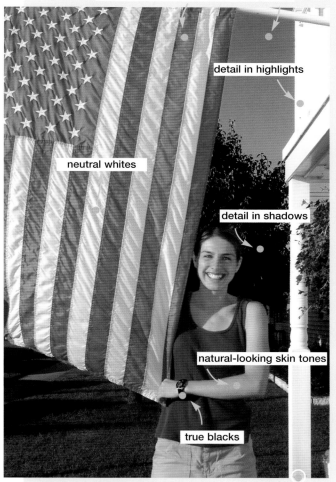

accurate memory colors (blue sky, flag)

detail in highlights

neutral whites

detail in shadows

natural-looking skin tones

true blacks

A good print starts with a good picture, both of which reveal the following characteristics called out here.

overall sharpness

trees a medium to dark green. The salivating lab poised under the picnic table waiting for scraps is a deep black, the Styrofoam cooler in the sun is a bright white, and the beach umbrella is rich and colorful. In short the picture looks like you'd expect a sunny day picture to look.

If a picture seems to be a bit dull, you probably need to increase its contrast, thereby brightening the lighter tones and darkening the darker to add some snap to it. How much? Well read on to learn how white "whites" should be and how black "blacks" should be.

Equally important is that the colors look correct. This, too, can be very subjective, but as you'll see in the following discussions correcting color can be fairly straightforward.

There are several tools that adjust brightness, contrast, and color, and they are available in all levels of image-editing programs. Tools in basic programs often use a "sliding" adjustment that is a bit crude as it impacts all tonal areas of the picture equally. More advanced tools, such as Levels and Curves, let you concentrate adjustments at specific tonal levels such as bright tones, medium tones, or dark tones. And, of course, there are the "auto" and "smart" tools for contrast, brightness, and color in which you simply click a button and the software analyzes and adjusts the picture. They can be very effective, but not always. So give them a try and see how they work. But don't hesitate to take over and manually adjust the picture yourself.

For adjusting pictures that are too dark, too light, or too contrasty, perhaps the most powerful tool is the Shadows/Highlights tool in Photoshop Elements and Photoshop. This powerful tool can quickly improve images with contrast or brightness problems with minimal effort on your part.

Matching Monitor and Printer

One pivotal process is trying to make your printer and monitor match in results. It's of little use to make a picture look great on your monitor only to have your printer spit out a print that's too dark or too red. If you find calibration too complex, then be sure to take notes on how your prints vary compared to what you see on your monitor. This should be consistent, so that if your prints always come out bluer than what you see on your monitor, you should learn to make your picture on the monitor look more yellow (the opposite of blue). And if your prints come out too dark, make them appear lighter on your monitor, and note on how much you have to adjust the lightness control to give prints of the correct brightness.

Try to keep the lighting consistent in your workroom. When working on the computer, the lighting should be somewhat dim. When viewing prints, it should be fairly bright and preferably always the same type of light, as different light sources affect the appearance of colors in your print. Tungsten light bulbs make prints appear a bit more orangish than they would in daylight; fluorescent lights make them appear a bit more greenish than they would in daylight.

The print of a colorful subject should be bright and saturated with clean whites and rich blacks.

Color Adjustments

You feel blue, turn green with envy or red as a beet, fall into a black mood, but you would like to be in the pink. Sensitivity to color permeates our lives so it's no surprise that even a slight tinge of wrong color can throw off a picture. To some degree what is wrong and what is right is subjective. It almost certainly is not a realistic or measured correlation to the real world. You probably like your apples to be shiny red in your pictures, your skies brilliant blue, the lawns perfectly green. If I were to tell you colors in your prints should match the reality when you took the picture, you'd smile and think that's a good idea. But if I gave you a print in which the colors of these subjects did match reality, you might frown at the drab colors. So color adjustment is not so much a matter of matching accuracy to the real world but to the expectations in our minds. To that extent our preferences can even be cultural.

One thing is clear. In recent years increased saturation of color has become a preference. It's reflected in photo products and processing from film to built-in digital camera adjustments to printer inks to image-editing gurus who frequently talk of selectively increasing the saturation of subject colors to make them more appealing.

initial testing

Before you start adjusting color, make sure your monitor is set to display millions of colors. On computers using Windows, you go to the control panel, choose Display, and then Settings. Select True Color—it displays millions of colors.

Unless you already know how to adjust your pictures to give good prints, make your first print without adjusting the color, and preferably without making any adjustment, although if the brightness or contrast is grossly out of whack, go ahead and adjust them.

Make your first print at a small size (4 x 6 in. or 10 x 15 cm) on the same paper you plan to use for the final. First inspect the black, white, and gray tones of the print. These are often referred to as neutrals, because they shouldn't have any color casts in them. If they do, correct them as just discussed.

Photographed in the warm light of early morning, this scene may appear a little too yellow. However, because the wall is white, it is quite easy to use the Highlight Eyedropper available in most image-editing software to neutralize the white.

the mighty whites

In looking at a print your eye goes to tones it expects to be white to verify that the colors are correct, that the color balance of your picture is accurate, and that the exposure is correct. No color is more sensitive to color contamination than white. So, if in a print, the eggs are a bit bluish, grandma's hair is a tad green, the snowy field is a little pink, or a seagull looks a mite yellow, we immediately perceive the color to be off. In prints with borders, this can be exacerbated because the white border provides a stark white reference that will show if the whites in the picture stray from neutral.

As displayed on a monitor, a neutral bright white contains equal amounts of red, green, and blue light. A recently painted white picket fence illuminated by midday sunlight should have a value of about 252 across red, green, and blue. On a cloudy day, its value would be in the low 240s and would show several more points of blue, thus R=235, G=238, B=246 would be typical. And in the shade on a sunny day, the light coming from the blue sky would boost the blue value even more to something like R=215, G=220, B=235. Of course, those values would vary depending on your white balance setting and actual exposure.

In the real world, your vision adapts strongly to a scene's illumination source, be it sunlight, fluorescent, or tungsten, to perceive white subjects as neutral even when their actual values stray far from neutrality. This is visual adaptation.

Next to correct color for whites is correct brightness. The brightness is correct when you can reveal the texture apparent even in all but the smoothest surfaces of bright white subjects. To reveal texture when making a print you generally need to keep the white values no higher than 250. Only specular highlights (light sources themselves or reflections of them) would normally lack surface texture detail. Without that texture detail, the picture will seem overexposed. Wedding dresses, Greek columns, puffy cumulus clouds, snowdrifts, breaking surf, and the hair of grandparents should all reveal texture within their whiteness. Exposure is critical to good whites. When whites are overexposed, the detail is simply not there and cannot be recovered through any adjustment process. Bracket exposures when photographing subjects with critical white detail.

In your prints, getting the whites to appear neutral is key. The best way to do that is by setting the white balance during picture taking. Set it to either the custom mode and take a reading off a gray card or to the setting representing the type of lighting illuminating the scene (for outdoors that would normally be bright sunlight, cloudy day, or shade).

Setting the Value of the Highlight Eyedropper

In Photoshop, the default value of the Highlight Eyedropper in the Levels and Curves controls is RGB=255: that's pure white (pure black is RGB=0). A pixel's value can range from 0 (no brightness) to 255 (its brightest possible value).

For a print, the purest and whitest white possible is bare paper—no ink whatsoever on the paper. Your picture probably has few pure whites. But it may have a wide range of tones you'd consider white. Tones with approximately equal values of red, green, and blue above 240 are usually considered white. Tones from about RGB=215 to just under RGB=240 likely seem a light gray. Surrounding tones can effect your visual impression, so use the Info tool to actually measure an area's "whiteness" before you adjust it.

With the Info window displayed, mouse over the area you want to appear as a neutral white tone and look at the values displayed. Open up the Levels or Curves control panel, click on the Highlight Eyedropper, and enter RGB values. If you want a specific white in your picture to be slightly darker than it currently is, then enter values lower than those displayed in the Info window. Lighter? Then enter values slightly higher than displayed. To make the area a neutral white that prints with some detail, enter all the same values in the range of RGB=245 to RGB=250 (example: R=248, G=248, B=248). Play with the

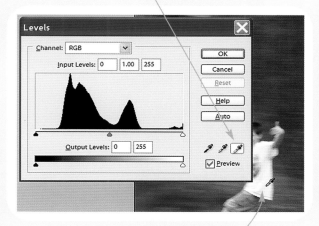

Choose the Highlight Eyedropper.

Click on a bright white area.

Highlight Eyedropper and see how raising and lowering its values (and then clicking in a white neutral area) affects the picture.

If the whites in your print don't show desired detail, in Photoshop try using the White Point slider to lower the highlight value of the Output Levels to about 248. You may need to experiment to determine the appropriate value that enables your printer to show highlight detail.

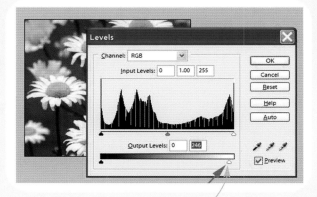

Use the White Point slider to lower the highlight value.

By first increasing the contrast and further dodging and burning the mountains and clouds to give deeper blacks and brighter whites, this scenic picture becomes much more appealing.

© Bari Doeffinger

great blacks make pictures shine

Have you ever asked yourself why so many new car and new camera brochures use a deep black background around their photos? It's because colors seen next to that deep black background seem to gain an extra sparkle. When surrounded by black, red, yellow, and many other colors seem extra bright, extra rich, and extra saturated. The power of black is that it behaves like a good chorus that makes other colors seem to sing beyond their normal range. Of course, it's an illusion. They aren't brighter, they aren't richer, they aren't more saturated. But because your eye recognizes the black as the deepest tone, other colors seem brighter in comparison.

Not convinced? Then recall that day you were out photographing autumn leaves when suddenly a squall swept over the mountains and the sun poured through an opening, illuminating the hillside against the dark, swirling storm clouds. Have colors ever seemed so brilliant as against that dark backdrop of storm clouds?

Don't try to fill your pictures with black (or storm clouds), but where true blacks exist, make them deep and dense—true blacks. And where dark tones exist with important detail, make sure their dark tones

reveal the detail within. And where dark tones exist with extraneous or little detail, consider darkening them evening further to make the surrounding areas stand out by contrast. It can be a fine balance between too black and not black enough, so play around when you're adjusting pictures to reach a level that works for you.

How do you know if an area is black? Most intermediate and advanced image-editing programs let you measure the tones of an area. A true black will have tone values below five and the values will be nearly equal. For instance R=3, G=1, B=3, will most definitely look black. And by using the eyedropper tool in Photoshop you can force the blacks to be completely neutral. Set the eyedropper to a low value, such as 5, for the R,G,B, and then click in the area that you want to be a true black. This will readjust dark values for the whole picture. If the effect isn't what you like, then make a feathered selection of the area you want to be true black and use an adjustment layer to set just that area to black. The shift from its original values to the new values can't be too great or the adjustment will appear obvious.

Setting the Value of the Shadow Eyedropper

In Photoshop, the default value of the Shadow Eyedropper in the Levels and Curves controls is RGB=0: pure black. Your printer can't print a pure black, and your picture probably has few pure blacks. So before you use the eyedropper, analyze the area you want to set as black.

Open the Info tool (in Photoshop go to Windows>Info) to measure pixel values. Mouse over the area you want to be black or near black and look at the values displayed. Double click the Shadow Eyedropper and enter RGB values. If you want the area to be slightly darker, then enter values lower than displayed in the Info window. Lighter? Then enter values higher than displayed. To make the area a neutral black, enter all the same values, such as R=9, G=9, B=9. If you want the area to be near black but to show some detail in your print, then enter a value between 10 and 15, such as RGB=13. You'll have to learn how low a value your printer can handle and still reveal detail. The main point is to play with the Shadow Eyedropper and see how raising and lowering its value (and then clicking in a dark neutral area) affects the picture.

Choose the Shadow eyedropper.

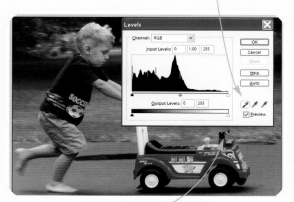

Click on a black area.

In bright sunlight, use the daylight white balance setting instead of auto white balance.

adjusting color balance

Set the white balance of your digital camera to the dominant type of lighting in the scene (instead of using auto white balance), and you'll consistently get better prints more easily, because you'll almost always be starting from a known color balance.

Also examine areas with "known" colors such as sky and grass, and areas with critical color, such as flesh tones. Review your picture-editing software manual to see if there are any "automatic" ways to neutralize colors. Many picture-editing programs let you click on a white or black area to make it neutral and in so doing removing any color casts from the whole picture. It usually works well.

What works less well is the auto color button common to most picture-editing programs. It works well on "normal" scenes with a wide mix of colors. It doesn't work well when a picture has a predominant color, such as a patch of pumpkins, a field of sunflowers, a grassy lawn. It doesn't know that the subject is pumpkins and the picture has a lot of orange in it. In its calculations, it sees too much orange in the picture. So it reduces the orange by adding blue and cyan. It doesn't know your child is kneeling in the pumpkin patch, and now looks like he's holding his breath.

determining which color to adjust

You can simply look at the table below to figure out how to adjust colors to make your print look good. Or you can read on for a brief review of color theory.

Like your television, your monitor mixes red, green, and blue light to create all the colors you see on it. Like your favorite magazine, your printer mixes cyan, magenta, yellow, and black inks to create all the colors you see in a print. These two devices work in opposite ways. That can be confusing. The good news is your printer understands your monitor and its red/green/blue language. So when you adjust colors to make your prints look better, think first in terms of red, green, and blue.

So if a print is too red, use your picture-editing software to make it less red. If it lacks red, you simply add the red using the software. Too green, reduce green using the software. Too yellow, reduce the yellow, using the software.

Your software may never ask you to reduce a color by adding a complementary color. Or it may. In which case, a little color theory comes in handy. Complementary colors are opposites. When added together they make a neutral gray, which could be light or dark depending on how much you add together.

That means you can correct a picture's color in two ways. You can either reduce some of the offending color or add its opposite to counteract it. You would tend to remove a color if the picture is too dark, and add its opposite if a picture is too light. The change in brightness depends on how much color you add or remove. And that's why color theory comes in handy. If your picture is a bit too light, but it's also too blue, you could add yellow. That would counter the blue and darken the picture a bit.

If a picture isn't red enough, it probably appears too cyan, which is sort of a greenish-blue color. If it isn't blue enough, it's probably too yellow. If it isn't green enough, it may be too magenta. Similarly, if it is too dark and not green enough, you could take away some magenta. Taking away the magenta, which is the opposite of green, lets more green show through. And because you're taking away some color, it lightens the picture a bit—again how much it lightens depends on how much you take away.

So knowing a little color theory can come in handy. Distinguishing red from magenta or cyan from blue can be a bit tricky at first. Again, look at white and gray neutrals to see if they have a color cast. Then play with color adjustments, undoing them each time. When you have a feel for what the correct adjustment is, make it.

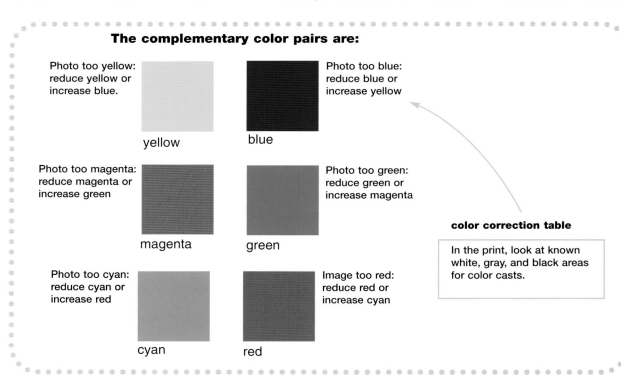

The complementary color pairs are:

Photo too yellow: reduce yellow or increase blue.

yellow

Photo too blue: reduce blue or increase yellow

blue

Photo too magenta: reduce magenta or increase green

magenta

Photo too green: reduce green or increase magenta

green

Photo too cyan: reduce cyan or increase red

cyan

Image too red: reduce red or increase cyan

red

color correction table

In the print, look at known white, gray, and black areas for color casts.

Testing Your Printer's Color Bias

Perhaps the phrase color bias is too strong, but if you aren't using a color management system, you can test your printer's color bias fairly simply. In your image-editing software, create a file that includes roughly five 1 x 4-inch (2 x 10-cm) stripes with these values.

R=150, G=150, B=150

R=175, G=175, B=175

R=200, G=200, B=200

R=225, G=225, B=225

R=250, G=250, B=250

Print this file and evaluate it under a special full spectrum color lamp or by diffuse daylight coming through a window and see if all the tones are neutral. If not, adjust the color in your image-editing software until the stripes appear neutral when printed. Whatever adjustment was required to produce five patches with no color cast is the adjustment you should make all future prints. In adjusting the color of future images, adjust them as normally until they look good onscreen, then make this additional color adjustment required to get the neutrals to be appear neutral in the print. This is subjective but should bring your prints close to neutral. True color management will do this scientifically and more reliably.

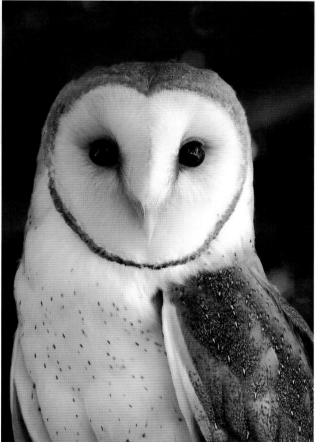

This photo of a barn owl is clearly too green. The color balance was easily corrected using image-editing software.

improving color

Just because you get true neutrals (clean whites and light grays) doesn't mean you'll like the other colors. You can probably assume they are fairly accurate but they may not be pleasing. You have a variety of controls to adjust colors. They include Levels, Curves, Color/Hue sliders, and Ringarounds.

So adjust those prints until the colors please you, but in doing so, do not disturb those critical neutrals. That means when the neutrals (whites and light grays) look good, you selectively adjust the other colors using a layer. Either select the specific colors you want to adjust, or if you want to adjust everything but the neutrals, select the neutrals, choose Inverse to select all the non-neutral colors, and then create an adjustment layer. Now you will have preserved the neutrals when you adjust color.

adjusting saturation

We live in an age of oversaturation and excess. Sex, money, ego, individuality, material goods, television channels, and, of course, color. Who doesn't revel in rich, bold colors? Don't overdo the saturation; your printer may balk at colors beyond its ability. Well, it won't balk, but it may not deliver the colors you want, especially when you push saturation across the full range of colors.

Instead, select critical colors subjects or areas and use saturation to emphasize them. In general, increasing saturation won't hurt true neutrals. If there is a color shift in the neutrals, then they weren't truly neutral. With Photoshop's saturation control, you can adjust saturation for a specific color, such as red or cyan, minimizing the effect on the rest of the picture. Just select Enhance>Adjust Color>Hue Saturation, and click on the Edit dropdown menu to pick the color whose saturation you want to adjust.

Jeff Wignall noticed this oil spot on the pavement while filling his car with gas at a service station. Although its colors were subdued, he knew once he got back home and bumped its saturation that the picture would make an attractive abstract.

© Jeff Wignall

Sharpening Your Pictures

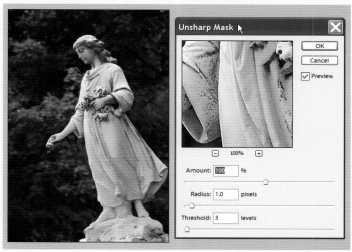

The proper amount of sharpening largely depends on the subject and your intent. This statue is shown at various levels of sharpening.

Why do you even need to sharpen pictures? I suppose the easiest answer is that it's just the nature of the digital medium. It's often needed to some degree to improve the appearance of an image. One could conclude that if a digital image must be sharpened, this means that the digital process, from capture to print, somehow softens it. Sharpening will not correct image blur. A picture that is blurred because the subject isn't in focus, you didn't hold the camera steady, or there is a big fingerprint on the lens is beyond redemption. Sharpening with software won't help, so don't waste your time.

Before we go further, many snapshot cameras automatically sharpen pictures inside the camera. You may not be able to stop the sharpening, but if you can, you'll probably want to turn the control off or reduce its sharpening effect. You'll have greater control and get better results using your image-editing software.

There may be more techniques, tips, and products for sharpening your pictures than there are for adding hair, losing weight, eliminating wrinkles, perfecting your backswing, or making money. Fortunately for us, most of these sharpening techniques and products have some merit. But if you become a perennial collector of them you'll likely not perfect any. Sharpening pictures just seems to bring out the tinkerer in digital gurus. For an example of a specialized approach, see the sidebar for the three-pass technique preferred by Photoshop master Bruce Frasier.

By now, you probably know that the preferred image-editing tool for the sharpening task goes by the unlikely name of "unsharp masking." The name is a carryover from traditional darkroom days. Back then, and now, it works by increasing contrast along edges. The increased edge contrast makes the picture look sharper. The Unsharp Mask tool is common in most intermediate and advanced image-editing programs but may not be available in some basic programs.

Unsharp Mask uses three controls: amount, radius, and threshold. The individual settings and subsequent interaction between the settings allow you to customize sharpening for a variety of subjects. Normally, when you use Unsharp Mask, the adjustment is made to the entire image. Since there may be several different subjects or uniquely different areas within a picture, that one setting may not be appropriate to each area.

Let's quickly review what each control affects and look at some examples. When evaluating the effects, view your image at 100%. Usually if the picture looks slightly oversharpened on the monitor it will give good results when printed. Make your own tests to determine the sharpening values that work best for you.

amount

The amount determines how much you increase the contrast along the edges. Typically, you'd set the amount between 100% and 300%.

radius

The radius is the width of the sharpening effect in pixels. Generally you use a low number such as 1 for smaller files (under 5 MB) and for subjects with smooth textures or very fine detail (branches and hair). For larger files, you might use a radius of 2 or 3. This is somewhat dependent on subject matter.

threshold

Unsharp Mask increases contrast along edges and it finds edges by judging tonal differences between pixels. The threshold determines how sensitive Unsharp Mask is to tonal differences. For general use, set 2 or 3. A higher setting, such as 10, reduces the impact of sharpening on subjects with similar tones, such as a sky or a face, while still sharpening subjects with different tonalities, such as tree branches against the sky.

If you are using Photoshop, after sharpening if the images looks a bit too harsh, try the Edit>Fade tool with the Mode set to Luminosity to cut back the effect a bit.

sharpening strategy

Your strategy largely depends on what you intend to do with the print. You certainly don't need to spend a lot of time sharpening a snapshot. But if you're printing for a gallery exhibition, sophisticated sharpening can have a major impact on the success of a print. For informal prints then, you can just apply a generic value of the Unsharp Mask for the entire image, varying settings by subject matter if you like.

But for important prints, you should customize sharpening by selecting critical areas and using layers to sharpen them.

How a Sharpening Guru Does It

Photoshop expert Bruce Frasier doesn't believe in sharpening just once. He explains that sharpening is required for three different reasons and thus you should sharpen three separate times during the image workflow so you address each of these reasons at the right time. The three times or stages to sharpen an image are capture, creative, and output.

Capture sharpening is done to counteract the softness inherent in the capture process, particularly from scanners (both digital cameras and scanners can sharpen an image but some experts turn it off or minimize it so they have greater control by sharpening later).

Creative sharpening is based on the particular needs of an image and the photographer's desires. For instance, instead of sharpening the whole picture, you might selectively sharpen eyes in a portrait, the center of a daisy, or a windsurfer sailing off a wave.

Output sharpening is done last and is customized to the output device and file size. Thus you would sharpen an image differently for inkjet printing than you would for offset (magazine) printing.

Emphasizing the Subject

When a two-year-old child wants attention she simply screams and jumps up and down. When your teenager wants attention, he sulks. When a car sales manager wants you to know about a sale, he shouts from a TV commercial. When a stage director wants to convey the importance of a scene, he dims the lights, directs the actor to center stage and focuses the spotlight on an actor's soliloquy. When a pastor wants your attention, he may well whisper. And a teacher, arms folded, may stand stone still silent in the front of the room.

There are just as many ways to focus attention on the subject of your print. Let's quickly review some of the ways to make your subject sing, shout, whisper, and otherwise attract the viewer's eye to the important parts.

In all of the above actions, the person seeking attention does so by contrasting (be it screaming or whispering) himself with the environment. Normally your prints will show a bit more restraint but ultimately it is by differentiating the subject visually from its context that you focus the eye on it.

Your visual elements of emphasis are the very ones we have been discussing all along. Hue, saturation, brightness, contrast, sharpness, blur, positioning, implied shapes and lines between picture subjects. You might put your subject in a subtle spotlight by darkening areas around it with the Burning tool and then lightening the subject with the Dodging tool. You might blur surrounding areas and sharpen only the subject. You might increase its saturation or even decrease it and do the opposite to surrounding areas. You might crop in tight so it fills the frame or crop to move it off to the side where it seems to draw more attention by its unusual position.

Even paper size can play a role. An apple printed the size of a beach ball demands attention. Equally demanding of attention would be the Empire State Building printed on snapshot paper, and matted and framed as a 16 x 20-inch (41 x 51-cm) print. The size disparity would be hard to ignore.

And while the actions you take may be obvious when seen as part of a before and after, in the final print they should seem entirely normal and appropriate or viewers will dismiss your print as too affected, too artificial. Your experience and artistic insights now play a major role. Which pictures require a heavy hand? Which require a light touch?

To accentuate this gorgeous lily, the bright yellow shapes in the background were retouched out and the soft background was blurred more.

adjusting a portrait

A portrait is a carefully posed, arranged, and lighted revelation of a person designed to create a flattering likeness of that individual. It's supposed to make that person look better than they do when they get out of bed in the morning or stagger home from work in the evening. So it's not your everyday snapshot.

Critical to the printed portrait is the preparation made before the picture is taken. Without a good foundation for the photo itself no amount of software manipulation (at least not from folks like us) can produce a miracle. From choosing soft lighting of an overcast day or north window to carefully applying makeup for a woman and combing hair to arranging a pleasing pose of the person's body, preparation is critical. Once you get a picture incorporating portrait fundamentals, follow these steps to prep it for print.

Everyone wants a whiter smile. It's a simple adjustment that can make a portrait look really good.
© Jeff Wignall

Paramount is the skin: its color, its texture, its tonality. And much of what we discuss here applies more for women than for men, because women take great care and pride in their skin, whereas men tend towards a rough hewn, masculine appearance more readily revealed.

The most obvious trait of the skin is its color. Skin tones vary significantly and it is very important that your subject's skin tone looks natural with no obvious color cast. At the time you take the picture you might want to include a white or gray card so you can later use a Levels eyedropper to obtain neutral colors and hopefully a good starting point for skin tones. Set the camera's white balance to either custom or the specific lighting of the scene.

Smooth, blemish free skin is also important. Use Photoshop's Clone or Healing Brush tool to minimize blemishes, being careful to choose skin patches that match the area you are repairing. You can soften wrinkles in a couple of ways. New plug-ins for Photoshop are designed specifically to smooth skin

tones. Just don't overdo it. An alternative is to apply Gaussian blur to a feathered selection of the area you want to soften. Skin tones can also be softened by lowering the contrast or lightening the shadows. This helps to minimize wrinkles.

Highlights on foreheads and noses tend to glare in a print, drawing undue attention to them. Burning in such areas usually doesn't work well. Instead use the Clone and Healing Brush tools for large bright spots on the forehead.

Often teeth need to be lightened and perhaps whitened. The Dodge tool works fine for slight adjustments. Don't over whiten them or they'll look unnatural and draw unwanted attention. You may also want to slightly lighten the whites of the eyes, but keep the pupils dark. Dodge and burn the hair as needed to give it shape and texture.

And when you're all done, carefully sharpen the picture with Unsharp Mask. To draw attention to the eyes—and perhaps the lips and teeth—sharpen them selectively a second time. If you sharpen the rest of the face, do it with the radius set to 10 or higher so you don't roughen the texture of the skin.

When printing a portrait, choose a paper that compliments your subject. That almost always means avoiding the glossy papers so popular for snapshots and colorful subjects. The shine and bright reflections of glossy paper can be distracting and its ability to show every little detail points out the flaws inherent in almost every face.

Instead of glossy paper, choose a luster, satin, or even a matte paper. Skin tones and complexions will look much smoother and the reduced reflections will make it easier to see the face within the picture. For those special subjects, you may even want to try canvas or watercolor paper. Portraitists have long offered the option of canvas-textured papers and canvas mounting. Not all printers can handle the extra thickness of some specialty papers, so review your printer manual before buying a specialty paper.

Creativity with the Adjustment Controls

We treat them with awe and respect, as if they were the tools of surgeons and not of artists. I'm talking about the controls we use to adjust and perfect the image essentials: brightness, color, contrast, sharpness.

But these can also be wacky creative controls. You can rocket the saturation control into the stratosphere and watch the colors go haywire. You can push contrast and brightness past the limits and turn your picture into a Warhol. Or, try my favorite technique, set Photoshop's Unsharp Mask radius setting to 6, 12, or 20 (wherever you want) and sharpen the image over and over again and watch it turn into a psychedelic work of art. During this foray into the land of excessive sharpening with the field of sunflowers shown here, I added one pass with a Watercolor filter.

The point? All the serious discussion and procedures about obtaining neutral whites, smooth flesh tones, and achieving the ultimate image should not deter you from your creative playfulness. Sure, try the procedures but don't let them enslave you. Occasionally, do the unthinkable with image adjustments, and see where you end up.

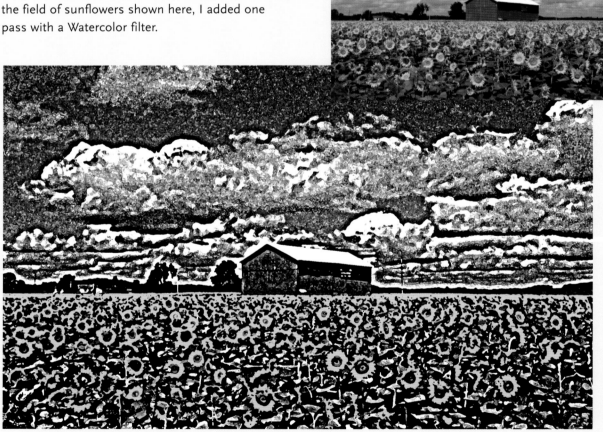

To make this slightly abstract, painterly illustration, Unsharp Mask was applied three times—Amount 100%, Radius 15, Threshold 0. I then added one pass with the Watercolor filter.

adjusting flowers

I have done more than my share of flower photography—to the point that I'm willing to try anything. I've even tried steamrolling roses; they didn't look so hot, don't waste your time. For most flowers, I photograph, adjust, and print them using techniques similar to those described for people photos.

I often bring the flowers indoors, away from breezes, so I can control the lighting, the background, and the setting. The best lighting to bring out a flower's quiet beauty and its many hues tends to be soft, diffuse light from a northern window. Set white balance for shade or cloudy day. For pure energy, flowers with translucent petals truly glow and seem to radiate their beauty when backlit.

But I digress. Let's talk about adjusting them for printing. A flower's most dominant feature is usually color. The rule I follow is that attractive color trumps accurate color. Unless the flower is a known white variety, such as a Shasta daisy, then accurate color isn't critical. I strive for attractive color instead. After adjusting brightness and contrast, you should play with the hue and saturation controls to give the flower the appearance you prefer. You may also want to locally adjust contrast, brightness, and saturation within selected petal areas to further intensify the often gradated lighting created by petals and their shifting colors.

The deep saturated colors of some flowers may challenge your printer. If you expect to make lots of flower prints, you may want to experiment with your printer's ability to print different flower colors. Simply choose some different colored flowers, and make a series of increasing saturation adjustments and see how your printer does. Make notes of its performance for future printing.

Many a flower, especially those photographed outside, can benefit by subordinating its competing surroundings through the use of blur. Using a slightly feathered selection (2 or 3 pixels), choose the flower, and then invert the selection to select the background. Create a new layer and use Gaussian blur to subdue the background and by contrast, make your flower stand out.

Finally, sharpen the flower carefully. For flowers with distinct, detailed features, such as the pistil of a tulip or the center of a daisy, I often selectively sharpen those areas, just as I would the eyes in a portrait.

To improve this coneflower, the photographer selectively sharpened and increased the saturation of the pistils. He also eliminated the stripe of yellow on the right that distracted the eye. © Herb Chong

Cut and Paste Flowers

Perhaps no subject benefits more from software than the flower—at least for me. One of the big drawbacks of photographing flowers outdoors is finding a suitable background, be it plain, harmonious, or complimentary. Before the digital camera, I often rejected even taking a photograph because of a distracting background. No more. Now I know that when I come across an attractive flower, even if I can't find an angle with a flattering background, I can still take pictures and perform software surgery later. Just select the flower, cut it out, and place it on a background of your choice. I often follow the simple route and use a plain black background. Not the most creative option, but the beauty of many a flower stands out when the background sits down.

adjusting a landscape

Whether it's a view of the waves crashing against the cliffs of Big Sur or a blazing autumn hill reflected in a local pond, nearly everyone crows over the fantastic scenic shots they grab on vacation. And more than most, these pictures deserve a place on your living room wall.

More than most, scenic and landscape photos are open to interpretation—your vision of how that scene should look not how it actually looked. Some photographers believe they should reproduce a scene accurately; its colors, its brightness range, its contrast. But the grand master of landscape photography, Ansel Adams, never let reality faze him. He saw not the scene before him, but the potential of a magnificent print emerging dripping from its final rinse in the darkroom in a form that would evoke wonder and awe when hung on a gallery wall. This resulted from hours of exploration and masterful manipulation in the darkroom.

Sure it's okay to show what the scene actually looked like by making a straightforward print correctly balanced for brightness, contrast, and color; with a good dose of sharpening thrown in to show the scene true to the moment you snapped the shutter. If the scene was truly magical at the time you took the picture, a straightforward interpretation may reveal this.

For other scenes, throw off your inhibitions, roll up your sleeves, and get to work. Be bold. Be daring. Lead and direct the eye through the scene. Strengthen and dilute the light as you see fit. Reinforce and shift colors and contrast to build the mood. If the setting sun didn't inflame those cliffs with orange light, select them and use the saturation, lighting, exposure, and color adjustments tools to ignite them.

The main improvement to this scenic picture of a farm was to make the grass greener. It's closer to what we expect grass to look like.

How? By studying why some landscape pictures tug at your heart and others don't—and by mastering your software tools to create the effects you envision. The crucial tools are those that affect color—saturation, hue, curves, levels—and those that affect brightness and contrast—again curves and levels but also dodging and burning. And, don't forget sharpening, most landscapes are conveyed with a great deal of sharpness.

But the most critical tool is your imagination. If you are as imaginative in manipulating your images with software as you are in taking them with your camera, then your home display will sure to be visited often.

6

Printing Your Pictures

introduction

A romantic evening planned two weeks in advance. A steaming cherry pie just pulled from the oven. The announcement that a new 10-megapixel, noise-free digital camera will be available in one month. A glorious sunset punctuated by the unexpected serendipity of the slow but steady approach of a hot air balloon. And best of all, having next Saturday free to stay home and print to your heart's content. Ahh, anticipation.

Your serious printing sessions deserve some planning. Although you view the session as "printing," it likely can be divided into two, three, even four separate stages, which could occur at different times. The typical stages of printing include preparation, adjustment of picture files, the actual printing, and print finishing (the storage or display of finished prints). You may find it works best to separate these tasks out for different times, even different days, so that you can give printing your full concentration.

Preparation

Although some of your printing may occur spontaneously when your spouse requests a print for your mother-in-law, it's better to plan your serious printing sessions ahead of time. Prepare a day or two ahead, so you can get right into the printing and know that you have everything you need. Nothing can be more disheartening and frustrating than to sit down to print and find out you've run low on ink or paper.

your preparations should include the following:

Plan: Decide which pictures to print, how many copies to make, and what sizes. Locate the files. Clear your calendar and schedule a specific time; eliminate distractions and other demands for your time.

Inventory supplies: make sure you have ink and paper on hand.

Check printer functionality: Make a few small test prints just to be sure it's working well. You may want to clean and align the print heads and perform other printer maintenance tasks a day ahead of time.

image adjustment

Will your printing session be for casual snapshots or for serious enlargements? If you're just printing snapshots, adjusting and printing images in the same session should go well. Adjusting images for framing and displaying can be time consuming and may require all your concentration. For important or complex photos, I like to give myself extra time so I don't feel under pressure. Often I separate the initial adjustment stage from the printing session. I'll adjust and save several images—that can easily take a couple of hours—and print later that day or the next day. So I often start my work with the expectation that I may not make the final prints before the end of the session. The advantage of waiting is not only will I see the images with a fresh eye after a day or two has elapsed, I'll also be fresh and reinvigorated and excited about printing them. And more patient about making the changes required to make the prints look their best. A long adjustment session followed by a long printing session just takes too much out of me. Of course, after making all those adjustments, you probably can't wait to see how they print out. So do whatever works best for you.

printing

Enjoy. If you planned well, your printer is spitting out tip-top prints, your supplies are on hand, and your picture files are organized and ready to print.

finishing

Trimming, matting, framing, storing—again, that's all a different mindset from adjusting and printing. Instead of working with the computer you're using your hands and completely different tools are required. Your mindset is completely different, so separating it into a separate work session again makes sense. Just make sure that you plan ahead and you have supplies on hand.

Top 6 Tips to Keep Your Printer Running Smoothly

1. Make a small print at least once a week to keep the ink from clogging up the nozzles.

2. When not in use, cover your printer to keep out dust and dirt.

3. Snug the paper guides up to the paper to help keep the paper aligned as it travels through the printer. And before putting in several sheets of paper, examine them to make sure they aren't wrinkled or excessively curled. Then fan the paper and carefully place it in the paper feeder or tray.

4. Don't use overly thick paper. Your manual will specify the maximum thickness of the paper it can handle.

5. Using the Printer Driver (go to the Maintenance tab), periodically clean and align the printer heads, and run a nozzle check. Don't overdo the cleaning as it consumes ink.

6. Read the maintenance section of your printer manual.

About
Ink Jet Papers

What is civilization's most important invention? My late father would've jumped up from his tattered recliner and shouted, "The television!" I would've scoffed and responded, "The computer." I imagine my good friend Jeff Wignall crafting a compelling one-thousand word essay on why it's the camera. (I admit I didn't ask him and he may have a different opinion.)

But there are only a handful of inventions that have endured the test of time and even fewer that have contributed to the furthering of humans and their accomplishments. If one can escape the excessive focus on our own technological times and see the expanse of the development of humankind, then there is but one answer. Paper. From inventorying stone supplies for the building of pyramids to recording the observations of ancient Egyptian astronomers to the penning of the Declaration of Independence, the answer can only be paper.

Over five thousand years ago, Egyptian craftsmen were slicing thin strips of papyrus and crisscrossing them into a mat that would record the proclamations, advances, and governing laws of their world. The Buddhists of Tibet and India scratched laws and scriptures onto the long narrow leaves of the bai-lan tree. The Bataks of Indonesia recorded their thoughts on bark strips up to thirty feet long.

Although the word paper comes from "papyrus," papyrus itself was a mere forerunner. Papermaking relies on plants but is reduced to elements much more basic than strips. To make paper, plants are reduced to their fibers, mulched into a wet pulp, and then reconstituted into a cohesive sheet.

It took nearly 5000 years for a true version of paper to be created. The Chinese are the hero of the story. A century before the birth of Christ the Chinese made their paper by beating hemp waste to a pulp with a mallet and mixing the pulp with water in a vat. Using a coarse cloth stretched taut on a bamboo frame, the Chinese paper makers would dip it into

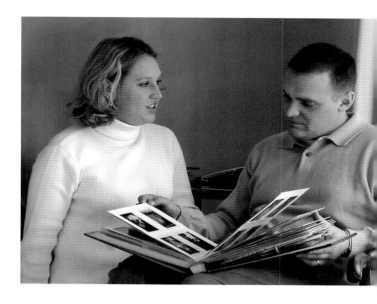

the vat. They'd then heave the heavy slurry-covered frame out of the vat and place it on a level stand to dry. The result? Paper. It would take over another thousand years before Europe made its own paper.

But now papers are made with all the powers of technology at the hands of manufacturers who crave the millions, perhaps billions, of dollars that could flow into their coffers. They use tools like high-speed video and electron microscopy to show ink paper reactions at nearly a molecular level. They can literally display droplets of ink being absorbed by microscopic paper pores.

By now you are well aware that photos to be printed with ink jet printers require specially made papers. The most important part of photo ink jet paper is the coating. Coatings are designed to control the interaction of the ink with the paper. They keep the ink from spreading too much so that fine detail and rich, true colors are revealed. The materials, the chemistry, and other multiple layers built into the paper all work together to optimize the prints of your photos: controlling flatness, fading from light and gases, durability, and overall feel. Our discussion will focus mainly on papers for printing photos—not text. If you want to print both text and photos, for newsletters, greeting cards, announcements, and the like, use one of the many special papers designed for those purposes.

papers for printing photos

There are two categories of paper, each originally designed to meet the specific needs of either pigmented inks or dye-based inks. The two paper types are microporous and swellable. Microporous papers are commonly used with pigmented inks. They are renowned for their speed in absorbing ink and are sometimes referred to as instant-dry papers. They have a carefully designed network of pores that absorb ink the moment it touches the surface of the paper. You can identify a microporous paper by

touch. When you run your finger across its surface, it squeaks and seems to grab at your finger—a sensation caused by its rapid absorption of the oils on your finger.

One advantage of their quick drying is that your print will not dry down or get darker minutes or even hours later. So the moment it comes out of the printer, its color will be stable and ready for your evaluation. One disadvantage is that its open porous structure leaves the inks unprotected from ozone attacks, which can result in quicker fading. Not much of an issue with pigment inks because of their great stability, but when used with dye-based inks print longevity may be shortened.

Swellable or polymer papers are most often used with dye-based inks. Their structure resembles traditional photo papers in that they use plasticizers. When ink hits the surface of the paper, it's absorbed at a slower rate than with a microporous paper. Then the polymers surround the ink, sealing it off from direct exposure to the air and ozone to reduce fading. One of the drawbacks with swellable or polymer papers is that upon exiting from the printer, even though they may feel dry they aren't. Prints require some extra careful handling, including air drying overnight before framing behind glass. Further their colors and density can shift, usually slightly, over the next several minutes, and even hours, making it a bit tricky to know exactly how your print will look and what color and exposure corrections it might need.

More companies are designing hybrid papers that try to combine the best of both papers, quickly drying while extending longevity. Here are the two big criteria in choosing a paper: Do you like how your pictures look on it? Does its longevity meet your needs (see the section on longevity)? Choosing is that simple. Pictures are all about appearance and with the variety of papers and surface textures, they will give your pictures a different appearance. Even different brands of papers of the same type and surface will render your pictures differently.

paper characteristics

Let's take a look at the main characteristics of paper: weight, thickness, whiteness, and surface.

Weight: A paper's weight is not particularly important in and of itself. It is typically expressed in pounds (lb) or gsm (grams per square meter) and is usually a bulk weight and not the weight of an individual sheet. Weight depends on a paper's thickness and added components, such as clay coatings and polymers.

Thickness: Defined in thousandths per inch or mils, standard photo papers are 9 to 10 mils thick. A nice thick paper is luxurious to touch and feel—possibly an important factor if you're handing somebody a print. For prints intended for an album or a frame, thickness is usually a minor factor.

Extra stiffness often increases a print's durability by resisting dings and creases from careless handling. Most printers can handle the thickness of standard papers, but some extra thick papers may not feed through your printer. Printers with front bottom paper trays tend to bend the paper more as they feed it along the printing path. That extra bend means thick papers can jam your printer. Before using a thick paper, check your manual for maximum paper thickness for your printer.

Whiteness: There is actually a standard from the International Standards Organization for determining paper whiteness, with 100 being the top score possible. Standard glossy photo papers have an ISO whiteness of 90-95. What does that mean? It means they're pretty white. You shouldn't necessarily compare the whiteness ratings of different papers. You should like the appearance your paper gives to the subject. Papers with a brightness range in the 90s usually achieve such great whiteness through bleaching during the paper making process. Some folks worry that bleached papers may yellow over time because the fibers aren't naturally white. One major manufacturer specifies that their longevity tests do not include a measure for yellowing.

A bright white paper is highly reflective and should excel in revealing bright, rich colors. Paper white can be creamy, even slightly yellow (warm) or blue (cool). Some papers add optical brighteners, similar to those in clothing detergents, to fluoresce ultraviolet radiation and make the whites seem, of course, whiter. Some fear that the increased interaction with UV radiation caused by optical brighteners could shorten a print's life.

Surface: A paper's surface can vary from super smooth to highly textured. Surfaces tend to fall into two categories based on how much they reflect light: glossy and matte. For everyday pictures, you'll likely use a glossy paper. The term glossy covers several surface types, each which tends to be just a bit less reflective and shiny than its predecessor: glossy, semi-glossy, luster, pearl, and satin. Except for glossy, the other terms can be somewhat interchangeable among the different manufacturers. One's semi-glossy paper may look quite like another's luster. Glossy papers excel in reproducing rich, saturated colors and in revealing minute details. But the shiny reflection of a glossy paper can also be an annoyance, as you have to adjust your angle of view to see the picture clearly. Also, pigment inks printed on glossy paper can result in a differential gloss, which can make the surface look flawed.

Matte papers often include papers with other names, such as watercolor, velvet, and smooth. They are neither shiny nor highly reflective. Reduced reflections make it easier to see the subject from any angle and eliminate the differential gloss of pigmented inks printed on a glossy paper. The lower level of reflection reduces contrast, brightness, and color brilliance—all benefits if you match the matte surface to the right subject—but not right for all subjects. Matte papers work well to create a quiet, classic mood, often well suited for portraits, still lifes, and landscapes. Many fine art photographers use them for gallery exhibitions. However, when mounted and framed under glass, the surface differences between glossy and matte papers become less noticeable.

Different surfaces require different amounts of ink, so it's important to choose the right paper type (usually identified by surface) when setting the printer driver during printing

Linen texture

Papers come in a variety of surfaces. On some the texture is three dimensional, adding a new element to the perception of the picture.

Matching Subject to Paper

et's just explore a bit more what we've mentioned earlier, that certain subjects look better on certain papers or surfaces. You're eighty-year-old grandmother may look wonderful on a matte paper that helps hide wrinkles and yet conveys the glow of her skin and personality. In general, matte papers work better for portraits of adults than do glossy papers. Those with beautiful skin, perfect complexions, and shiny hair may indeed sparkle on a glossy or probably better, semi-glossy paper. But the rest of us would ask that you choose a matte paper.

Canvas texture

When should you use a glossy paper? Anytime brilliant colors and sparkling highlights shimmer in a picture or when small details, such as in a feather or a quilt are critical. A bed of red tulips backlit by the morning sun, a bright orange kayak rocking through the rapids, the sheen of rain on the road stretching for miles into the distance, the finely segmented antennae of a butterfly seen up close. All call for a glossy paper.

Take a look at the table on this page for guidelines on matching paper to subject.
In the end, your taste should dictate which paper surface to use.

SUBJECT BEING PRINTED	SUGGESTED PAPER	COMMENTS
Everyday snapshots	Glossy or semi-gloss paper	Snapshots should snap so use one of the glossy papers. Go for a reliable but relatively inexpensive paper from a third party or your printer manufacturer. Make sure longevity exceeds 10 years.
Snapshots of important events	Glossy or semi-gloss paper	Same as above but longevity should exceed 25 years.
Portraits of people under 18 and wedding pictures	Semi-gloss (also known as luster or satin)	Semi-gloss paper carries bright colors and wide contrast symbolic of the vibrancy of youth but minimizes the annoying glare of a high gloss paper. Use matte paper for quieter, contemplative portraits or for complexion problems.
Portraits of adults	Matte	Matte paper subdues wrinkles and conveys a more serious tone. Use semi-gloss to liven up an image. Canvas paper can add a nice touch.
Still life	Matte or canvas	Most still life photos seek to impart a feeling of art. Matte papers more subtle tonalities mimics art papers. Watercolor or a fine-art paper makes a nice alternative. For fine-art sales, use papers only with longevity greater than 50 years.
Landscape in sunny lighting	Semi-gloss (also known as luster or satin)	High contrast inherent in a sunny scene needs a semi-gloss paper (sometimes even a glossy) to convey the brilliance you saw.
Landscape on overcast day	Matte	To communicate the quiet light, use a matte paper. If you want to boost a scene's energy, use a semi-gloss paper.
Flowers	See comments	Brilliant and bold: use a glossy or semi-gloss. Serene and subtle: use a matte paper.
Sports	Glossy	Brash, bold, powerful. High energy shots require a glossy paper to reflect that energy.

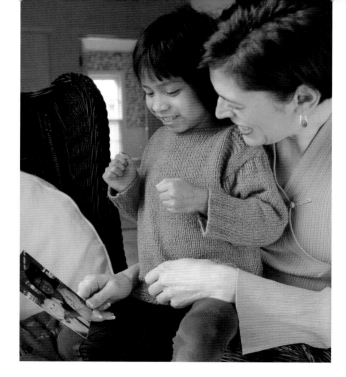

So which papers should you use? That depends on the type of pictures you print. But most people should have the following:

everyday papers

Glossy or semi-gloss paper: Keep a good, medium-quality, but modest cost glossy or semi-glossy paper on hand so you can quickly make good (don't have to be great) prints. Have available in 8.5 x 11-inch (22 x 28-cm) and snapshot sizes.

Matte paper: Again, choose a good, medium-quality, but modest cost paper to use when a glossy paper doesn't meet your needs. Have available in 8.5 x 11-inch (22 x 28-cm) and snapshot sizes. Your two everyday papers should be from the same manufacturer.

gift- and gallery-quality papers

High-quality semi-gloss paper: For gifts and home framing, you might need to spend a bit more for this paper. Make sure its longevity exceeds 25 years with your printer.

High-quality matte paper: Watercolor and other fine-art papers are useful should you ever try to sell your work. Tested longevity should exceed 50 years.

experimental papers

You should always be trying new papers to extend your personal vision, so whether you like to play with specialty papers or fine art papers, keep a packet or two of unusual papers on hand and experiment with them when you have the time.

specialty papers

Papers, or media, in this case come in a variety of forms that enable you to use your pictures in extraordinary ways. Many media let you put pictures on unusual surfaces, such as fabric, mouse pads, magnets, business cards, labels, and a variety of what might be called novelty uses. Other media offer unusual surface characteristics—extra shiny, metallic, pearlescent, heavily textured—intended for more traditional display surfaces.

choosing your papers

For day-to-day printing, narrow your choices down to two or three paper types and perhaps two surfaces. Because each paper prints differently, regularly using several different papers will cause you to spend more time reprinting and adjusting your prints. That can be costly, time consuming, and frustrating. Even if you use color management and paper profiles, printing on many papers will cause you to remember how they appear with different subjects. Too many variables arise when you use too many papers.

Printer manufacturers go to great lengths to get you to use their papers. They talk of the increased longevity resulting from the interaction of their inks with their papers and of the better quality and reduced waste derived from using the paper made by the same folks who make the printer, its inks, and its drivers. And there is truth to what they say.

Conversely, most of these folks do not try to discourage owners of other printers from using their papers—indeed they often encourage it. Third-party paper makers try harder. Many offer equal or even better quality, reasonable longevity, and profiles or driver settings to give you good quality. For everyday printing, you shouldn't hesitate to use a high-quality, well-priced third-party paper, such as those from Kodak. Stay away from the office store brand papers. Thus far, they haven't withstood the test of time.

Matching Print to Monitor

Getting your monitor to display neutral tones without any color bias may be the most important step to better prints. The neutral tones include the full range of whites to grays to blacks. Your monitor should be set to display such neutral tones so they are indeed neutral and do not show any color bias (hints of red, blue, yellow, etc).

adjusting your monitor

The best way to achieve this is by calibrating your monitor. If you are using Photoshop or Photoshop Elements with Windows operating system, use the included gamma calibration software. On a PC, choose Start > Settings > Controlpanel and click on Adobe Gamma. The wizard will lead you through a series of visual calibration steps to adjust brightness, contrast, and neutral tones. On a Mac, refer to the manual and follow the instructions on using Color Sync, a built-in program.

If you're using a picture-editing program that doesn't offer a monitor calibration tool, refer to the monitor manual to see if it instructs you on calibrating or adjusting the monitor. As a last alternative, you could photograph a white cardboard and a gray cardboard side by side and then open the picture and evaluate it on your monitor. If you see any color casts, try to adjust your monitor's color controls to eliminate them. This last method is especially subjective; it should help some but it is not precise.

compare a print to the monitor display

Once you've adjusted the monitor, make a sample print. Choose a favorite subject, but make sure it includes pure white and gray areas, and preferably even black. If you take a lot of people pictures, then make sure a face is fairly large in the picture. You may want to create a special picture including these requirements. If you do, take the picture at midday under bright or hazy sunshine. Adjust it on the monitor so the neutral tones lack color casts and the flesh tone is pleasing. The picture should also show a pleasing brightness and contrast. In other words, you should like how it looks on the monitor.

Now make a 5 x 7-inch (13 x 18-cm) print to evaluate. Print on your favorite photo quality paper and make sure the printer driver is set for that photo paper and to the high-quality (minimum 1200 dpi) setting you normally use. Everything you do to make this print should be the same as you would for most prints.

When the print is completed, compare it to its corresponding image on the monitor (see the sidebar on viewing a print). Are you satisfied with the print? Does it approximate what you see on the monitor? Print and monitor won't match perfectly, because each uses a different technology to create color: the monitor creates an image by transmitting red, green and blue light; the print by reflecting light off cyan, magenta, yellow and black inks. However, the print should approximate what you see on the monitor.

If the print is simply too dark or too light, you can adjust the monitor's brightness and contrast controls until you get a better match. If the print's colors are off, adjust the color of the image using the picture-editing software, and then make another print. Keep a record of your adjustments. The adjustments you make to obtain a pleasing print are the approximate picture-editing adjustments you should make on all future prints. Note the exact amount of adjustment you make to colors, brightness, and contrast to make the monitor approximate the print. In future printing, after you make all your other adjustments, apply these final settings to your picture-editing program.

This trial-and-error method can be time consuming, and sometimes ineffective. Hopefully you won't need to do it. There is a better way. But it's complex. It's called color management, and we'll discuss that next.

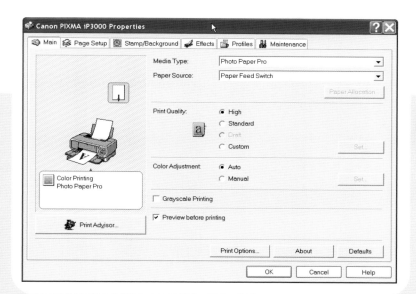

The main Printer Driver window is your portal into a variety of settings and adjustments required to output good prints.

The Printer Driver

ot only does a printer driver sound a bit like a chauffeur, it actually is a bit like a chauffeur. If you don't make friends with this chauffeur, then you could be going on some wild rides to parts of the printing town you'd rather not visit.

The printer driver is your entry into the world of interacting with and understanding your printer. It's a software program provided by your printer's manufacturer that you install when you first set up your printer. And the printer manufacturer usually updates it several times a year in a form that you can download from the support section of their website. It's probably a good idea to download the latest version at least once a year. The actual driver resides in the Macintosh and Windows computers. Newer printer drivers are starting to integrate these functions directly into your picture-editing program, making it easier for you to access them.

The driver affects all sorts of things for you—or against you if you don't use it correctly. Perhaps most importantly, it lets you select the type of paper you

are printing on. Selecting the paper type tells the printer how to adjust the ink output, which can have a huge impact on how a print looks. This is doubly true if you use paper provided by the manufacturer of your printer (or have downloaded a profile). The printer and paper are developed to work together, and the profile (special instructions) is created to truly optimize the application of the ink to the paper selected. If you load photo paper, but leave the driver set to plain paper, your print will suffer.

Let's take a more organized look at what a driver does by simply looking through the windows of a typical driver. You should explore your driver by clicking on its different tabs and buttons. What you'll find is that making different selections sometimes opens up new, unexpected options. It's like exploring an old abandoned house and finding secret passageways. If you find buttons or options with words like "Custom" or "Advanced" or "Manual," clicking on them is almost certain to open up new options that were hidden until you made your click.

Wrong paper setting

Correct paper setting

If you don't set the Printer Driver paper setting to match the type of paper you are using the results can stray far from the picture's original appearance.

Top 5 Printer Driver Settings

The Printer Driver settings you choose have a major impact on making a successful print. Although there are literally dozens of settings possible through your Printer Driver, correctly setting a few important ones can help you make great printers easier.

1. Choose the paper setting that matches the paper in your printer. This is the most important step in making a high quality print.

2. Set the quality setting to its highest setting when making high-quality prints, to standard or normal when making snapshots or everyday prints.

3. Set the paper orientation mode to match the orientation of your picture: for most printers you select Landscape for horizontal pictures and Portrait for vertical pictures.

4. Select the paper size that matches the size of the paper in your tray, and then set the image adjust to Scale or Auto Size so the image fits onto the paper.

5. Select Preview. This gives you a final approval by showing how the image will appear on the paper based on its size and the settings you have chosen.

And a non-driver tip: be sure to place the paper in the printer with printable (or coated) side facing out. Glossy, semi-glossy, luster, and satin papers can only be printed on one side—the back, non-printing side usually has the manufacturer's name printed on it. Most matte and other non-glossy papers can be printed on both sides.

driver functions

The main windows for printer drivers all vary somewhat in organization and features, but they all include three similar categories:

• Main (printer setup)

• Page setup

• Maintenance

main (printer setup)

In the main window, you choose the variables that directly affect your print. You choose the type of output you are printing, such as text, text and photos, photo, best photo. You choose the type of paper you are printing on, such as Photo Glossy, Photo Semi-glossy, Photo Matt. You choose the size of the paper, and its orientation—portrait (vertical) or landscape (horizontal). If you want to see how your picture will look on the paper (you do) before you print it, choose Print Preview. That provides you a last check to visually confirm that the picture fits the paper, that you chose the right paper size, and that the orientation is correct—before the printing starts. The Main window also provides navigation to other features and functions of the driver.

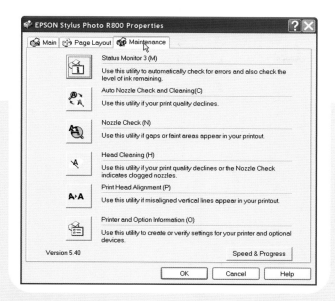

maintenance

Go here when you're having problems. Specifically, the Maintenance window lets you align print heads, as well as check and clean the nozzles. It helps you keep your printer fit, trim, and healthy so it accurately and precisely emits ink to create high quality prints. It also lets you access a variety of custom functions, such as quiet mode and monitoring of ink levels.

page setup

The Page Setup window offers more functions for text printing than photo printing. Functions like duplex (front and back printing on the same sheet), collating, reverse order printing (page 9 prints first instead of page 1), and adding watermarks are typical of this window. However, on some drivers it also enables you to set the paper dimensions, the orientation (portrait or landscape), and may offer special printing applications, such as poster size printing.

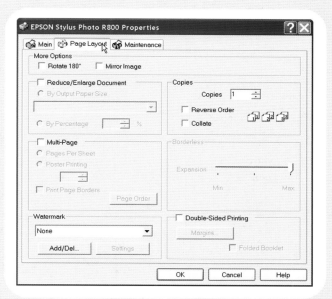

color

Your printer driver may not have a tab or category that says "Color" or "Color Management" but it does offer several functions addressing those concerns. You'll likely find color adjustment controls, such as sliders, and special personal color preferences, such as a "Vivid Color" choice that saturates and boosts contrast on all colors. Again, you're better off addressing individual picture color through your picture-editing program.

Color management controls also exist. If you implement a formal color management system, the color management settings in the printer driver need to be set correctly or you may counteract your color management.

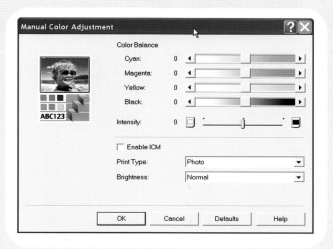

what you shouldn't use your driver for

Most printer drivers offer a variety of image adjustment controls that are generally less sophisticated than those of your picture-editing software. If you're curious, feel free to play with these settings, but when you're done set them to neutral or turn them off. Compared to most picture-editing programs, these adjustments offer less control. Perhaps more importantly, you may be adding confusing variables if you are adjusting your pictures with two different sets of controls. I suggest you adjust your photos only with your picture-editing software (with a few rare exceptions).

If you use color management software and printer profiles, you'll have to review your driver setup to make sure you don't accidentally override any of the color management functions.

Adding Borders and Edges

Just as matting and framing help set off a picture and direct attention to it, so can borders. Perhaps I should use the singular "border" as applying one border around a single picture, rather than multiples, tends to work best. And perhaps, I should also apply the term "edge effects" as a border implies a simple straight line drawn with a ruler.

Borders, edges I mean, come in a surprising number of forms. In fact, there are software programs and Photoshop plug-ins dedicated solely to overwhelming you with the creative possibilities of applying edges to your pictures. They start with straight lines and soon transform into a variety of brushed, burnt, pixellated, twisted, torn, and crosshatched patterns that can surround your pictures in ways you never dreamed. And you can use your picture-editing program's brushes and selection tools to create your own edge effects.

But if you are using one of the consumer level picture-editing programs, such as those from Ulead, Microsoft, Roxio, or another consumer editing program, you likely have a good choice of borders and possibly edges. In most instances, you simply choose the border function and up pops a thumbnail gallery of borders and edge effects. You may find a modest collection numbering twenty to forty. Or if you buy Extensis PhotoFrame you can choose from over 2000 possibilities. Mind-boggling. You could spend the rest of your days pondering frames, edges, and borders.

Which type of border should you use? My short advice is this, most of the time you don't need a border. The picture will speak for itself. However, borders do have their uses, so let's look at the options.

Pictures with light tones on their edges tend to fade into the paper, making it difficult to tell where the picture ends and the paper starts. These pictures look better with borders. In this case, a simple black hairline border running around the picture to define its edges works well. The line should be thick enough (5 to 10 pixels usually suffices) that it is clearly visible but not so thick that it detracts from the picture. Pictures that are not going to be framed or matted but flush mounted on a board can benefit from a border if you center the picture on the paper and leave a white one- to three-inch (two to ten cm) band of white paper around it to create a faux matte effect.

The First Print

I t's not quite as exciting as your firstborn, but that first print can stir up a thrill of anticipation. After all, you've put a lot of work into adjusting and improving a favorite picture and it looks great on the monitor. As it inches out of the printer, your hopes are high that that your hard work will be rewarded. So let's make sure that first print saves you time and tells you everything you need to know—just in case you need to make a second print.

prepping the print

Unless you're printing a snapshot, many people look at the first print as a test print. They'd like it to be perfect but, if it isn't, they want it to provide enough information that they can make a second print that will be near perfect.

So if you view your first print as your penultimate (that means next-to-last and I can't avoid the chance to use this word as the opportunity seldom arises) print, then you might want to treat it a bit differently than the ultimate print. If your final print will be 8 x 10 inches (20 x 25 cm) or larger, then make your first print smaller so it will print quickly.

Some folks always print at full size to get a true feel for what the final will look like. But I'm too impatient and I print it smaller because that's faster. But first—if you haven't already—be sure to save that fully adjusted, full-resolution, ready-to-be printed file in a folder called PrintReady. Because the only change you'll make for the test file is resizing it, there's no need to save it. And be sure you don't accidentally save it over your full resolution version.

In all other regards, keep the settings—resolution, paper used, printer driver settings—the same. Some folks, particularly those who don't formally or informally use color management processes, opt to create a ringaround on the first print. You can do this by reducing the image to about wallet size (2 x 3 inches or 5 x 8 cm). Then copy it and create several new files. To each file, make a slight to medium color variation (add red to one, blue to another, yellow to another, and so on). Add text under the picture that

indicates the amount of change you made. Then create a new file that is 8 x 10 inches (20 x 25 cm), and copy each color variation into the new file (see the illustration) and print it out. Review the printed ringaround print to see which color shift looks best. Adjust your original picture accordingly.

Slighlty more Cyan

Much more Cyan

Original

More Yellow

More Red

print preview

Before you hit the Print button, turn on the Print Preview feature in the Printer Driver. This gives you a last-second visual check to confirm that orientation, positioning, and size are correct. Select quality (highest or next to highest setting), match the paper (media) type and size settings to the paper you are printing on, choose orientation (landscape or portrait), and other color or dithering settings you expect to use. For many printers, you get to these settings by first going to the File menu and selecting Print. This opens a Print window that includes a Properties button. Click on the Properties button and it opens the printer driver window where you can make these settings. Getting to the printer driver settings can be confusing. Refer to your printer manual as needed.

In the Printer Driver window always select Print Preview. The Print Preview window shows you the orientation and size of your picture relative to the paper size you selected.

Print Review Checklist

- ☐ Highlights are bright but show detail
- ☐ Black areas are truly black but dark areas show subject detail
- ☐ Whites and light grays are neutral—little or no color casts
- ☐ Overall color balance and saturation is good. Skin tones are appealing
- ☐ Memory colors (grass, blue sky, apples, etc) are appropriate
- ☐ Sharpness is good (bigger print will need a higher sharpness adjustment)
- ☐ No extra retouching is required to eliminate spots, stray hairs,
- ☐ Ink laydown is good: no banding, streaking, puddling, excessive graininess, etc

evaluating the first print

So the printer is busy chugging out the first print. You can hardly wait. But wait you must. Just as you don't eat chocolate chip cookies or a cherry pie the moment the oven door opens, so you don't evaluate your print the second it leaves the printer. Give the print at least a few minutes to dry because density and colors may shift. And you may know from experience that you need longer, half an hour or so with some papers. I know it's hard to wait that long, so maybe you have other prints you can work on at the same time. Of course, being the impatient type, I would switch to a faster drying paper or one that doesn't show much change upon drying. But don't change what works for you.

Review your print under diffuse daylight or with a full-spectrum color light source. At first, just glance at it to get a first impression. Do you like it? Good. If not, why not? Look at general criteria, such as composition, subject matter, snap (contrast, saturation), and paper surface. If it needs general improvement, make notes.

After you evaluate it for general criteria, look at specific technical criteria. The list applies whether you used a ringaround (several variations of the same subject) or just printed a single picture.

Makes notes of any areas to correct. I often write on the print itself and save it for future reference in a special binder. I don't do this for all prints, just favorites.

If necessary, make adjustments and another test print.

If adjustments are minor, incorporate them and make the final print. Remember to return to the full resolution version saved in the PrintReady folder. You'll need to give the full-resolution print a boost in sharpness compared to what you used for the small test print.

I like to annotate my prints so I have a fast and clear visual reference to the adjustments made for the final print.

Snapshot printing lets you crop in tightly—a huge creative advantage for improving and even making new pictures out of what you might have thought were discards.

Printing Snapshots

A bit before Henry Ford revolutionized manufacturing with his assembly line production of the Model T, George Eastman, founder of Kodak, did a little bit of revolutionizing of his own. His unique solution led the infancy of photography into a growth spurt that has since given every family its own personal history book—the photo album. It could be said that George invented the snapshot. He coined the timeless slogan, "You press the button, we do the rest." Every customer who bought his camera, no longer had to worry about the sloppy, unreliable, and inconvenient method of obtaining pictures from their new cameras. They simply sent the camera back to Kodak and some days later would receive a camera loaded with fresh film and a packet of pictures— their snapshots.

The snapshot has fallen on hard times. With the advent of the digital camera, it might even be on the verge of extinction. More and more of us (me included) relegate too many, if not nearly all, of our casual pictures to the depths of the computer or to the ether of email. Snapshots are critical to your family history. Often informal and casual, they form an intermittent photo diary of the events and evolution of your fami-

ly, a record far too important to leave as invisible bits and bytes on a hard drive. Simply look at your parents' or grandparents' album and you'll understand the amazing history revealed, not only of their lives, but of the times in which they lived.

What snapshots should you print? Any that add to the story of your family's life and development. How should you print your snapshots? Quickly and with little time spent adjusting them. After all, they're only snapshots. The very essence of a snapshot is its informality, which includes a relaxed approach to design and quality. Sure you want the colors to be good, and the brightness and contrast to be good. In short, you want the picture to be good, or at least okay. But if it goes beyond good, then it's really not a snapshot anymore. I once sat on a panel of judges for a snapshot contest with the late and famous photojournalist Eddie Adams. As we poured over hundreds of photos, some amazing once-in-a-lifetime shots, some incredibly artistic, others quite professional looking, one, ultimately the grand winner, to our horror, caught his eye. Against all arguments, like the lone

juror in Twelve Angry Men, Adams would not be swayed from a slightly out-of-focus picture of a mother and child poignantly standing in the doorway of their home. For him, even though it was slightly out of focus, it was the quintessential snapshot.

And the whole point is to use your snapshots as a record of your family's life through its growth and generations. So make it easy on yourself. Print them quickly, using a mid-level grade of glossy or semi-gloss paper. Keep adjustments to a minimum, relying as much as possible on auto adjustments for brightness, contrast, and color. But don't hesitate to crop tightly. Because the print is small, resolution requirements are also small. With cropping, you can improve a picture in which the subject is too small.

You can get paper in the 4 x 6-inch (10 x 15-cm) size or you can use your image-editing program's package feature to create an 8.5 x 11-inch (22 x 28-cm) album page containing several pictures. For pictures headed for the album choose a paper with at least twenty-five years of predicted life and use an archival album.

Because of their small size, snapshots often let you creatively crop to remove substantial portions of a picture and still produce a good quality print.

Printing for Your Home Gallery

hether it's a home gallery or an art gallery, hanging a print on a wall is putting your pride and ego at risk. Admittedly, the risk is quite a bit lower for a home gallery, although let's face it, relatives and children can be downright brutal in their appraisals. So the goal in making a home gallery print is to create a photo worthy of your name. Or at least one good enough that your big sister doesn't snicker when she walks by it. Out of a possible score of 10, your home gallery prints need to be an 8—no easy task. Unlike a snapshot that you can print in a few minutes, a good home gallery print could easily take thirty to sixty minutes to prepare and print.

Start by choosing a good digital file, one that shows correct exposure, one that is sharp, one that is well composed so it needs minimal cropping (meaning it will retain enough resolution for enlarging). Be ruthless in your selection. Ignore picture files that are even slightly blurry or overexposed. Because repairing them is next to impossible, send them off to the snapshot pile if you can't give them up entirely. And above all, choose pictures that are compelling either artistically or contextually (meaning their subject matter will appeal to your home audience). And don't forget your

audience. If it's only you—which means it's displayed in your bedroom or your home office—feel freer in choosing your pictures. If it's for "public" display, keep your audience in mind—unless you're darn confident your pictures are so good they'll appeal to everybody.

Make sure your picture has enough resolution to be enlarged to the size you want. In a gallery print, revealing sharp detail is critical. For a 5 x 7-inch (13 x 18-cm) print, you'll need about a 5 MB file (1575 x 1120 pixels); for an 8 x 10-inch (20 x 25-cm) print, about a 12 MB file (2250 x 1800 pixels). That's without any interpolation and the ppi should be set no lower than 225.

First crop the file to the aspect ratio you want and then size the file using a ppi setting of 225 to 300. Now prep the file. Use adjustments layers if you expect to rework the print later. They make it easy to revise and undo adjustments. Make sure color, brightness, and contrast are dead on. Whites should be neutral and reveal textural detail; dark tones should also reveal texture, and if blacks exist they should be truly black in color and density. Retouch both major and minor flaws, such as dirt on a flower petal or blemishes on a face. Increase and decrease saturation to provide the emphasis you want. And especially dodge and burn to direct the eye to the important areas of the picture. An old darkroom trick is to burn (darken) the edges and corners of a picture to direct the eye inward where the main subject usually resides. Not every picture benefits from this technique but consider it in prepping your print.

Study your picture to decide where and how to improve local (small) areas of the picture. Do the eyes need lightened and selectively sharpened? Does the background need to be darkened or blurred so it doesn't distract from the main subject? Does that glaring highlight on the vase need to be subdued?

You may even want to consider where the print will be displayed. If the area is quite dim, lighten your print. If quite light, perhaps darken it. Take it to the display area and see how it looks. If it will be displayed with other pictures, consider how all the pictures will work together: size, shape, color.

Allow your print a few minutes to dry and observe if its color or brightness shifts at all. On some papers, color and brightness change subtly for up to several hours.

Once you think you've made all necessary changes, save the layered file to your WorkInProgress or Print folder so it's available for future printing. After you save it, flatten the layers to reduce the file size and speed up printing.

Now that the picture is ready to send to the printer, choose a paper appropriate for the subject and your longevity requirements (see the section on longevity). Set the printer driver for your paper (or Photoshop if you have downloaded the paper's profile). Remember, if you're using a new paper without a profile, you may have to remake the print several times to get it right. Let the print dry several minutes before evaluating it. If it needs more work, make notes of the adjustments required, then make them and send another file to the printer. Let the final print dry for several hours before mounting it. Use acid free materials and cover it with glass to reduce the fading effects of ozone.

Borders

Some photographers like to add borders to their prints. I usually don't because I matte them to set off the photo. Borders can range from a simple black rule around the picture to a variety of torn, scalloped, and brush effects that intrude far into the edges of the picture. A number of image-editing programs let you achieve both simple and more complex (and often intrusive) effects. Border plug-ins for Photoshop can offer you hundreds of choices. Don't go overboard. The creativity is in your picture—not the border.

Making Black-and-White Prints

hat could be simpler than hitting a little white ball and making it go the direction and distance you desire? What could this question possibly have to do with printing your digital pictures? Because sometimes the very task that appears so simple can be the most difficult.

The irony of photography has long been that you haven't mastered photography until you've mastered the black-and-white print. Color photography with its millions of colors has long been considered the easier craft to master. And so it may be in the world of ink jet printing. Especially since so many cameras

and printers are designed specifically to produce color photos that match your vision of reality. Only recently has producing black-and-white prints that match traditional silver halide prints become a mainstream goal.

Trying to get a neutral (no color cast) from a printer using four, six, or even eight different colored inks has stymied and frustrated many a manufacturer and even more photographers. Trying to get a full range of "grays" from a deep intense black through

tions of dark, medium, and light grays to a wisp of detail in a cirrus cloud may be child's play for a traditional darkroom craftsman. Not so for those that have chosen the ink jet highway. Even the traditional black-and-white craftsman regularly reached into a repertoire of darkroom chemistry and techniques that would impress an alchemist. It was not only I who used to enter the darkroom after breakfast to toil away, slipping print from enlarging easel to developer tray to stop bath, fixer, and wash and start all over again only to finally emerge surprised that the sun was about to set.

The black-and-white print beckons with mystery and misery. Its practitioners are a hard crowd to please and if you undertake more than the printing of snapshots, accept that arcane and esoteric adventures await you.

converting color images to black and white

Although many digital cameras allow you to create original black-and-white pictures, sometimes even using filters to alter the tonal range, we're going to assume you're converting your picture from color to black-and-white. Tonal conversion and tonal manipulation are critical to successful black-and-white printing. If you're serious about making black-and-white prints, you'll need the tonal manipulation tools available in advanced image-editing software, such as Adobe Photoshop.

If you're using an intermediate image-editing program, your choice is likely limited. You can either use the Saturation control to completely desaturate the image until only gray tones remain or simply convert the image to black-and-white by selecting the black-and-white (often called grayscale or monochrome) mode. After you make that conversion, adjust contrast and brightness to give the best effect.

With advanced image-editing software, use the channel mixer (set to monochrome), and adjust the red, green, and blue channels to create the tonality that best matches your vision. In Photoshop, go to Image > Adjustments > Channel Mixer, and click on the

photos © Stephanie Albanese

Monochrome checkbox. The combined values of the red, green, and blue channels should not exceed 100. The channel mixer lets you manipulate the tones corresponding to the colors in your image, almost as if you were using yellow, orange, or red filters with black-and-white film.

Play around with them until you get a feel for their effects or find the tonality you prefer. You might want to explore the world of Photoshop plug-ins, such as Nik Color Efex Pro to see how their offerings might simplify and improve your conversions to black and white. In the world of black-and-white, tonal manipulation is everything.

printing in black and white

If you take black-and-white printing seriously, then you'll have a choice of dedicated products—inks, papers, printers—to use, people to listen to, and techniques to learn. But for the first go, let's assume you are using your color printer. Again, the challenge is to get neutral (not a touch of red or a hint of blue) from the cyan, magenta, yellow, and other ink colors common to current ink jet printers. Don't expect your letter-size printer to yield the intense, deep blacks you see in a fine art silver halide black-and-white print. The day may not be too far off that an ink jet printer can produce such deep, rich blacks, but desktop models haven't achieved that intensity quite yet.

Your controls over the black-and-white image are limited. So once the image file looks good, simply send it to the printer, setting the driver for the type of paper in your printer. Unless your printer has extra black and gray inks for printing black and white, do not check the "black ink" box that appears in some drivers. That setting forces the printer to use only the black ink, which will give poorer results than using all the color inks. That said, some printers can recognize that you are sending a monochrome picture to the printer and use only black ink. If your printer does that, use the desaturation method of converting your picture to black-and-white. That way you'll keep it in the RGB mode and make use of all the printer's colors to get a better range of tonality.

Evaluate the print looking for excessive color shifts. Completely eliminating slight color tinges can be difficult so I suggest you accept slight ones. If they are more than slight (or you want to eliminate even the slight ones), use your printer driver to adjust the color (you can't do it in most picture-editng software, because your image is colorless and no longer an RGB file, thus the color controls aren't available). Don't know where the color controls in your printer driver are? Search your driver. You need to know it well. On many, clicking the "custom" setting and then the "advanced" setting gets you to the color adjustment controls.

The simple fact is that creating high-quality black-and-white prints exceeds the ability of most letter-size color printers, but not all. A few printers, such as the upper-end desktop models from HP and Epson, are designed for printing both color and black and white. For the Epson tabloid-size printers, several independent manufacturers, such as Lyson and ConeTech Piezography make specialized products for black-and-white printing. The upper-end page-size HP models include three sets of "black" (dark black, dark gray and light gray) inks to provide the wide range of tones required by black-and-white prints. Special printing software called a RIP (raster image processor) that substitutes for the printer driver is made by some companies to enable higher end Epson printers to give neutral black-and-white prints from their color inks. Two popular RIPs for black-and-white printing are ColorByte's ImagePrint and Ergosoft's StudioPrint. I've not used either, but a friend reports good results using ImagePrint with his Epson 2200 Printer.

Once the Achilles heel of ink jet printing, black-and-white photos are beginning to submit to technological advances. Soon, maybe by the time you're reading this, exceptional black-and-white printing will be on par with the quality and simplicity of color printing.

7

All About Color Management

introduction

You spent an hour posing mother and baby in a rocking chair illuminated by the soft light of a north window. You set up a white reflector to bounce light back on the shadow sides of their faces. You did such a good job, that only a little image adjustment was required. On the monitor, their skin tones are soft and glowing.

You click the Print button and anxiously await the glorious culmination of your artistic endeavors. But wait. What's this? The image emerging from the printer looks nothing like the image on your monitor. Mother and baby are green; they look like they should be in bed under a doctor's care. What gives? And what should you do?

Producing prints that match or at least approximate the images displayed on your monitor is perhaps the biggest challenge a printmaker faces. The monitor displays millions of colors by combining varying amounts of red, green, and blue (RGB) light. The printer tries to match those millions of colors by combining varying amounts of cyan, magenta, yellow, and black inks (and perhaps red and green if you have an 8-color printer). Light versus ink: two different, almost opposite, technologies for producing color. And you are caught in the middle.

Perhaps the greatest and most difficult goal of digital photography and print-making is to make a print that almost matches the monitor on the first try. Ultimately that's what color management for making prints is all about.

Why Color Management is Needed

Why is color management a concern? If you ever saw the movie *My Cousin Vinny* you'll understand. In a memorable courtroom scene set deep in Alabama, Vinny, a lawyer from the Bronx, stands before the judge and asks, "Is it possible the two yuuts..." The judge rudely interrupts him, "The two what? Uh, what was that word?" Vinny repeats it. Bewildered, the judge asks, "What is a yuut?" Vinny finally clearly enunciates the word "youths." They were both speaking English but the proper meaning wasn't conveyed.

Something similar happens to your digital pictures as they go from camera (or scanner) to computer to monitor to printer to paper. Each device along the path describes your picture in its own dialect, leaving the next device to interpret that dialect. They're all speaking color, but they all speak it a bit differently. By the time your picture reaches the printer, it may print "Yuuts" when you want "Youths."

With color management, you convert the dialect to a standard form that compensates for each device's dialect and is also independent of the device. Sort of like the neutral voice of a national newscaster. For the most part, you're trying to make the image that comes out of your printer closely match its appearance on your monitor. When your image comes out as you expected, you control the process.

You make it predictable by calibrating the monitor and creating color profiles of your monitor, your paper-ink combinations, and possibly your camera and scanner. Profiles are generated by replicating a series of color patches with each device and analyzing how accurately the colors are reproduced. The most critical device is your monitor since you use it to adjust your pictures.

Two Approaches to Color Management

Consider two professional photographers. They share a studio and both shoot almost solely digital. Scott is a commercial photographer with advertising providing most of his revenue. Gary is a versatile freelancer who travels the world on photo assignments. Scott is a Photoshop expert and thinks nothing of assembling twenty individual photographs into one final realistic looking photo to achieve the effect he wants. Gary uses Photoshop, too, but prefers to be behind the camera, not the computer. One of these photographers has embraced color management. The other eyeballs his way to good color. Both feel they have tamed the monitor-printer fight.

Can you guess who embraces color management and who eyeballs it? It might surprise you to learn that Scott, the computer geek, wants nothing to do with an instrument/software-based color management system. He uses the visual calibration system offered by Adobe and feels he knows his system intimately and can get the consistent accuracy he needs. Gary, the footloose freelance photographer, loves to print but doesn't love his computer. (He does love his digital camera.) He rejoices in the consistency, efficiency, and improvements instrument-based color management has brought to his printmaking. Now he's spending more time behind the camera and less time remaking prints to get good color.

Instrument versus eyeball—these are the two methods of color management. We'll take a look at both methods. Once implemented, be it the instrument or eyeball method, good color management practice requires you to use the same process over and over. Change one thing—monitor, ink, or paper—and you should adjust your color management process accordingly.

instrument-based color management

Instrument-based color management is a scientific method of calibrating and customizing the devices (and the workflow processes) that handle your color pictures so you can consistently and predictably get the print results you desire.

Sound scary? It can be. Sound good? It can be. Is it for you? If you answer yes to the next three questions, then you should consider this method of color management. Do you regularly read computer and digital photography articles on the web and in magazines? Is your photography important to your finances or to your ego? Are you having trouble getting good prints on the first or second try? If you answered yes only to the first question, then you may enjoy implementing this method but you probably don't need it. If you answered no to the first but yes to the second or third questions, you probably need color management but you should first discuss your needs with a color management professional. Try asking at your local professional photo lab. You can then decide whether to implement it yourself or hire a pro to do it.

To calibrate and profile your monitor, you install software and then place a colorimeter, a mouse-size device, on the monitor to measure the values of the colors displayed. You then close the loop by producing profiles for each type of paper you use with your printer. You can even create a profile for your scanner. This is important if you use it regularly to digitize pictures for printing. A kit costing $150–$400 provides the necessary tools for do-it-yourself color management. Products in this category include Colorvision Spyder2Pro, Gretag MacBeth EyeOne Photo, and Monaco EZColor 2.

Once you install the software, a wizard leads you through a series of steps to calibrate your monitor's brightness, contrast, and color reproduction. You need to know your monitor's shortcomings and that's where the colorimeter comes in. You place the

Before You Adjust Your Monitor

Before you adjust or calibrate your monitor make sure you follow these preliminary steps first.

The desktop is the monitor's color background. Remove any wallpaper or photos on the desktop and adjust the desktop of your monitor so it is neutral gray. Judging one color against another strong color can throw off your color perception.

Make sure the monitor is set to display millions of colors. If you bought your computer in the last four years, it probably is set correctly but double check to be sure.

Before you start any critical monitor adjustments or image adjustments, let your monitor warm up for about 20 minutes.

Work in a dimly lit room with neutral-colored walls. Do not wear any brightly colored clothing when sitting in front of the monitor. Colors reflected from your clothing and the walls can reflect onto the monitor and affect the colors you perceive, resulting in incorrect color adjustments.

colorimeter against the monitor's screen. The calibration software you installed instructs the monitor to produce a wide range of specific colors. The colorimeter measures how accurately your monitor reproduces these specific colors. The software then compares the actual colors produced with the colors that were supposed to be produced. Any differences are accounted for and used to create new "color mixing" instructions that enable the monitor to more accurately display colors. This custom set of directions that tells your monitor how to accurately reproduce color is known as a profile.

You can use a similar process with your printer to improve color accuracy for a specific paper. You print a file of known color patches on a specific paper and then measure the color patches on the paper with a colorimeter or spectrophotometer. The provided software analyzes the results (mainly the differences from the known colors). It then creates a file (a profile) that characterizes the color results and is stored on your computer. When you make a print, you select the profile and software instructs the printer how to adjust ink output to accurately print colors for that specific paper. By the way you already use printer profiles. When you select a paper type, such as glossy or matte with the Printer Driver, you are invoking a generic profile for that type of paper made by the manufacturer of your printer.

How difficult is this? And how effective? My experience is that it's not difficult, and that it's fairly effective. The main goal is to get the monitor calibrated so it accurately displays colors. Many paper manufacturers provide profiles for specific printer models or specific driver settings. These do a reasonably good job. The real issue is when you print on a paper for which you have no profile or no suggested settings for the printer driver. Then it's pretty much trial-and-error on your part.

Conflicting Color Management Settings

To successfully implement instrument-based color management, you need to turn off any conflicting color settings that could interfere with your color management system. The instructions that come with your color management product will probably point these out. They include deleting the Adobe Gamma Loader (or moving it to a folder where it won't be turned on) and setting the printer driver to turn on ICM (Image Color Management) in Windows-based computers and turning off any special color settings your driver might offer, such as enhanced color or digital photo color. Finally, although you can use profiles with image-editing software other than Photoshop or Photoshop Elements, these programs are almost standard for using color management.

visual color management

Adjusting your monitor to display colors accurately and a full range of neutral tones (from blacks to grays to whites) without color casts may be the most important step to better prints. Doing it solely with your eyes and no instrumentation is problematic. Yet many photographers swear by their ability to visually adjust their monitor-to-print system.

Once you know that your monitor consistently displays the approximate values in your digital pictures, you can more confidently adjust the brightness, contrast, and color of your pictures with your image-editing program. These adjustments don't guarantee that the print will match the monitor, but they do increase the likelihood that the monitor's display will be fairly accurate. So if the prints don't match

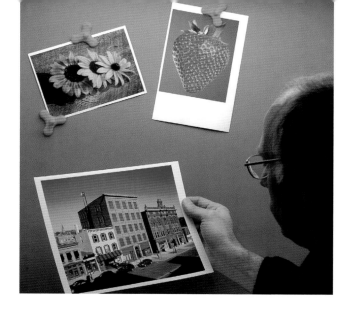

the monitor, it is the printer that is a bit out of whack. With eyeball management, you won't actually adjust the printer, but will compensate for its wanderings by adjusting the image with your editing software or possibly the printer driver.

You have a couple of options to choose from to visually adjust your monitor. You might use tools provided by your image-adjustment software or your monitor, or you can implement a do-it-yourself procedure.

calibrating with image-adjustment tools

Although other image-editing programs may provide monitor adjustment tools, we're going to review the Adobe Gamma tool provided by Adobe Photoshop as well as Adobe Photoshop Elements. Both programs use the same adjustment wizard. The wizard leads you step by step through a series of visual comparisons to correct the brightness and contrast of the display. Because it's a visual calibration, it is somewhat subjective and thus prone to error. For many folks it greatly improves the consistency and quality of their prints. The Adobe Gamma tool isn't available for Macs using OS X. Use the Mac ColorSync tool.

The easiest way to start using it is to open up Photoshop's Help menu and look up monitor calibration. Then follow the procedure provided by Adobe. That way you know you will have the most accurate procedure for your version of the software.

If you aren't using Photoshop, you may want to do a search on monitor calibration in the Help menu of your software to see if they provide calibration tools or procedures.

calibrating with monitor tools

Many better monitors provide software calibration utilities to tweak the provided monitor profile or create a new one. Because procedures and calibration tools vary from monitor to monitor, we won't try to elaborate on the procedures. Check your monitor's manual or use the CD if one was provided with your monitor. The presence of a CD just for your monitor likely indicates that it offers some form of calibration utility.

The concern you might have is implementing multiple forms of monitor calibration. If you calibrate the monitor with tools provided by the manufacturer and then do the Adobe Gamma process, which one is actually in control? The Adobe Software may raise that very question when you open it up if it finds conflicting information.

do-it-yourself monitor calibration

When all else fails you can adjust the monitor by creating your own test file with neutral-toned and color patches, and then adjust the monitor's controls to best display it. Once you've adjusted your monitor (or even if you haven't), print out the test file and see how well the print matches the monitor display.

Use your picture-editing software to create the test file. It should include ten neutral-toned patches ranging from almost black to white. Each patch should have equal amounts of red, green, and blue in them to ensure they are neutral. To check for accurate color reproduction, create patches of pure cyan, magenta, yellow, red, green, and blue. You might want to also add a face with good skin tones, and maybe a colorful subject such as a box of crayons or several different flowers.

RGB Values	Tone	RGB Values	Color
R=25 G=25 B=25	extremely dark gray	R=255 G=0 B=0	bright red
R=50 G=50 B=50	very dark gray	R=0 G=255 B=0	bright green
R=75 G=75 B=75	dark gray	R=0 G=0 B=255	bright blue
R=100 G=100 B=100	dark medium gray	R=0 G=255 B=255	bright cyan
R=125 G=125 B=125	medium gray	R=255 G=0 B=255	bright magenta
R=150 G=150 B=150	light medium gray	R=255 G=255 B=0	bright yellow
R=175 G=175 B=175	lighter medium gray		
R=200 G=200 B=200	light gray		
R=225 G=225 B=225	very light gray		

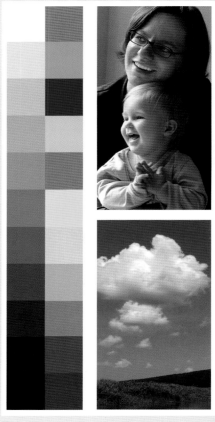

To help you create a test image for adjusting your monitor, this table gives you the values to create a light-to-dark gray tonal scale and color blocks.

You may have to refer to the user manual for your monitor to find the correct procedure for adjusting brightness, contrast, and colors. And you may want to keep notes on the outcome of each step during the whole process. Here's the procedure to adjust the monitor.

Turn on the monitor and allow it to warm up for about 20 minutes.

Refer to your monitor's user manual and set the white point to between 5500 and 6800. Most monitors come preset to 9300, which is too bluish.

View the test file you've created.

If the gray patches appear to have a color cast, adjust the monitor's color controls to eliminate it.

Look at the test patch printed opposite, and adjust the brightness controls so the darkest test patch is almost black but clearly distinguishable from its neighbor.

Adjust the contrast control to make the white test patch white, while keeping the 3 top gray bars clearly distinguishable from each other.

Tweak the brightness and contrast controls to make any further adjustments.

Compare a Print to the Monitor Display

Once you've adjusted the monitor so the gray tones appear neutral, the skin tones on the face are pleasing, and the colorful subjects seem appropriately colorful, make a print.

Use your favorite photo-quality paper and make sure the print driver is set for that photo paper and to the quality setting you normally use. When the print is completed, compare it to its corresponding image on the monitor. Are you satisfied with the print? Does it approximate what you see on the monitor? Print and monitor won't match perfectly, because each uses a different technology to create color. However, the print should approximate what you see on the monitor.

If the print is simply too dark or too light, adjust the monitor's brightness and contrast controls until you get a better match. If the print's colors are off, adjust the color of the image using the picture-editing software, and then make another print. Keep a record of your adjustments. The color adjustments you make in the picture-editing program to obtain a pleasing print are the approximate picture-editing adjustments you should make on all future prints. Note the exact amount of adjustment. In future printing, after you make all your other adjustments, apply these final settings to your picture-editing program.

If you were able to make this work, then try it again with the two or three other papers you use. The biggest variable is paper type. The more types you use, the more difficult it becomes to get good results with each paper. With this method, either use the papers made by your printer manufacturer or use papers that provide specific settings (or even a profile) for your printer. Otherwise, there's too much guessing involved.

This trial-and-error method can be time consuming, and sometimes ineffective. If it does not enable you to make good prints within two or three tries, consider going to instrument-based color management.

hire a professional

If you want the advantages of color management without the hassle of figuring it all out, spend the money to have a pro do it. The installation process will be about the same but it will be done faster and probably better, because you won't have to solve the problems that inevitably occur. The person will likely give you a quick training session. All in all, it's not a bad way to start out with color management.

If you're happy with your monitor's display accuracy, but want to try out some new papers, get a profile for that paper. Some paper manufacturers provide free downloadable profiles on their websites. You can also buy generic profiles for a variety of printer-and-paper combinations or print out a standard color patch and pay $50 to $100 for a custom profile to be created based on the results of the color patch made on your specific printer-paper combination. You might think a profile is a profile, but just like ice cream, the equipment, ingredients, and craftsmanship that go into a profile can make a big difference.

The good news is that I have calibrated and profiled my monitor and made prints with the canned profile that came with the printer for the manufacturer's paper. The results have been pretty good.

How a Professional Lab Helped Me with Color Management

By Stephanie Albanese

When I dipped my toe into the pond of digital imagery a few years ago, I had no idea where it would lead. I have always enjoyed artistic endeavors and over the past ten years have concentrated on taking and printing traditional fine-art black-and-white photographs. A digital point-and-shoot camera, given to me while on vacation, started the ball rolling toward digital photography.

It didn't take long for me to learn that digital printing is a far cry from the black-and-white images I had been making for years. Hours spent in the darkroom processing film and producing prints was reduced to minutes. This new way of making pictures was exciting and seemed easy. In retrospect, my naiveté was astounding. This past year and a half I began taking my digital photography to a new level when I bought a digital SLR and a tabloid-size inkjet printer. I wanted to control the outcome of my newly created images. I wanted them to have the same colors I saw when I adjusted them on the monitor, but it usually took me three, four, even five tries to make a print that came close.

During a class in Adobe Photoshop, the subject of color management was mentioned. It became clear why I wasn't getting the color I saw on my monitor. I had been operating in a digital fog. I needed to calibrate and profile my monitor for consistent viewable results. The mysteries of ICC profiles, inks, papers, and monitor and printer calibrations were more than I could manage. I needed professional assistance.

John Latimer, an experienced custom digital printer and adjunct professor of digital imaging and fine-art printing at the Rochester Institute of Technology (one of the top photography schools in the U.S.), was able to help me out. His ability to clearly explain how he could solve my problems made me confident I'd soon be making prints that matched my monitor. John told me the most critical step was to calibrate my monitor. He felt that the built-in paper profiles I was using with my printer were quite good and that it wouldn't be that much of an improvement to profile my paper. I think he didn't want to overwhelm me with color management processes.

On a snowy February morning, John came to my house and began the monitor calibration by using GretagMacbeth's new Eye-One Display2 hardware and Eye-One Match software. In less than an hour, he calibrated my monitor and taught me how to do it myself. The improvement in my printmaking was immediate. After months of struggle, I was finally getting prints that were not only excellent but most importantly, nearly matched what I saw on the monitor. Since I make so many prints, the savings in time, paper, and ink should quickly pay off my investment. Most importantly, my frustration has been overcome, and I now greatly enjoy making prints. I think I may be ready for the next step—profiling my papers.

Some Creative Print Projects

By Cynthia McCombe-Akers

introduction

I take pictures to chronicle my life. I used to keep a diary, but I found that the richness of visual images far surpassed what I could record about my daily life with words alone. At last count, my husband informed me that I have 9,000 digital pictures on our computer. What is the point of taking and storing so many pictures? The answer is simple—photo projects.

Ink jet printing puts the power of creativity at your fingertips. Not only are you your own photo lab, but you also have the ability to print on a vast array of papers, fabrics, and materials. You are in control of your photos from capture to print without contending with the cost, mess, and time of chemical processing of film and light-sensitive papers in a traditional darkroom.

All of the photos used in the following photo projects were taken with no end purpose in mind. For me, the core benefit of shifting from analog to digital photography has been that I can take as many pictures as I want and then use them in all sorts of projects.

Overview of my Picture Activities

I take pictures everyday. I have learned that the best photos are normal everyday moments. I try to shoot in the early morning or late afternoon when the lighting is more attractive.

I download the photos to my computer everyday. I simultaneously re-charge the batteries in my camera so I'm always ready to capture the next events in my life.

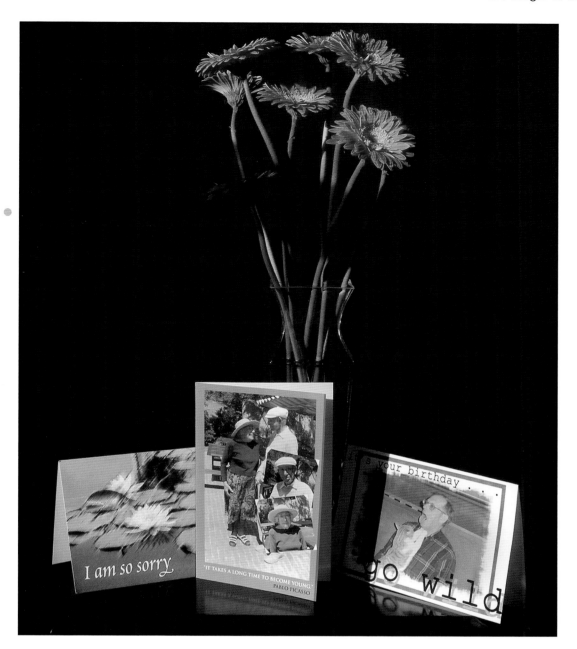

I review my photos in photo management software. I delete the ones that are obviously bad. I rotate photos that are sideways. Sometimes I fix obvious red-eye. Good photo management software lets me look at my images in batches. I happen to use Adobe PhotoShop Album, but there are many similar programs on the market. (The web site www.about.com has a review of several of them.)

I post my favorite photos to a web site, where family and friends comment on my photography. Their comments help me see which photos have the most appeal. I tuck these photos away in memory and they bubble back up when it comes to making projects.

I use my favorite photos for cards, presents, creative projects, and to decorate my house. I look for inspiration by reading magazine and online articles about scrapbooking, decoration, and book design. I experiment with new products, such as unusual photo papers and project kits.

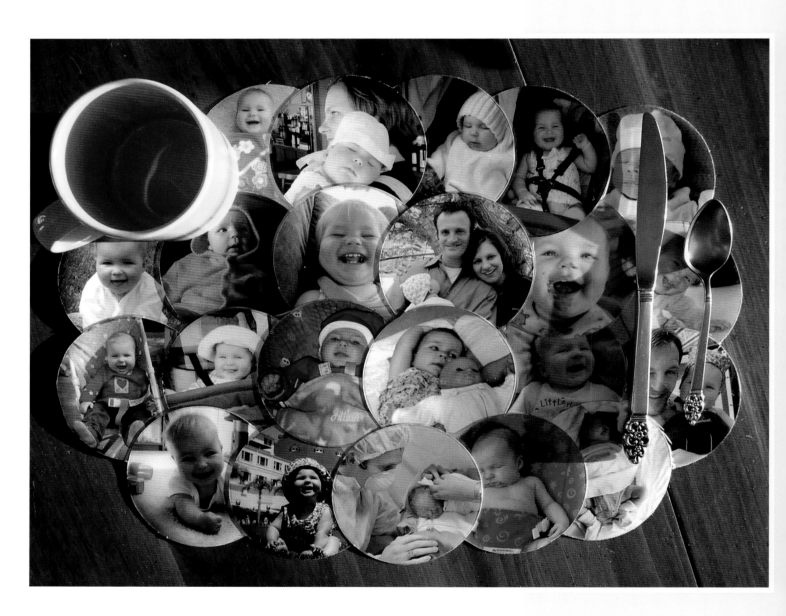

Collages

With photo collages, the creative combinations of photos are endless. When I create collages for my photo projects, I flip through all my photos and look at each one as an element for my new design. All of a sudden, a photo of a sunset or a tree becomes a backdrop to hold other photos. I look for sequences of photos to see if a simple story could be told of a family outing or a day trip.

To get you thinking creatively, you should consider the ways you can use photo collages:

Calendars—Because calendars cover a whole year and should be given shortly before the start of a new year, you'll need to do some long-range planning. To build up your stock of calendar photos, each month try to take photos that represent that month or season for your family or whatever the subject of your calendar. When it's time to make your calendar in November or December, you'll have enough photos to tell the story over a full year. Not only do calendars make excellent gifts for family and friends, they also chronicle your life and serve as an heirloom in years to come.

Commemoratives for anniversaries and birthdays—I can think of no better way of celebrating the life of a person than to illustrate his or her life in photos. You can assemble smaller collages together on poster board to create a larger work of art if you don't have access to a large printer.

Personalized cards—Use collages to personalize messages. For instance, if you are creating a birthday card for your brother, you might go through all your photos of him and select the ones that show him in his favorite places and activities. Since my brother enjoys car racing, bowling, fishing, and golf, I make him a card with pictures showing him involved in these activities.

Gifts—It's easy to turn photo collages into gifts. If you are working with smaller images, you can always make bookmarks. One of the favorite bookmarks I use is a collage of a relative who has passed away. It commemorates her life. If you are working with larger images, you can make small posters, placemats, or a nicely framed work of art.

Once you decide which pictures to use, follow the steps below to make your collage:

1. Organize your photos.

Save copies of all the photos you are going to use in one folder. Once you start a photo project, you don't want the hassle remembering the individual location of each photo in your collage.

2. Choose your software and create your document.

Start by opening up a new file in the software application you are going to use for assembling your collage. Make this file the appropriate size and resolution for your final project. You can import other images into this file by opening them up separately, and then copying and pasting them onto the initial file. Most photo manipulation applications have layers. If your software application has layers, become familiar with how they work, so you can manipulate and move your image pieces.

3. Design and lay out your collage.

Figure out which image, if any, you want as the backdrop to your collage. I work from the bottom up, designing the larger elements first and finishing with smaller design embellishments. Turn off the layers you aren't working on or hide them until you need to see them. I have experimented with a program called PhotoMix (www.photomix.com) to design the layout of collages. If you don't want to learn the technical aspects of working with layers, this program takes this step out and allows you to work with pre-made layouts.

4. Add text.

Text provides a nice touch to a collage. While digital scrapbookers often include complete stories with their work, for most collages, I use just a few words and focus on making them an attractive part of the design. Limit the number of fonts you use on a collage. If you are using two different typefaces, choose very different ones to achieve contrast. For instance, a nice script typeface can work well with a plain, less ornate typeface.

5. Save and preview the collage.

Make sure you save your collage in two different formats so you can easily print as well as alter your original images in the future. Save your collage in the file format native to your software. For instance, when I use PhotoShop Elements or Adobe PhotoShop, I save a layered file in the PSD file format. I also save a copy in the JPEG format so I can easily print it using virtually any software program. Remember that when you save an image in the JPEG file format, the image is merged. It is no longer separated into layers.

6. Determine how you will use your collage.

Instead of doing extensive scrapbooking to catalog my daughter's life, I make one collage illustrating her life per month. When I am done, I can use each collage as a page in a calendar, as a mouse pad, as an iron-on transfer for t-shirts or mouse pads, or for a photo book for my mother. A good rule of thumb is to size your collage down to the size of your final output and keep the resolution at least at 200 ppi. You can normally find an Image Size dialog box somewhere within the software you are working in. Try not to reduce your collage more than 50 percent or enlarge your collage more than about 20 percent from its original size. You can certainly push these limits, but you will have to assess image quality to make sure you are happy with the results.

7. Print your collage.

Print your collage using the printer driver's highest quality option for the type of paper you have selected. When the sheet comes out of the printer, put it on a table without another sheet touching the ink on it. Let it dry overnight.

8. Finish your collage project.

Frame, bind, or fold the collage project when you are done.

Calendars

Photo calendars make wonderful Christmas presents. I gave a calendar to a friend last year, and in a thank-you note she mentioned that although she will enjoy the photos each month, she would treasure the calendar long after the year has gone by.

Before you get into the mechanics of making a calendar, sit down and think about for whom you are creating the calendar and who else might be viewing it.

If you are creating a calendar for your family, write down the names of the people you will be sending it to. Add to the list, people who will be viewing it. Next, make a list of important birthdays and anniversaries appropriate for these people. This will help you pick the best photos and decide in which months to place them. You might also want to review calendars at bookstores to see what you like and don't like about them.

If you are creating a calendar for a club or an organization, make some notes about what makes this group special. Who are the primary members, staff, or volunteers? What are their important events for the group and when do they occur?

1. Select 13 photos (one for the cover) for the calendar.

After jotting down some notes based on the guidelines above, sort through your photos and narrow the possibilities down to your final choices. Since most calendars use pictures of the same orientation—horizontal or vertical—figure this into your picture selection. Sometimes you can use two smaller vertical pictures side by side to fit into a horizontal space.

2. Print out 4 x 6-inch photos of your images.

Print your pictures and lay them out on a table. Look at them all together to get a feel for how well they meet your needs and how well they work together. This step may seem unnecessary, but I recently put together a calendar without following this step and only later did I realize that I included only photos of women!

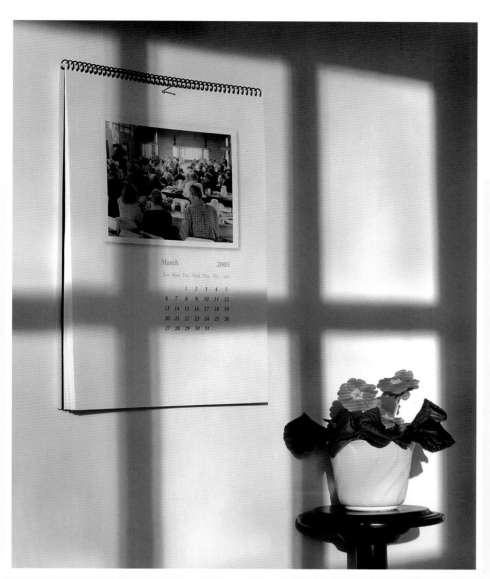

Strathmore's online calendar creation tool and their "Digital Photo Calendar Kit." If you're creating a calendar for people to write on, use a matte photo paper instead of the hard-to-write-on glossy or semi-glossy photo paper.

5. Arrange your photos and customize the design.

Assign a photo to each month. Again, lay them all out on a table from January to December to make sure the arrangement works. Then customize the design of the calendar. Some software has a wizard that enables you to caption the photos you are uploading. Some software lets you choose design elements or typefaces. For instance, Adobe PhotoShop Album allows you to choose between Classic and Modern styles.

6. Save and preview the calendar.

As you create it, save the calendar file frequently. Before you print, preview all the months as a final quality check. You can go through the step of printing out a set of previews on cheap paper using draft print quality if you like.

3. Decide which type of calendar you want to create.

The two major categories of calendars I create are ones that have areas to write in information for each day, and ones that have the dates in a small grid and are used for reference only. The first calendar type makes it easy to write in important dates. The latter type is good to use when you have really strong photos and individual dates don't matter as much. I normally do the latter type for organizations.

4. Choose software to design your calendar.

Many image-editing programs provide templates to create your own calendar, but good calendar creation programs will give you greater flexibility and ease of use. I have used Adobe PhotoShop Album's calendar creation tool and heavyweight ink jet paper, and

7. Print your calendar.

In the printer driver, select the paper type you are using. Choose the highest quality setting available for the paper type you selected. If available, click the Print Preview option, so you can see how the printed pages will look before you actually print them. After each sheet comes out of the printer, put it on a table without another sheet touching the ink on it and let it dry overnight.

8. Bind your calendar.

If you have the right materials, you can bind your calendar at home, or you can go to a local print or copy shop and have them do it. Some calendar kits have perforated edges and a spiral binding included.

Cards

Everyone enjoys receiving handmade cards for thank-you notes, birthday greetings, announcements, and holidays. Even the most creative and funniest of purchased personal greeting cards seldom escape the wastebasket. They simply lack the personal touch that makes them worth keeping. When you take the time to add your own heartfelt sentiments and use a photo that connects you and the recipient, your card will probably become a treasured keepsake.

When I make photo cards, I try to keep in mind that these cards may be put on a bulletin board or a refrigerator and may be viewed all year around. Knowing that my name may be on display, I try to be creative and entertaining but not outlandish or offensive.

You can choose from a variety of special materials designed for ink jet printing of cards: embossed note cards, glossy postcards, white postcards, white manifold cards, half-fold cards, and quarter-fold cards to name a few. Avery even has ink jet metallic print cards. Or you can simply print a photo on your standard photo paper and glue it to a regular blank card and write your sentiment.

here are a few creative ideas:

For a clever thank-you card, take a photo of the gift in use. If your mother bought a new jacket for your baby daughter, take a photo of her wearing the new item.

Personalize the sentiment. When I take my daughter to a doctor's appointment, I bring a personalized photo card. When a doctor gives her special attention, I leave the doctor a card that reads, "Thank you for caring about me."

For a birthday card, use a recent photo of a person. Put the year on the photo or card to make it a great keepsake gift.

Assemble a photo collage for holiday cards. As a holiday approaches, I ask my family members to dress in outfits to complement the upcoming holiday: red and pink clothing for Valentine's Day, pastels for Easter, orange and black for Halloween, and red and green clothing for Christmas. So far my family looks upon my requests with amusement.

Once you have selected your photos, complete your card as follows:

1. Open the card software application.

Many different software programs offer templates or wizards to create cards. You can probably find a greeting card template in your image-editing program. If not, try specialty project software, such as Hallmark Card Studio or Broderbund PrintShop. You can also create your cards with web-enabled tools from Strathmore (www.strathmoreartist.com) and Avery (www.avery.com/print).

2. Add your photo or photo collage.

Import the photo or collage you created for your card into your software.

3. Personalize your card.

Personalize your message with text on the front and/or inside of the card.

4. Select the proper size.

Under page setup, enter the proper size of the card you will print. Also, do this in the properties dialog box in printer setup. Some printer drivers will allow you to specify Fit to Page.

5. Print a practice card.

Print a trial run on standard letter-size paper before you print the final card. This is especially important if your card is printed on two sides. If you don't have a duplexer, consult the documentation for your ink jet printer to determine how to reload the paper after the first side is printed

6. Make any final adjustments.

Review the trial card and make final adjustments to the layout, orientation, or artwork for your card.

7. Print your card.

Always print your card using the Best or Highest Quality option available for the materials you are printing on. After your card comes out of the printer, leave it to dry for several hours.

Magnets

I am well known for my magnet collection. For the last decade or so, I have purchased a magnet at almost every city or landmark I have visited. When I move into a new house, the first thing I unpack is my magnet collection. It is only recently that I started experimenting with making my own magnets. I started looking at the printed items I stick onto my refrigerator, and I thought it might be fun if I added some of these items to my permanent collection.

You can print on photo-quality paper and stick the images onto magnetic sheets with an adhesive surface or you can purchase magnetic sheets designed for ink jet printing made by Avery and Xerox. These printable magnetic sheets have a white surface on one side. You can print anything you would print on photo paper. Some of the ideas for photo projects that I have come up with are birth announcements, recipes, children's artwork, holiday greetings, favorite sayings, heirloom family photos, and a list of emergency photo numbers. What is so wonderful about giving photo magnets as gifts is that the magnet will find a home on the refrigerator or filing cabinet for many people to see.

To make and print out my own magnets, I follow these steps:

1. Make your plan.

You have 8.5 x 11 inches (22 x 28 cm) of space to design your magnets. Determine the different sizes and types of magnets you want to create before getting into the mechanics of creating each one. As long as you don't waste space on the magnet pages, these projects are very inexpensive. If you have some extra space to fill, you can always print inspirational or funny sayings.

2. Design your magnets.

Sketch out the different options—either on the computer or on paper. Although I am well versed in many software applications, I still work out the mechanics of my designs on paper.

3. Combine all magnets on a printing page.

Save each magnet picture as an individual file while you are creating it. I like to keep layered versions of all my complex artwork in case I need to make changes to the original design. After saving layered files, create JPEG versions of your various magnets. Open up a new file sized to the paper or magnet sheet you will print on. Open the JPEG version of each magnet and copy and paste each design into the document (like a collage). Leave about 1/2 inch all around the page. In my experience, sometimes the edge of a magnet sheet doesn't print out smoothly.

4. Print out a proof sheet.

Load the printer with regular paper, and print out a proof of your page of magnets. A proof sheet is just a practice run made on inexpensive plain paper. Make sure the designs aren't cut off at the edges of the paper and there are no mistakes in the text.

5. Prepare your print job.

Under Page Setup in your software application, configure your printer for the media you are using or follow the instructions included in the magnetic paper package. In my case, I use an HP printer. For magnetic paper, I set the Paper Type to "Premium Plus Photo Paper Gloss," the Print Quality to Best, and

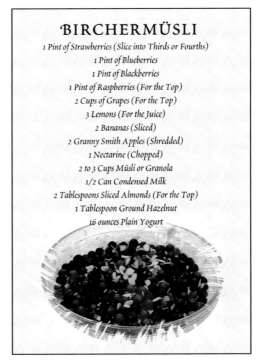

You can keep a favorite recipe handy by printing it as a decorative magnet and putting it on your refrigerator.

Source to Rear Feed Slot. Like very thick papers, magnetic sheets should be fed straight through if possible. Avoid sending it through a stack-feeding tray, which bends paper in a U-shaped path. It is not as pliable as thin paper and might jam or not print clearly.

6. Let your magnet dry.

Set your magnet to dry on a flat surface for at least a few hours. I normally let mine dry overnight before cutting.

7. Cut out your magnet shapes.

You can certainly use ordinary scissors to cut your magnet shapes out. For those who are perfectionists, an Exacto knife, and a ruler or T-square will produce the nicest results. Be sure to use a very sharp blade as some magnetic media print surfaces can have ragged edges otherwise.

In addition to printing out magnets, you can also print out photos on regular photo paper to incorporate with magnets. With different colors of foam, glue and magnetic strips, you can create some wild and innovative pieces. I found a few easy-to-assemble photo magnetic kits on Oriental Trading Company's web site, (www.orientaltradingcompany.com). These are great projects for young artistic children.

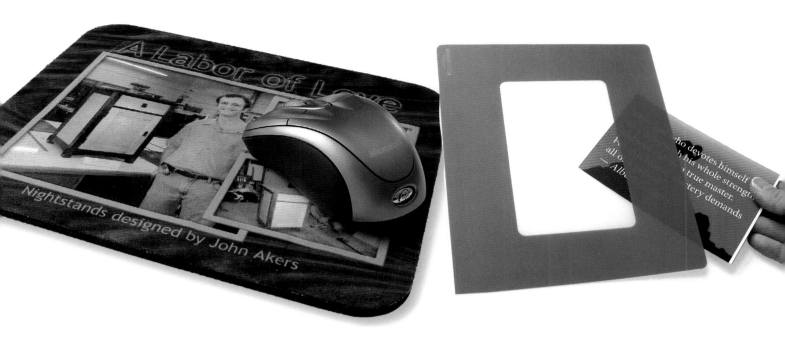

Additional Ideas

mouse pads

Bwhen I first started working on the Kodak web site in 1996, I was given a mouse pad with the homepage of the site on it. That was the first time I had seen a mouse pad that used personalized printing. Now, however, the tools for creating your own personalized mouse pad are at your fingertips.

I have experimented with several mouse pad products. The easiest one incorporated a frame on the surface to hold your photo. I found an interesting photo, doctored it up with some creative imaging techniques, typeset a quote on it, and printed out the new work of art. I put this photo in the mouse pad frame and was done. It made it simple to create a photo mousepad, although the use of the frame meant it wasn't just a mousepad.

The second type of mouse pad product resulted in a beautiful traditional mousepad but was a bit more complicated to use. I found white mouse pads at the

McGonigal Paper and Graphics website (www.mcgpaper.com). These mouse pads have a plain white fabric top with a black rubber base.

I designed a collage to put on the mousepad and printed it out on transfer paper. Transfer paper is available at retail stores and is also used for iron-on designs on t-shirts. Since I included text with my image, I flipped the image horizontally before printing because the image is reversed during the transfer process. If your printer driver has a t-shirt or transfer media option, you probably don't need to flip the picture in your image-editing program—the driver will do that automatically when you select transfer media.

Before I began the transfer process, I let the image dry completely. Next, I preheated my iron on high cotton setting with no steam until it was very hot. I aligned the printed transfer on the fabric side of the mouse pad and aligned it exactly. I ironed the transfer in a circular motion while applying constant steady pressure. When completed, I let the transfer dry completely. (I actually let mine sit for a few hours.) Finally, I grasped a corner of the transfer paper and peeled it back from the mouse pad. The result? One beautiful photo mousepad made by my very own hands.

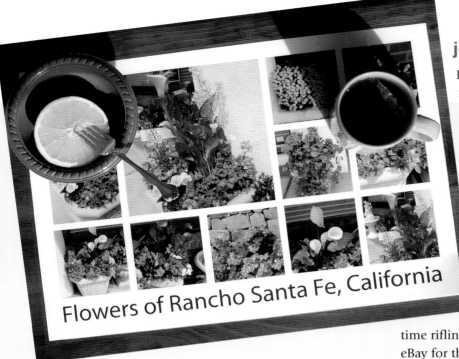

Flowers of Rancho Santa Fe, California

jewelry

I inherited a beautiful heart-shaped locket from my Grandmother McCombe. This heirloom sat in my jewelry box until I had a home printer. The process of finding the right photo to reduce at a photo lab was just enough of an obstacle to make me not use this wonderful piece of jewelry. Now that I have a few ink jet printers in my home, I have experimented with using different photos. I can easily size photos and practice cutting out hearts until I get just the right fit.

While you can certainly spend some time rifling through antique shops or searching on eBay for the perfect antique locket, you can also

placemats

Tabloid printers let you take on bigger photo projects, such as placemats. With these printers you can use paper up to 13 x 19 inches (33 x 48 cm). I have enjoyed playing with my new tabloid printer, and I started thinking about what I could create that would be suited for this new size. I decided that placemats would be a fun project. Follow the instructions for making a collage that were outlined earlier in this chapter and you can come up with all sorts of different ideas for placemats. Just design them to take full advantage of the 13 x 19-inch (33 x 48-cm) paper. After I printed my placemats, I had them laminated at Kinko's for a few dollars apiece.

ornaments

I have seen many different types of photo ornaments for Christmas trees. Most of the ones I have seen aren't versatile enough to display year around. Since I would like to showcase the photography I put in my frames all year, I have gravitated toward photo ornaments that look as good on the wall as they do on the Christmas tree.

You can easily adapt small picture frames into Christmas ornaments by securing a loop of beautiful silk ribbon on the back of each frame to hang it. Print out your favorite photos to put in these frames.

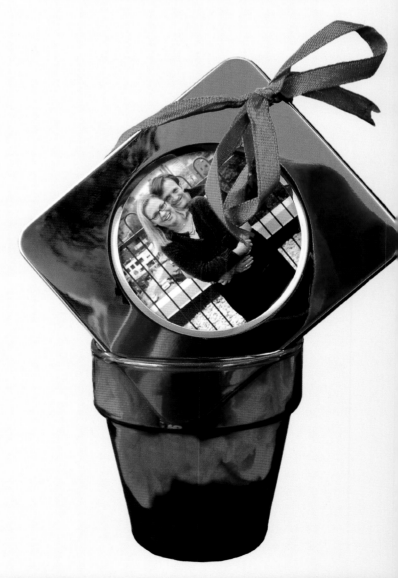

order ready-to-make photo jewelry pieces created for the do-it-yourselfers. Memory Makers, (www.memorymakerbracelet.com) has bracelets, pendants, money clips, key chains, pendants, and pins all ready to be filled with your precious photographs.

My Life Designs (www.mylifedesigns.com) also has beautiful photography jewelry. At this time, you are unable to insert a photo you print from your home printer. Instead, you send your photo by mail or upload it from your home computer to their website, they will reproduce your image as a color, sepia tone, or black-and-white image and seal it into one of their designs using a waterproof coating process.

shrink art crafts

I hadn't experimented with shrink art crafts since I was a little girl. And then, on the McGonigal Paper and Graphics website, I stumbled across Shrink Art Paper that can be used in an ink jet printer. I experimented with photographic nametags and came up with some designs I really like. When creating the

design for your shrink art craft keep in mind that your picture will shrink to approximately 40 percent of its final size. It helps to lower the contrast of your artwork before printing it because the heating process increases the saturation of your artwork. Rectangular nametags seemed to work better than the long slender bookmarks I first attempted to make.

After printing your image, cut it out to size and bake it for 4 minutes in an oven preheated to 300° F. Your artwork will curl and then flatten back down on the baking sheet. When you take it out, you have just a few seconds to adjust the shaping before the artwork becomes solid. To make the artwork really flat, I found that pushing on the shrink art with another baking pan worked beautifully. The McGonigal Paper and Graphics website suggests using a thick hardcover book.

self-publishing

Your ink jet printer puts controls for home publishing in your hands. You can design your own small books, photo albums, invitations, and programs. If you are designing several items to be used for one event, you can create a beautiful matching suite if you share the design elements such as typography and paper selection.

For my wedding, I created my own invitations, table tents, programs, and CDs. The CDs held the key songs from our wedding. I had a fun time using a fancy rice paper for all the different pieces of stationery. I even scanned this paper to use as a background for a sticker I adhered onto the CD.

on-location printing

Some of the new home printers have opened up opportunities for enhancing events while creating one-of-a-kind gifts. If you purchase a home printer with an LCD, on it, you may find that you add this printer to your list of supplies when you go on vacation, have a party, or visit friends and family.

I recently went to a party where there was a photo contest. Adults and children were running around taking photos of the event. Someone had brought along a small printer, and we all took turns printing our images. In the end, a "judge" awarded prizes to winners in a few categories. This event not only recorded the party and served as a great way of gathering up images for a traditional scrapbook, but it also gave everyone something to do.

When we had our little girl, Jillian, we downloaded all the lists from the Internet on how to pack for the hospital. We followed most of the advice and online suggestions, and the only real addition we had was a home printer, ink cartridges, and paper. My husband took pictures of each and every one of our friends as they visited to greet the new addition to our family. We immediately printed out these photos, and gave our friends the mementos as they left. We received such positive feedback from doing this that several

people thought there might be a business plan in this just waiting to happen. If I were to do it again, I would probably include a few picture frames to host the images for the really special people in our lives to take away.

digital scrapbooking

I made the hard transition from shooting the majority of my photos with a film camera to a digital camera a few years ago. I did so reluctantly. I was fearful that I would never like the quality of my pictures as much, that I would run into image permanence issues, and that I would never get around to printing the photographs that I stored on my computer. My fears crept up again when I started scrapbooking. I liked the flexibility that printing my own images afforded. I was able to enlarge, reduce, adjust, and crop my images exactly as I wanted them. My friends using traditional processes were not finding it as easy to alter their photos. In the back of my mind, I still wondered how long pages that were painstakingly created were going to last. I ultimately stopped scrapbooking.

Recently, however, I have become excited about the possibilities that digital scrapbooking affords. In digital scrapbooking, you design the entire page on the computer and you print out completed works of art. Not only does this excite me from a creativity standpoint, it also gets me thinking about how easy it is to make duplicates copies for friends and family. The longevity issue is not so worrisome to me now because it would be quite easy to reprint pages if there was an issue with them fading. At the same time, I am learning that the life span of ink jet prints has expanded and in the future I am sure image permanence will not be such an issue with ink jet printing.

I was a sliver of harvest moon

Content in the billows of darkness.

It was me shadowed by the twisted limbs

Of midnight trees----

Me, who was gently buffeted in a vast

expanse of space and time.

To this I could give

But a transient shaft of reflected light,

Yet still it was mine.

And I knew from the moment its soft

Pinkness touched a reflecting pool

That there was a place for me in the

Heavens.

Pair a photo with your favorite poem or a verse you've written yourself.

©Theresa Airey

Print Longevity

introduction

How long is long enough? If you were a mayfly, 24 hours would be a life-time, and every minute would seem like a day. If you were Methuselah you might have been counting on living another thousand years. Although ink jet prints and mayflies may have had similar life spans a decade ago nowadays they're worlds—or years—apart. And no doubt we're not too far from the day that some ink jet marketing person pleads with a lawyer to brand his line of papers the Methuselah media.

Defining Longevity

Before we go any further, let's ask a question: What the heck is print longevity anyway? It's a simple question with a complex answer. But generally, print longevity is how long a print retains its color without noticeable or objectionable fading. In scientific print testing, that is quantified by specific amounts of color loss. Loss of certain colors is more noticeable than others. Keep in mind that, as of yet, there is no international standard for testing print longevity.

longevity testing

Since those fast-fading prints of the 90's, manufacturers have made huge strides in developing fade-resistant inks and papers. You can expect prints to last not just for years, but decades, and if tests are to be believed, some even make it past the century mark. Of course, all the longevity claims are based on forecasts from tests, not reality.

There's no doubt, it is rigorous testing conducted according to the most scientific testing principles. These tests are known as accelerated fading tests. These tests that last for weeks are supposed to represent what will happen dozens of years later. Anyone who follows the fluctuating recommendations of medical science knows that scientific testing is…well, let's just say it's less than perfect.

If I'm cynical and skeptical it's only because I've lived dozens of years and faded a bit myself. I'd like to suggest that the most rigorous testing is life itself. It's important to acknowledge that published print testing results do not account for delamination, crackling, paper yellowing, or a variety of untested variables ranging from fingerprints and dog saliva to mildew, air freshener, your cigar puffing cousin, your furniture refinishing wife, your shower taking teenage daughter who seems to be testing the water heater, and the other wild environmental fluctuations encountered in the particular environment you call home. So, subjecting ink jet prints to rigorous tests in controlled chambers at steady temperatures with known amounts of light of a precise spectral content and an unvarying and steady level of humidity, with a known quantity of harmful gas may build your confidence. I'm still not convinced. When somebody can show me a one-hundred-year-old ink jet print as brilliant as the day it was created, then my mind will be somewhat eased.

If my somewhat skeptical and ranting tone is not building your confidence regarding longevity, then I've achieved my goal. It's safe to say ink jet prints made now will last much longer than those made ten years ago. In many cases you can expect them to last decades. But keep that proverbial grain of salt handy until they actually do last decades and their longevity isn't just a prediction.

general rules for lasting prints

In support of longevity, there are several rules of thumb that experts seem to agree on.

Pigment-based inks create longer lasting prints than dye-based inks.

Prints made with the printer manufacturer's ink and paper combinations often last longer than those made with third-party materials.

Prints framed under glass better survive ozone attacks.

Prints made with dye-based inks last longer on colloidal paper, which seals in the inks and resists humidity and ozone attacks better than those made on microporous papers.

For ultimate longevity, prints should be wrapped inside one-hundred-percent silk prayer cloths made by Tibetan monks, hermetically sealed, and stored at absolute zero in a nitrogen-rich atmosphere. (I'm kidding of course, although sub-zero storage is the ultimate way to increase longevity.)

What I'm trying to say, if you want to make a print last as long as possible, never let it see the light of day (certainly not direct sunlight), never let it contact the ozone-rich air the average home, never subject it to fluctuating temperatures or humidity, never let it touch impure materials. Well, you get the picture; pictures last longer when their exposure to detrimental elements is minimized. So what's the downside? When will you get to enjoy your pictures?

Are Prints the Best Archival Strategy?

Let's face it, if it's technology-based it will be obsolete within a decade or two. A quick run down through the Hall of Fame of Obsolete Storage Methodologies gives us 5-1/2 inch floppy disks, diskettes, Syquest cartridges, Zip and Jaz cartridges, hard drives in old computers with long forgotten operating systems. Soon to be obsolete are CDs (whose longevity is also coming under increasing scrutiny), and while currently popular, DVDs may not be far behind. Then, of course, there are the numerous file formats considered standard today. Current formats, like JPEG and TIFF, may yet survive for a while, but how long will proprietary files, like the current Photoshop PSD format and all those proprietary RAW camera files, endure? After all, companies must be profitable and eventually the cost of supporting "ancient" software is more than the benefit.

The solution? Make prints. With paper the worry isn't obsolescence but durability. You need only print your favorite pictures on a long lasting paper with the appropriate ink and then store them using archival methods. They'll outlast any technology solution based on hardware.

Longevity Strategies

It's easy to say you want prints that will last a hundred years or more, not quite as simple to achieve this goal. The overall strategy is to select materials as well as display and storage methods that meet your longevity needs. Keep current with manufacturers longevity claims, and choose materials that fit your needs for the use of each particular image. A snapshot may not need to last as long as a family portrait. To increase print longevity requires an investment in money and time. Better papers, better inks, better mounting materials, better frames, better storage boxes, longer printing times, longer drying times, increased expertise on your part. How long you want your prints to last is a personal choice.

Oddly enough, while we all would prefer that our photographs never fade, let's admit that an imperfect world brings emotion to our lives. What emotional value does a faded photograph carry? It speaks of age, of time gone by, of simpler and happier times (all the joys of nostalgia), and how the ravages of time take their toll on photos. A faded photograph spurs songs and poetry.

Software restoration techniques can nicely restore those faded colors to nearly normal, and will likely do an even better job in the future. So for some of us maybe the issue isn't quite as big as we may think. If a faded photograph is a big issue to you, you'll definitely want to create a print longevity strategy.

Let's set three levels of increasing need for print longevity and base our strategies accordingly.

• Everyday prints that you'd like to last several years.

• Family photographs to display or store in an album. You want these to be around for a few decades, until they become somebody else's problem to deal with.

• Priceless pictures that must last fifty years or longer. These include pictures intended for fine art sale and the really special family photos.

Make Snapshots Last for Years

This is actually fairly easy. Use good quality paper made by your printer manufacturer or a reputable third-party manufacturer. Match paper type to printer type: colloidal (swellable) emulsion paper for dye-based printers and microporous paper for pigment-based printers. Let prints dry for half an hour or so before handling.

Display pictures out of direct sunlight. Hang a few on the refrigerator, but expect the high traffic and ozone from the fridge to reduce lifespan. Store them in albums with archival qualities. Cheap albums with plastic pages and non-archival adhesives (rubber cement, white glues, sticky pads) will all shorten print life. If you want to squeeze a few more years out of your album prints, choose an album labeled archival and stay away from general-purpose glues. Still, expect to remake some of these prints in five to ten years.

Top tip: Keep snapshot prints out of direct sunlight

Your snapshots will be around to make you laugh for years if you use good quality paper and inks, and display prints out of direct sunlight or store them in an archival album.

If you display your work in a gallery or sell your prints, longevity is very important. Use all archival materials to make and mount the print. Put it behind UV glass that does not touch the print surface and use a metal frame.

make family photographs last for decades

You want some prints to last not just for years but decades. On the product packaging or at the manufacturer's website, read their longevity claims closely and see which combinations of papers and inks will last twenty-five years or more with your printer. Review the fine print of longevity claims and make sure you understand the specific paper-ink combinations and what they've been tested for. Ideally, they've been tested for both light fastness (resistance to fading from light) and gas fastness (resistance to fading from gases—primarily ozone).

Top tip: To help prints last for decades, use high-quality materials to print, display, and store your pictures.

Let prints air dry for a few hours (overnight is best) before handling. If you are mounting the print, use acid-free archival materials and cover with UV-blocking glass (use spacers or a mat to keep the glass from touching the print) to protect the print from ozone. Consider metal frames instead of wood. Wood frames can exude chemical contaminants that react with your print, shortening its life. Display prints away from direct sun and limit their exposure to daylight to a few months each year before storing them in a dark archival photo storage box or album. Don't stack the prints on top of each other without interleaving them with an acid-free paper.

For album storage, choose materials made to high archival standards. Such materials are acid-free and inert so they don't chemically react with your photos. In general, try to control the environment in which you store your prints. Keep humidity below 75%, temperature below 75°F (24°C), and minimize airborne contaminants, such as ozone and cigarette smoke.

make pictures last as long as possible

Eternal print life is your goal, but for now a hundred years sounds good. Is it possible? Let's be frank, nobody knows for sure. Accelerated tests say yes a few products can do that. But who actually knows what unexpected variables could reduce print longevity in the years ahead. A volcano erupts downstate spewing sulfur, your house gets fumigated, air pollution triples over the next 50 years, or those acceleration tests just didn't account for some key interaction.

Enough of the pessimism. Let's take a crack at making your prints last long enough to be passed down to your children, grandchildren, and great grandchildren. We'll start by giving testing its due. Use

Use archival storage boxes to hold your prints for the next generation.

only materials that have been tested for both light fast-ness and gas fastness. The results of these tests should indicate that the prints can last seventy-five years or longer.

As of this writing, prints made with ink and paper from the same printer manufacturer generally last longer than those made on third-party materials. But keep in mind that there are only a few major printer companies and lots of motivated, innovative third-party paper makers can customize their products to work with the relatively few printers preferred by ded-icated print makers. Whether you want to try third-party products is up to you, but stick to companies that publish longevity data for both light fastness and gas fastness.

When you choose your ink-and-paper combination and are ready to make your final print, make two prints instead and let them dry for 24 hours. For the print you want to display, mount it using all archival materials and put it behind UV-blocking glass (with-out the glass touching the print) and use a metal frame. Display it out of direct sunlight. The second print is for dark storage. After it dries, place the sec-ond print in an archival storage box. Sandwich it between two sheets of archival paper for protection and don't put so many prints in a box that the pres-sure becomes excessive. Store the box in a cool, fairly dry (about 35% humidity) area.

This is just an overview. Archival printing (and stor-age) is an art and science in of itself. Procedures and products are rapidly changing. So read up on the sub-ject, but be just a little bit skeptical. Most of all decide how much you really care who sees your prints in a hundred years.

Top tip: Use only archival materials and processes. Read books and articles dedicated to archiving to become stay up-to-date on the latest developments in ink jet print preservation.

Useful Printing Websites

Photography and Imaging Magazines

The following websites qualify as e-magazines, with many articles on various aspects of photography and digital imaging.

About Photography (photography.about.com/cs/digital/a/): Features brief articles about choosing and using digital cameras and links to numerous photographic websites..

Apogee Photo Magazine (www.apogeephoto.com/LGD.shtml): A "full spectrum" on-line magazine, Apogee includes a comprehensive range of topics on both film and digital photography.

Better Photo (www.betterphoto.com): An on-line magazine with informative articles about digital photography and image editing.

Digital Outback Photo (www.outbackphoto.com): Published by professional landscape and travel photographer Uwe Steinmueller, this is a web magazine for advanced shooters who enjoy outdoor photography using digital cameras.

Kodak e-Magazine (www.kodak.com/US/en/corp/magazine/): Feature articles about photographers as well as numerous photo tips.

MSN Photos (photos.msn.com): This on-line photo magazine publishes new articles each week, and its archive of articles includes a myriad of topics including many on digital cameras and shooting techniques.

Take Great Pictures.com (www.takegreatpictures.com/digital): Weekly articles about equipment and techniques, as well as articles about celebrities who enjoy photography.

Wet Pixel (www.wetpixel.com): As you might expect, this site features underwater photography and equipment, and includes reviews, an extensive library of feature articles, and discussion forums.

Other Websites

The following websites are worth visiting, offering a broad mix of content as well as links to other sites that you may wish to explore.

Blue Pixel (www.bluepixel.net): Offering educational programs and services, including photo expeditions, this site provides choices for those who want to learn more about digital photography.

Computer Darkroom (www.computer-darkroom.com): A website dedicated to articles, tutorials, reviews and technical discussions relating to digital image processing.

Digital Photography Review (www.dpreview.com): Published in England, this website provides extensive coverage of new digital cameras and extraordinarily comprehensive test reports with extensive technical documentation.

Imaging Resource (www.imaging-resource.com): Includes daily news items about new equipment, often with an analysis by the publisher as well as thorough test reports, particularly of digital cameras. Other features include articles on selecting the right camera, scanner, and printer ,as well as tips on using your new equipment.

PhotoBlink (www.photoblink.com): A photographic forum and competition site for serious photographers.

PhotoPoints Photography Community (www.photopoints.com/main): This international site features critiques as well as ratings (on a points basis) of images submitted by members.

Product Information

ACD Systems (Software) www.acdsystems.com
Adobe Systems (Software) www.adobe.com/digitalimag
Archival Methods (Archival storage) www.archivalmethods.com
ArcSoft Inc. (Software) www.arcsoft.com
ArtZ Products (Storage) www.artzproducts.com
Auto FX Software (Software) www.autofx.com
Breeze Systems (Browsers, converter software) www.breezesys.com
Canon Inc. (Printer manufacturer) www.canon.com
Cerious Software Inc. (Browser software) www.cerious.com
Chromix (Custom Color Profiles) www.chromix.com
ColorVision Inc. (Color management tools) www.colorvision.com
Corel Inc. (Graphics software) www.corel.com
Crane Paper (Paper supplies) www.crane.com
Delkin Devices (Memory cards) www.delkin.com
Digital Mastery (Seminars and training) www.digitalmastery.com
DisplayMate Technologies inc. (Calibration software)
 www.displaymate.com
Driver Guide (Drivers for scanners and printers)
 www.driverguide.com
Eastman Kodak Company (Equipment and supplies)
 www.kodak.com
Epson (Printers, inks, and papers) www.epson.com
Extensis Inc. (Software) www.extensis.com
FM Software (Software) www.fredmiranda.com
Fuji Photo Film (Equipment and supplies) www.fujifilm.com
Gretag Macbeth (Color management products)
 www.gretagmacbeth.com
Hahnemuhle Paper (Paper supplies) www.hahnemuhle.com
Hawk Mountain Paper (Paper supplies)
 www.hawkmtnartpapers.com
Hewlett-Packard Development Co. LP (Equipment and supplies)
 www.hp.com
Color Consortium (Color standards organization)www.color.org
Legion Paper (Paper supplies) www.legionpaper.com
Monaco Systems Inc. (Color management tools)
 www.monacosys.com
Nik Multimedia Inc. (Software) www.nikmultimedia.com
Pantone Inc. (Color management tools) www.pantone.com
Phase One (RAW converter software) www.c1dslr.com
Strathmore Artist Papers (Paper supplies)www.strathmoreartist.com
Wilhelm Imaging Research (Information on image stability,
 preservation) www.wilhelm-research.com

Index